Critique of Critique

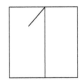

SQUARE ONE
First Order Questions in the Humanities

Series Editor: **PAUL A. KOTTMAN**

CRITIQUE OF CRITIQUE

Roy Ben-Shai

STANFORD UNIVERSITY PRESS

Stanford, California

Stanford University Press
Stanford, California

Printed in the United States of America on acid-free, archival-quality paper

ISBN 9781503632684 (cloth)
ISBN 9781503633827 (paper)
ISBN 9781503633834 (electronic)

Library of Congress Control Number: 2022022166

Library of Congress Cataloging-in-Publication Data available upon request.

Cover design: Rob Ehle
Typeset by Elliott Beard in Minion Pro 10/14

*To Eda (R.I.P.) and Jack Solome, my guardian angels,
and to Vero, my love.*

At the still point of the turning world. Neither flesh nor fleshless;
Neither from nor towards; at the still point, there the dance is,
But neither arrest nor movement. And do not call it fixity,
Where past and future are gathered. Neither movement from nor towards,
Neither ascent nor decline. Except for the point, the still point,
There would be no dance, and there is only the dance.
I can only say, there we have been: but I cannot say where.
And I cannot say, how long, for that is to place it in time.

—T. S. ELIOT

Here is the rose, here dance.

—G. W. F. HEGEL

Contents

Foreword by PAUL A. KOTTMAN

In *Critique of Critique*, it is as if Ben-Shai noticed that all around him people are engaging in, or claiming to be engaging in, what they call "critique." And so, Roy wants to know what all these people are doing when they claim to be doing "critique"—what *is* critique anyway? That is Ben-Shai's first order question.

Turning to certain philosophers who proposed answers to just this question—such as Immanuel Kant, for instance—Ben-Shai notes that, for Kant, "critique is the activity that uncovers the conditions for the possibility of thinking." Ben-Shai then asks, well, can Kantian critique *itself* be subject to critique? That is, as he puts it, "If critique is the activity that uncovers the conditions for the possibility of thinking, then a critique of critique should ask what the conditions for the possibility of *this* activity are."

But then, we might wonder, why stop there? Why not a "critique of critique of critique of . . . ?"

My sense is that Ben-Shai does not at all want to prevent such regress, nor does he want to stop such open "reflection," as he calls it. Rather, he wants to remind us—sometimes provocatively—that bids to quiet a questioner amount to nothing more than mere entitlement, nothing more than the pretension of proceeding in whatever one is doing without having to justify it, without having to think about it or explain it.

So, we can see in Ben-Shai's insistent *Critique of Critique*, I think, the Socratic spirit that animates philosophy itself; indeed, Socrates emerges as one of the heroes of Ben-Shai's books. By pinning us to the "critique of critique of critique . . . ," Ben-Shai induces in his readers what Socrates's interlocutors sometimes called *aporia*, a kind of confusion out of which we can find no quick or easy path.

Of course, whether from fatigue or a feeling of exasperation, we might cry, "Enough for today!" But—Ben-Shai wants us to notice—in such moments we have already learned something. For a start, we have been forced to recognize that critique is not so easy to define. For another thing, we face how exasperation and such learning go hand in hand.

Not only that. Insofar as we see that we do not really know what critique is, something specific about our ignorance comes into view; and this, we start to realize, is the real source of our exasperation. We still do not know what critique is. But now a more precise knowledge of our own ignorance is taking shape—albeit with some discomfort. Ben-Shai's book, I think, asks us to feel our way to a better grasp of our own ignorance of what we are doing when we claim to be engaged in critique.

Why bother with this kind of inquiry?

Ben-Shai worries—with good reason, I think—that our culture and politics are deeply marked by uncritical forces of persuasion and propaganda, by forms of "critique" that do not subject themselves to critique. Indeed, it could be said that our culture's very emphasis on "critiquing everything," usually by taking a side, masks a deeply uncritical way of life. For Ben-Shai, such a culture risks privileging mere rhetorical side-taking and persuasion over genuinely open critique.

In a culture of uncritical persuasion, it can be all too easy to end up with what we nowadays call false balance or "bothsidesism"—often leading opposing sides to try to impose their view by means other than talking. Ben-Shai wants to take a step back from both uncritical persuasion and bothsidesism. He wants to keep the question of critique—of what we are doing when we say we are engaging in critique—genuinely open, discursively alive.

Ben-Shai begins his book by noting that many of us habitually go around critiquing this or that. Like Socrates, or like children, or students, or Twitter denizens, we constantly poke one another with questions: "How can you say *that*?" or "What do you mean by *that*?" or "Why are they doing *that*?" In this way, like children, we address ourselves to some audience who, we think, ought to have the knowledge. Or, sometimes we may think that we ourselves already have the answers. It is as if we feel that someone somewhere *ought* to have responsible answers.

Yet if we persist, we may find that our inquisition never leads to final answers or even to settled forms of questions. For Ben-Shai, that is all to the good. For, at least we might better map our own ignorance.

Preface

Across the street from our apartment building, something ghastly is being built. Judging by the signs, it is to be an office building with an adjacent hotel. Construction crews start work around 5:00 a.m., as we can tell by the beeping sounds of mobile cranes and tractors. They have a whole arsenal of these vehicles, each with its distinctive beep, but all sound uniformly horrid this early in the morning. Following the ancient wisdom—"If you can't stop them, bitch about them"—my wife, Verónica, and I have acquired the habit of critiquing the construction work from afar. At first, when we were amateurs, we judged this worker for never wearing his hardhat, that one for frolicking aimlessly about instead of helping his friends, and above all, we criticized the one we deduced is the foreman for his complete lack of leadership. With experience came expertise. Today we judge all aspects of the process—from reverse-driving to bricklaying to project management. Never have two people with so little knowledge or interest in construction spent so much time scrutinizing it. The other morning, as I awoke, I saw Verónica sipping her coffee at the window, shaking her head in dismay, muttering, "What a spectacle . . ." What a way to capture the situation, I thought. The ever-industrious, plague-stricken world outside is a spectacle (and a shameful one at that), and critiquing it from our bedroom window is our way of being human—a metaphor for much of human existence.

We all do it, in one way or another: we critique. There are different ways of thinking; there are even different ways of thinking critically, but *critique* is the one that consists in evaluating something or passing judgment. While characteristically inclined to the negative pole, critical judgment falls on a scale between two opposites: good or bad, true or false, beautiful or ugly,

as conveyed in the film critic's thumbs-up or thumbs-down, in the tomato that is fresh or rotten, and in the right or left swipe of the dating app. We critique our friends, our teachers and students, random strangers, world events, politicians and governments, books, movies, and TV shows, and the world itself (or "what has become of it"). Some of us do it professionally as art critics, professors grading papers, or peer reviewers casting our stones over the walls of double-blind anonymity. Many others do it casually in everyday life, when commenting on a film they saw or writing an online restaurant review. And, of course, we critique ourselves. One of the first things some of us do in the morning as we confront our faces in the mirror is exclaim: "God, must you be so cruel?"

The oppositionality of judgment is intrinsically related to the spatially oppositional orientation of the critic with respect to the thing she critiques. This relationship establishes two opposing sides and opens a space between—a "critical distance" as it is sometimes called. The two sides confront each other from opposite directions (→ ←), as is the case, for example, when we look in the mirror and it looks *back* at us. In reading, too, we find this duality: the author worked "forward," constructing the text from ideas, and the reader now works "backward," deciphering the ideas from the text—and might, indeed, tear it apart. The fact that this oppositional orientation frames the environments in which we learn how to think, and how to think critically (like the classroom, in which we sit opposite the professor, looking at her as she is looking back at us), can make critique and judgment seem like the most natural thing in the world. Yet there are other orientations of critical thought. A reader may, for example, experience herself as *inside* the text, like a visitor to an unfamiliar place. She can get lost, find her way, get lost again. She chooses her path, draws her connections. In such a relation there are no two "sides" and no opposition.

The oppositional relationship that is unique to critique is therefore not a rule for all thought or experience. This book's argument is that critique is a *particular orientation* of thought that frames not only our approach to this or that object but also our experience of the self, the world, and everything in it. The parameters of this orientation form, inform, and delimit our encounters. Hence the value of a critique of critique, which enables us to take a step back and consider the specific way we are oriented when we think and alternative ways we might be oriented.

This book would not exist without the support of trusted editors, friends, and interlocutors. I am especially indebted to Paul Kottman for his faith and patience, to Erica Wetter for her support, and to Lissa McCullough for meticulous editing and deeply insightful suggestions. I was fortunate to have two particularly perceptive reviewers, whose input helped significantly improve the book's argument. I started working on this project with the support of a Mellon postdoctoral fellowship in the John B. Hurford '60 Center for the Arts and Humanities at Haverford College. During that time, I benefited from, and deeply enjoyed, conversations about the project with Jill Stauffer and Gabriel Rockhill. I also thank Paulina Ochoa Espejo, Tom Donahue, Jeremy Elkins, and Joel Schlosser for their helpful feedback following a presentation of my project at the Tri-Co Political Theory Workshop. A very special thanks to David Kishik and Scott Shushan for reading and commenting on different versions of the manuscript and for our conversations, which made a profound impact on the book. My brilliant student assistants at Sarah Lawrence College, Victoria Mycue and Niamh Martinek, were great interlocutors. Finally, three collaborators stand out—Joe Lemelin, Amy Smiley, and Verónica Zebadúa-Yáñez—not only for their consistent contributions to my thinking and the writing process but also for pushing and encouraging me to see this project through. You have made the process so much freer and more pleasurable. I thank you all deeply.

Abbreviations

A	*Apology* (Plato 1997)
BT	*The Birth of Tragedy* (Nietzsche 1967)
C	*Confessions* (Augustine 2006)
CCPE	Preface to *A Contribution to the Critique of Political Economy* (Marx, in Marx and Engels 1978)
CG	*City of God* (Augustine 2014)
CH	Introduction to "Contribution to the Critique of Hegel's *Philosophy of Right*" (Marx, in Marx and Engels 1978)
CM	*Manifesto of the Communist Party* (Marx and Engels 1978)
CPR	*Critique of Pure Reason* (Kant 2003)
DE	*Dialectic of Enlightenment* (Adorno and Hokheimer 2002)
EPM	"Economic and Philosophic Manuscripts of 1844" (Marx, in Marx and Engels 1978)
Eu	*Euthyphro* (Plato 1997)
G	*Gorgias* (Plato 1997)
LMT	*The Life of the Mind*, Vol. 1, *Thinking* (Arendt 1981)
LMW	*The Life of the Mind*, Vol. 2, *Willing* (Arendt1981)
LR	"For a Ruthless Criticism of Everything Existing: Letter to Arnold Ruge" (Marx, in Marx and Engels 1978)

M	*Meditations on First Philosophy* (Descartes 2005b)
Meno	*Meno* (Plato 1997)
NE	*Nicomachean Ethics* (Aristotle 2001)
P	*Poetics* (Aristotle 2001)
Ph	*Phaedo* (Plato 1997)
R	*Republic* (Plato 1997)
S	*Symposium* (Plato 1997)
TF (+ thesis number)	*Theses on Feuerbach* (Marx, in Marx and Engels 1978)

Critique of Critique

INTRODUCTION

Critique as Orientation

What is the role of a critic in relation to her society and culture? One answer is given to us in the figure of Socrates. This archetype of critical thinking in the Western tradition was tried and executed by the court in his city-state of Athens. According to his most famous apprentice, Plato, Socrates's sole crime was practicing philosophy—the kind of philosophy we would today call social or cultural critique. He openly questioned the values, ideals, and customs of his people, and when he refused to stop doing so, they silenced him with a lethal dose of poison. This story, now raised to near mythical status, entrenches the image of the critic as an anti-institutional figure, waging intellectual and sometimes heroic and sacrificial war against the polity and the powers that be. Looking back at Socrates from our vantage point, however, we don't see him as an outlier, let alone an outcast, but as one of the foremost representatives of Athenian culture itself, if not of the Western tradition more broadly. Those who critique this tradition— its biases, exclusions, and values—often turn their critical eye on Socrates himself and what he represents, even though such critique of tradition *is* in many ways what Socrates represents. The same can be said of later cultural critics, such as Jean-Jacques Rousseau. One of the heroes of the

French Enlightenment and an anarchist by temperament, Rousseau was a stern critic of modernity and French culture who ended his days in forced exile and solitude. Today, Rousseau is no longer an anti-institutional figure. Like Socrates, he *is* the institution; his name is practically synonymous with French culture and modernity—the very social structure he critiqued. At least in hindsight, then, the critic appears less as an oppositional figure and more as an emblematic representative of his or her culture and its essential values.

Today, it seems that the difference between critic and institution is blurred to begin with. Owing in part to the persistent influence of exemplary critics like Socrates and Rousseau, critique is increasingly becoming a mainstream cultural norm. The critique of culture evolved into a culture of critique. The critic is no longer an outsider, and the lines of division between critics and what they oppose proliferate and shift: one minute's hero is the next minute's villain, and one minute's critic is the next minute's reactionary. In many settings one is *expected*—by culture, by custom, and by the powers that be—to act as a critic. The art of critique is taught to us at school. There are required textbooks that teach the same methods for which Socrates got himself sentenced to death, which can make one wonder: what methods does one use to critique a textbook that teaches the methods of critique? Is this situation conducive or damaging to critique or, for that matter, to culture? Is it possible to genuinely *critique* a culture of critique, or is that just a way of conforming to its norms and expectations? Or is it the case that a culture that encourages and teaches critique places itself beyond critique, a culture whose customs and values must be accepted simply because these are the customs and values?

The culture of critique has come under fire in recent decades, especially by thinkers exasperated by the atmosphere of mutual hostility among critics. Bruno Latour asked whether, with so many wars raging in the world, "[we should] be at war, too, we, the scholars, the intellectuals. Is it really our duty to add fresh ruins to fields of ruins? Is it really the task of the humanities to add deconstruction to destruction?" This warring atmosphere, Latour observed, is causing "the critical spirit [to] run out of steam" (Latour 2004, 225). Eve Sedgwick similarly lamented the ubiquity of critique. She spoke of a "paranoid scene," in which "protocols of unveiling," "suspicious archeologies of the present, [and] the detection of hidden pat-

terns of violence and their exposure . . . have become the common currency" (Sedgwick 2003, 143). This "near professionwide" trend in cultural studies, she worried, "may, if it persists unquestioned, unintentionally impoverish the gene pool of literary-critical perspectives and skills. The trouble with an impoverished gene pool, of course, is its diminished ability to respond to environmental (e.g., political) change" (144).

The twenty years that have passed since the expression of these worries have done nothing to quell them. More recently, a growing number of critical theorists have sought to think past critique altogether, using terminology such as "beyond critique" or "postcritique" (Hoy 2004; Anker and Felski 2017; Fraser and Rothman 2018; Sutter 2019). There is, however, something paradoxical about critiquing critique and even more so about trying to move "past" it. The need to move past critique, and the general desire to break new ground, as exhibited in the proliferation of phrases like "-Turn," "Post-," and "New-" in titles of academic publications, is itself expressive of the culture of critique and its oppositional tendencies. I will argue that, if we are to think seriously about this situation, the first step is accepting critique as a perennial and irreplaceable modality of thought: there is no getting past it and no need to. It is one thing to argue, as I do, that critique is not, and ought not to be, the only game in town; it is another thing to oppose it or to suppose we can avoid practicing it. Instead of looking *away* from critique, I propose to look more closely at it. Investigating critique on historical and conceptual grounds, my primary task is to raise the question of what critique is, where it starts, and where it ends, and to make the critic more aware of and responsible for its assumptions, commitments, and values. This is worth doing on the premise that any kind of thinking, critique included, stands to lose its integrity and its critical edge when it becomes normalized and automatic.

By "critique of critique" I do not, therefore, mean an opposition or objection to critique nor an effort to debunk it. An analogy to Immanuel Kant's practice of critique in his *Critique of Pure Reason* can help to explain what I mean by this phrase. By "pure reason" (*reine Vernunft*), Kant meant the faculty responsible for scientific knowledge. By "*critique* of pure reason," he meant the endeavor of articulating the conditions that make such knowledge possible. The upshot of a critique of pure reason was to show that if scientific knowledge is only possible under specific structural premises, then it does not have unbridled reign over human existence and thought.

In this way, Kant's critique sought to *limit* the dominance of scientific thinking without undermining its validity or its necessity within its proper domain. His motivation was, in his words, "to [limit] knowledge in order to make room for faith" (*CPR* 29). "Faith" (*Glaube*) does not refer to a religious belief in God but to the rationally justifiable faith in human freedom, whose existence we can never *know* but have every reason to believe in. This faith in freedom, for Kant, opens up the possibility and necessity of a *moral* reflection about our existence, as falling entirely outside the purview of science and theoretical reason. Kant named this kind of moral reflection "practical reason" (*praktische Vernunft*), as opposed to "pure" or theoretical reason. The limitation was mutual: on moral reflection, Kant argued, scientific thinking should have no say, but at the same time, moral thinking cannot infringe on the work of science. Theoretical (scientific) reason and practical (moral) reason are two fundamentally different orders of rational thought, each with its own structural assumptions and operations: one investigates what we can *know*, the other what we can (and ought to) *do*. With this, Kantian critique secures within the domain of rational thought something akin to the separation of powers in a democracy.

The analogy to Kant has its limitations here, for my book is not a critique of pure reason, or of any other kind of reason, but of critique itself. If "critique" is, as Kant sees it, the activity that uncovers the structural premises of a certain mode of thinking, then a critique of critique cannot simply take this activity for granted; it should, rather, bring the premises of this activity itself into question or awareness. Otherwise, we would be practicing critique rather than investigating this practice, and we would certainly not be working toward *limiting* critique's own domain. It is a tricky operation that involves exploring the premises of critique without already presupposing them, *suspending* its ordinary operations and the commitment to its assumptions. For it not to be redundant or paradoxical, the first iteration of "critique" in this book's title should be neither identical to the second nor oppositional to it but more like a murky or ironic mirror. Martin Heidegger's analysis of *Shoes* (1886) by Vincent van Gogh can provide a helpful illustration of this alternative.

The bulk of Van Gogh's painting features an ordinary pair of shoes, well-worn but empty, set against an unidentifiable background (neither floor nor street nor field, just color): ordinary shoes outside their ordinary context. Heidegger, for some reason, took these shoes to belong to a peasant woman

and conjured up a whole story around this assumption, whereas some of his critics have made a point of stressing that the shoes were, in fact, owned by the painter. To my understanding of Heidegger's analysis, or what I take from it at least, the question of to whom the shoes belong misses the significance of the painting, which is to make patent the essence of shoes *in general* and, by extension, the essence of "equipment" (*Zeug, prágmata*—things of use). What makes this task daunting is that the essence of shoes is *to be worn*, and the essence of equipment is *to be used*, not to be painted or looked at. How can one paint the essence of something whose essence is not to be painted, and how can we look at the essence of something whose essence is not to be looked at but worn? Moreover, to the extent that equipment is what it is (that it "works"), it must remain inconspicuous. You are not aware of your computer when you are writing or reading on it; you are focused on what you are writing or reading, and a well-functioning computer is one that does not disrupt your attention but facilitates it. Well-functioning equipment draws attention *away* from itself, allowing you to concentrate on the task at hand. Conversely, if your working shoes demand your attention while you are wearing them, then something about them is out of order; it is perhaps time to replace or fix them. The challenge in Van Gogh's innovative practice of painting ordinary use objects (an empty chair, an empty bed, empty pairs of shoes) is to make their essence conspicuous and available for reflection while retaining their integrity as inconspicuous and ordinary. *Shoes* lets us observe the features of the shoes not as we would at a store, as a commodity for evaluation and possible purchase, but as they serve us, as having-been-worn-often and as ready-to-be-worn-again. *Shoes* invites reflection not only about *this* pair of shoes but about the shoe-ness of shoes. Think about it this way then: by "critique of critique" I mean the critique-ness of critique, its essential features as having been used often and as ready to be used, neither in order to sell it nor to deride it.

Critique, too, is a use object: when we critique, we are focused on what we critique, not on critique itself. The critique of critique needs to make critique conspicuous in its ordinary practical features. To do so, it must follow Van Gogh's lead: just as he sets his shoes against a nonspecific background, so must this analysis set critique against an unusually broad and formal background or, rather, against a shifting array of settings and possibilities. In this way, the goal is to put critique itself in relief and let its essential features shine forth. By casting something that is close and familiar within a

less familiar light, we may become *re*familiarized with it, no longer taking it for granted.

In their book *Leviathan and the Air-Pump*, historians of science Steven Shapin and Simon Schaffer interrogate "the culture of experiment" in a way that resonates with my approach to critique. Following Alfred Schutz, they describe their method as a "stranger" approach as opposed to a "member" approach to their subject of inquiry: "We wish to adopt a calculated and an informed suspension of our taken-for-granted perceptions. . . . By playing the stranger we hope to move away from self-evidence. . . . If we pretend to be a stranger to experimental culture, we can . . . appropriate one great advantage the stranger has over the member in explaining the beliefs and practices of a specific culture: the stranger is in a position to know that there are alternatives to those beliefs and practices" (Shapin and Schaffer 2017, 6). I will likewise "play the stranger" when probing critique, approaching it as "a field of adventure, not a matter of course" (Schutz, cited in Shapin and Schaffer, 6).

ORIENTATIONS

Critique is not, however, a pair of shoes or equipment, nor is it a mere attitude or even a "culture" or form of practice such as what Shapin and Schaffer have in mind. Critique is, as I noted in my preface, an orientation of (critical) thought. By *orientation*, which I use as a term of art, I mean not only a way of thinking but a way of being as well. An orientation is not only a way of being and thinking *in* the world but an orientation *of* the world itself.

The first thing I should underscore about my conception of orientation is that I envision it not simply as *movement* or *navigation* but as a sort of *turning* or *rotating*, and I consider that there are qualitatively different orientations. A simple way of thinking about qualitatively different orientations in this sense is considering the different ways in which an airplane rotates. Airplanes have three different ways of rotating, each around a different axis: *yaw*, where it moves its nose from right to left relative to a vertical axis; *pitch*, where it moves its nose up and down relative to a horizontal axis; and *roll*, where it rolls about itself like a dolphin. The downside of this metaphor is that, while it shows us three different rotational dynamics, these only pertain to the movement of the plane, not to *the air* in which it moves. An

orientation, in the way I employ it here, affects not only the way in which the thinker moves and thinks but also the world in which and about which she moves and thinks. The question at issue is not only how we orient ourselves in the world, but how our world is oriented with us in it.

Perhaps a better metaphor for envisioning orientation is the rotation of a kaleidoscope, assuming that the kaleidoscope represents *everything* there is, so, unlike the airplane, it is not rotating *inside* something else but rather signifies the rotation of the whole. Imagining that you are one of the colorful pieces inside this kaleidoscope, consider that, as you turn about, the kaleidoscope—with everything in it and around you—turns about with you. Each turn of the kaleidoscope changes the nature and arrangement of the pieces within it, including yourself (like all the pieces in the kaleidoscope, your being changes with the rotation, as it enters different relations with the other pieces). In life, we rarely experience *turns* of this sort in such a dramatic way. Ordinarily, our world appears relatively stable, just as our planet appears stable, though it is in constant motion around its own axis and around the sun. But sometimes we do, or can, experience critical turns, in which things *suddenly* acquire an entirely different significance, and fundamental structures and assumptions shift or come into question to the point that one, for a moment or for a while, loses one's bearing on oneself and on the world. With or without such an experience, I would argue that we mostly find ourselves turned and oriented (or *dis*oriented as the case may be) in one way or another. Better said, we find ourselves in a world that is oriented in a certain way, and if we do not experience this *as* an orientation or a "turn," it is because we are to some degree entrenched in it or habituated to it. The kaleidoscope—to push the metaphor a bit further— has certain points of stoppage or alignment, and it can get temporarily "jammed" at any one of these points. This is the sort of thing that happens when critique becomes automatic. Then we assume, whether we love it or abhor it, that our world just *is* how it is, and not, as T. S. Eliot describes it, a "*turning* world" (Eliot 1971, 15). We neglect to consider that the world, and the self, can be otherwise, not simply in the future but *in the present*. We fail to consider that the world, and the self, are always turned a certain way.

Now, I have in mind at least three different ways in which we can be "turned" or oriented: as spectators or judges (a spectatorial orientation), as actors or participants (an agential orientation), and as sufferers or victims (an affective orientation). These are not simply ways in which we—as

some solid object, like an airplane—turn about; rather, they are the ways in which being itself turns. The world of the spectator *is* a spectacle, the world of the actor *is* a work (or a project, or a play), and the world of the sufferer *is* oppressive. These orientations rarely exist in purity or isolation. Proximally and for the most part, we are spectators, actors, *and* sufferers or victims to some extent. But at any given moment, one of these can become a more decisive feature of our experience than the others. For example, if one falls terminally ill or is severely victimized, everything can radically change all of a sudden, including space, time, social relations, and the relations between body and thought. In such circumstances one's orientation becomes decisively that of sufferer, and life and world become a weight that is difficult to bear. This becoming a sufferer does not yet mean that I stop being a spectator and an agent, only that spectatorship and action take a back seat. What incurs such decisive orientation, and the degree to which a person or a culture has choice in the matter, depends, in part, on the orientation itself. This is because under each of these orientations, what it means to be a self, and the very nature of "orientation," changes. If we were to attempt a characterization of "the self," or the world, or simply being and thinking, as that which *undergoes* orientation without presupposing the auspices of any particular orientation, it would have to be as Eliot describes it: "*the still point* of the turning world" or "the dance" (15)—that is, rotationality itself.

The orientation to which critique belongs is the *spectatorial* orientation, in which the world is a spectacle, a view, and the thinker is primarily a spectator, viewer, looker, or watcher. Austrian poet Rainer Maria Rilke depicted this orientation on a broad and existential scale:

> And we: the watchers, always, everywhere,
> looking toward the all and never from it!
> It overpowers us. We arrange it. It falls apart.
> We arrange it again. We ourselves fall apart.

> Who has turned us around this way, so that,
> no matter what we do, we look as though we're leaving?
> Like someone standing for the last time
> on the last hill from which he can view
> his whole valley—the way he turns, stops, lingers—
> this is the way we live. (Rilke 1981, 48)

Yes, we are watchers—not all the time but often enough. This book will highlight the intrinsic connection between this orientation and the capacity and inclination to evaluate, judge, critique—often negatively—as well as the tendency to classify and categorize (to "arrange," in Rilke's words). The dominant characterization of being and thinking under the spectatorial orientation is *consciousness*. While we often use this word as a synonym for thinking in general, it, in fact, names a certain kind—a certain orientation—of thinking and experience. Consciousness is the kind of thinking and being that *looks*. It splits existence in two, placing each side—the looker or perceiving subject and the look or object perceived, the spectator and the spectacle—as opposite and facing one another. Reality under the spectatorial orientation is objective. We usually use the word *object* to name solids, like this table or this book. But people can be objects, as can the world as a whole and the subject itself. What makes something an object is not size or solidity but its being a spectacle. An object is always constituted in relation to and as separated from a spectator. The spectator or subject is constituted in and through the same orientation. Science itself is a spectator in that sense, and it constitutes itself in relation to an objective world. There is no real primacy here because no subject could exist without objects and vice versa.

In our ordinary dealings with the world, we may well be oriented as spectators (as, for example, when sitting before a computer screen or watching a movie) yet so absorbed in the spectacle that we hardly feel separated from it. But when we judge something, the spectatorial orientation becomes more emphatic, and the separation is realized as an opposition: I stand opposed to the object that stands opposite to me. Critique, therefore, *is* the spectatorial orientation when it is most firmly and actively upheld, so I will be using the terms *spectatorial orientation* and *the orientation of critique* interchangeably. Critique is a particularly active, indeed critical, consciousness that does not accept things as they are or, which is initially the same, as they *appear* to be but digs underneath the surface appearance, into the underlying conditions. As critics, we often affiliate ourselves with (or simply are) activists or revolutionaries, visionaries, as we also call ourselves, who are determined to change the world, our lives, or our students' lives to make things better. By assuming this activist attitude, we do not cease to be spectators, however. On the contrary, if we want change, it is because we do not (fully) approve of what we see around us; we judge the world or

ourselves as wrong or unjust or at least as something that could be better. The revolutionary is therefore often primarily, or concurrently, a spectator, a critic, and a judge. There is no contradiction in that sense between being a spectator and being an activist or revolutionary. I will argue that the view of activism as opposed to (mere) spectatorship, like the view of being as opposed to (mere) appearance, is itself among the hallmarks of the spectatorial orientation.

Orientation is a generative principle with manifold *entailments*, as I will call them. The spectatorial orientation *entails* a certain logic, a certain conception of being (ontology), a conception of truth (epistemology), a conception of good and justice (ethics), of human relations and power (politics), of space (topology), and of time (chronology). Here is a brief statement regarding each of these entailments as they will be discussed in the book:

Logic: Oppositional, dialectical.

Ontology: Being is presence but not necessarily sensorial; mere appearance is opposed to true being.

Epistemology: Truth is knowledge; objectivity is opposed to subjectivity; knowledge (often prefigured as vision or light) is opposed to deception (blindness, darkness).

Ethics: What is the case is opposed to what ought to be the case. There is therefore a difference between the true and the good, between knowledge and morality.

Politics: Power is conceived as power-over (ownership, control); in its negative manifestation it is oppression (rule over or ownership of others); in its positive manifestation it is autonomy and liberty (rule over and ownership of self).

Topology: Space is conceived as a container, defined through the oppositions between inside and outside (inclusion and exclusion), above and below (surface appearance and deep structures), and through the figures of limit and ground.

Chronology: Time is conceived as a forward movement, defined through the oppositions between before and after, beginning and end, progress and decadence, and through the figure of revolution.

By calling these *entailments*, I emphasize that ethics, ontology, epistemology, politics, and so on, are not different assumptions or claims but *facets* of a single orientation. The divisions themselves, between ontology and epistemology, topology and chronology, and the like, are relatively arbitrary. There is no clear point in which one ends and the other begins, and it is not always possible to separate them in experience. For instance, the conception of being as presence and of truth as knowledge are two ways of saying the same thing or, at most, two emphases. The list of entailments above is therefore only a matter of *analyzing* and *articulating* what in truth is a unified experience and orientation of thought and being. The list could expand or shrink depending on the resolution with which we study the orientation, just as the number of heavenly bodies can expand or shrink depending on how closely we look. The challenge at hand is to maintain a healthy balance between the telescopic and the microscopic, between the forest (the orientation) and the trees (the entailments). The main task is to show that and how they *are* entailed in one another and in the orientation as a whole. Additionally, each of these entailments admits of variations, or different iterations, some of which are incompatible. For instance, the conception of (true) being as matter and the conception of (true) being as form are potentially incompatible variations on the conception of true being as presence. Part of the task is therefore to recognize the same entailment through various iterations.

The spectatorial orientation and its entailments form, inform, and delimit the purview of critique. As I noted regarding Kant's *Critique of Pure Reason*, to demonstrate the necessary conditions of critique is, at the same time, to limit its scope and authority. Kant's aim was to limit scientific knowledge to allow room for moral reflection. The aim of this book is to limit critique, in part, to allow room for the exploration of other orientations of thinking and being. Here, I am not talking about different iterations or variations but of *orientations* so different from each other that they can hardly overlap, since they exist in (or through) a different space and time, different conceptions of being, truth, and goodness, a differently oriented world. And, as is the case with Kant's rational registers (theoretical, practical), different orientations neither replace nor delegitimize each other. They can only alternate.

A difficulty with which both the writer and the reader of this book will have to contend is that in the context of such a relatively short work, there

is only space for critiquing critique, not for expounding on other orienta-
tions. This is one difficulty we do not encounter in Kant, since his claim
that there is something like moral reflection that is fundamentally different
from a scientific investigation is intuitive enough, even if it requires expli-
cation and justification. I do not assume the claim about the existence of
an agentive and affective orientation as fundamentally distinct from the
spectatorial one to be intuitive, which is all the more reason to focus our at-
tention on one of them. I should nevertheless state that, just as I see critique
as the critical manifestation of the spectatorial orientation, I consider that
the other orientations have their own modalities of critical thought. The
critical thought that belongs to the agentive orientation I call *emancipatory
thinking*, and the one that belongs to the affective orientation I call *(thinking
in) revolt*. If critique is rooted in consciousness, emancipatory thinking is
rooted in desire, revolt in suffering. Emancipatory thinking is recognizable,
for example, in its appropriative, affirmative, and immanent standpoint as
distinct from the evaluative, oppositional, and transcendental standpoint
of critique, whereas revolt is recognizable in its deconstructive, pessimistic,
and self-excluding standpoint. These are neither personal differences nor
differences of identity, nor are they simply different claims about the world;
they are different ways of being in a world that is not the same. Each of these
orientations comes with its own set of metaphysical entailments—different
conceptions of being, truth, good, power, space, and time.

One of the implications of this thesis is that it is not possible to index these
orientations of thought historically or geographically. It would make no
sense, for example, to regard critique as a modern or Western phenomenon,
or emancipatory thinking as a postmodern or premodern one. Ironically,
the view of history that such terms as *premodern*, *modern*, and *postmodern*
imply belongs squarely within critique, which construes history as a more
or less unified course of events and sequence of periods. We cannot locate
critique or its "emergence" at a certain period within this history, because
this entire history and all "periods" in it exhibit critique's orientation. For
the exact same reason, we cannot date the emergence of emancipatory
thinking in postwar France or trace revolt back to decolonization. Each
of these orientations historicizes differently; they formulate alternative
orientations in, to, and of history itself. It would likewise miss the point
to herald the transition from one orientation to the other as a "paradigm
shift," as it would be to regard the transition from science to morality or

from theoretical to practical reason in Kant as a paradigm shift. The point is not the shift but the structural *difference*.

It is possible to speculate about the historical and cultural conditions involved in the rise of a certain orientation into prominence (or dominance) or the circumstances in which reorientations or disorientations occur. So something like *"a culture* of critique" is a historical development but not critique itself. This culture does not *create* critique; it only *entrenches* its orientation to the suppression of others. To me, it is even more important to recognize that, however dominant, naturalized, or culturally entrenched critique may be in contemporary democracies and in the history of Western philosophy, we can nonetheless discern other orientations in contemporary discourse, in the history of philosophy, and in our own ways of thinking. We can, for example, recognize the affective orientation that I name "revolt" in those (often angry) critical voices that are rooted in the personal testimonials of experiences of exclusion, victimization, and abuse. The critical intervention of such voices is not to judge or change the world, as is the case with critique, but to disrupt and disquiet or, even more basically, to *exist* in a world that is incapable of accommodating them and to *assert* themselves in a world that is reluctant to see or hear them. We can similarly recognize the orientation I call "emancipatory thinking" in those critical voices that are defiantly *affirmative*. Rather than exposing and denouncing systemic injustices in the vein of critique, they create or disclose avenues of empowerment and joy in the present as well as in revisionist historiography.

Like critique, these other orientations are as new as they are old. Within the Western tradition alone, we can hear critique just as clearly in Plato as in contemporary critical theory; we can recognize emancipatory thinking in Epicurean philosophy no less than in new materialism and posthumanism. And revolt is present in ancient tragedy as it is in Afropessimism.

For the remainder of this book, I will focus exclusively on critique and the spectatorial orientation, which means that I will *deliberately* and *methodically* isolate critique, as much as it is possible to do so, in the themes I consider and texts that I cite. There is something artificial in this procedure, and I would only ask the reader to bear in mind that my ultimate goal is *not* to isolate critique but to facilitate the exact opposite—namely, the capacity to recognize other orientations *as* other orientations and, therefore, as equally viable orientations of critical thought. Thus, if I portray Platonic philosophy, Catholicism, Marxism, and existentialism, for instance, or

any other figures and traditions in Western philosophy, as embodying the orientation of critique—as indeed they do—this is not to deny they can also be read and portrayed otherwise.

AN APORETIC JOURNEY

If the phenomenon of orientation can be described as a landscape—or, better put, a *conceptscape*—the book is, in effect, a *voyage* through this conceptscape. I emphasize the terms *conceptscape* and *voyage* to prepare the reader for the distinctive "feel" of this work. Although this introduction puts forth several arguments, the book itself is not structured or narrated as an overarching argument. While each chapter has its own central thematic, its course is searching, tangential, and circular rather than architectonic. Populating, or rather exemplifying, our conceptscape are citations from canonical and contemporary works of Western philosophy, philosophical theology, and philosophical psychology. The prevalence of certain philosophers—Saint Augustine, Descartes, Kant, Hegel, Marx, and above all Plato—might provoke the impression that the book regards them as "critics" and that its intent is to critique *them* and their work. This is not the case. I draw on philosophical texts because I think philosophers are particularly good at describing the landscapes of thought. As Marx once wrote: "In the general relationship which the philosopher sees between the world and thought, he merely makes objective to himself the relation of his own particular consciousness to the real world" (Marx 1975, 42). In general: the subject of this book is not the history of philosophy or ideas but the orientation of critique *insofar* as it is exemplified and elucidated in the history of philosophy.

Moving in more or less rapid succession from one context (thinker, tradition, idea) to the other, the book means to draw attention *away* from the particular contexts and toward the patterns and family resemblances that would gradually crystalize, as the journey advances, the structural premises of the spectatorial orientation. As I have said, orientations of thought rarely exist in purity; we tend to shift between them and mix up the different vocabularies they produce. It is therefore the case that each of the philosophers I draw on, like each one of us, *also* gives expression to other orientations of thought. Moreover, the orientation we find in a philosophical text or tradition depends in large part on the way *we* are

oriented—it is never "simply there." Acknowledging this from the outset, I want to make clear that my treatment of texts is deliberate, selective, and tendentious, akin to a caricature portrait. Caricature drawing, even when just as observant as realistic portraiture, is the art of the line rather than the filling. It ignores (when it needs to) nuance, complexity, and detail, selecting and exaggerating certain features instead. My work, accordingly, focuses on the *formal* features of critique, deliberately marginalizing the *specific contents* and *objectives* that differentiate authors and traditions, their histories and preoccupations, as well as conflicting aspects of their thought. This is not to deny that differences exist among authors and traditions that exemplify critique; if anything, the differences, and even hostilities, are so pronounced that they obscure the common orientation. By zigzagging between traditions that are historically antithetical, like liberalism and Marxism, idealism and materialism, I mean to highlight the fact that critique is not only capable of accommodating antithetical expressions but is prone to *generating* such antitheses.

Take the notion of "enlightenment," for example, which is, as I will claim, a fixture in the vocabulary of critique. The European Enlightenment understood itself as exiting the dark age of faith and entering the age of reason and science. Yet we find a homologous movement *within* the so-called dark age, as Catholicism already conceived of itself as an enlightenment movement, exiting the darkness of paganism and entering the light of true faith ("I was blind but now I see"). Nor did this movement originate in Christianity, for we already find it among the "pagans" themselves. The idea of enlightenment features prominently in the work of at least one such pagan, Plato, who famously portrayed the philosopher as exiting the cave of ordinary perceptions and ascending into the light of true knowledge. Plato himself likely appropriated this idea from Pythagoras, who in turn brought it back with him from his travels in the East. Enlightenment may have taken on a particular form and content in eighteenth-century Europe, but its underlying structure and the conception of history, progress, knowledge, and maturation it entails are neither modern nor European.

In the context of this book, therefore, the specific history of the enlightenment idea is far less important than its *logic* and the orientation to which this logic belongs. In all the cases just noted, the logic is that of a radical *turn* between the oppositional poles of blindness and vision, darkness and light. As we can see, this turn continually *returns*, turning around itself,

so that what was previously considered light is now considered darkness. Yesterday's enlightened are today's "blind," just as those who once perceived themselves in the arrowhead of progress are seen as "backward" in contemporary eyes, which again assume themselves to be in the arrowhead of progress. It is therefore unsurprising to find the Enlightenment logic reiterated in postmodern critiques *of* the Enlightenment and, more recently, in the "woke" movement (wakefulness, after all, means the same as enlightenment, in that one only awakens if one has been asleep). Such is the course of things: *they* were blind or asleep, but now *we* see or are awake. But there is one thing that "they" saw just as well as we do now: that blindness, apparently, precedes vision and that the present is more woke than the past, the self more woke than the others.

I would like to show how this structure repeats itself while remaining blind to its repetitions, exaggerating the extent and degree to which it constitutes a "break." With each new turn, we get a new opposition, each time fiercer than the previous one. Marxists, for example, often see themselves as radically anti-Christian and their materialism as radically anti-Platonic. Revolutionaries in spirit, they see themselves as breaking radically new ground. I would like to make it patent that, at least in one fundamental respect, no new ground is broken, and these historical revolutions are as cyclical as the revolution of Earth around the sun. Can there ever be enlightenment or wokeness that is not at the same time an ignorance? And is there any blindness involved in the automatic reiteration of revolutionary-progressive tropes that are about as old as written history? Might there even be something conservative or traditional in the valorization of radicalism and change? And might not we, contemporary critics, expect that future generations of critics will look back at *us* as blind and dormant? Blind to what, for instance?

There are vastly varying degrees of consistency, sophistication, and knowledge in which the orientation of critique can be lived. There is a difference, for example, between the perspective of a person casually critiquing a film and the work of a film critic with years of expertise. Different from each is the work of a critical theorist who analyzes the cinematic medium and its ideological function in a capitalist society. And different again is the work of the philosopher who studies the conditions for the possibility of judgment and knowledge. Yet the core orientation of critique is common to all these iterations. By looking at them, this book is above all an invitation

to *self*-examination, an opportunity to think about the way we habitually think and the conceptscape that we inhabit.

With this goal in mind, I aim at neither accuracy nor finality nor conclusiveness; there is no finality to orientation as I understand it, for orientation is a generative principle. It is only a question of how much time we have to spend on this journey, which places we want to visit, and how long we want to stay in each. And the responses to these questions are relatively arbitrary, having to do with my own associations and intellectual education. It would be possible to draw on other texts than the ones I do, to draw on some more and others less. It would also be possible to highlight different entailments than the ones I do, to highlight these more and those less. But the orientation would remain the same; I am not manufacturing it but describing it. My objective is to make it recognizable and at the same time, adopting the "stranger approach," perplexing.

Just as a tour guide has his own favorite spots and tells anecdotes and jokes along the way, my mode of narration involves going into various tangents, making observations that I consider of potential value and interest in themselves, apart from the overall trajectory. We are not going anywhere in particular. I roam and invite you to roam with me. Because of the nature of the subject—that is, the orientation that makes up the conceptscape itself and thus the entire "environment" of the book—the chapters frequently overlap in theme, and the same texts are cited at different points and from different angles. A certain claim or analysis that seems unclear and very partial may well be picked up again at a later point, where it will become a bit more rounded out and make more sense. In other cases, the lack of clarity or adequacy is simply the fault of this author. But in either case, I would advise against getting stranded on any single point on this voyage because the message of the book lies in the whole and in the way, in the patterns and repetitions rather than the details and variations. My hope is that with each chapter, the mind's eye will become increasingly habituated to these patterns, and the ears will become accustomed to the wandering course of the book, its rhyme and rhythm, and the occasional irony or attempt at a joke.

THE STRUCTURE OF THE BOOK

The book is divided into two parts, with four chapters in each. Part 1 is titled "Aporias of Critique." By *aporia* (Greek for impasse or "no exit") I denote two things: first, the structure of my own analysis, which admits of no end point but instead studies the terrain and the nature of the movements within it. Second, the *aporia* refers to a constitutive reversibility at the heart of critique itself and its various iterations. The titles of the aporetic chapters of part 1 convey this reversibility: "Critique of the Spectacle or the Spectacle of Critique," "Critique of Power or the Power of Critique," "Critique of Injustice or the Injustice of Critique," "Critique of External Authority or the External Authority of Critique." The reversals in these titles suggest that the things against which critique wages war (the spectacle, power, injustice, external authority) are also the conditions that make it possible.

Let me briefly illustrate my point with the case of injustice. Many of us hold the conviction that the world is unjust, where "injustice" means something like inequality. Because the world is unjust, we feel we must critique it and ultimately change it. I will propose that the converse is equally true. It is not only injustice that requires critique but also critique that requires injustice. This is what it means to say that injustice belongs to the conditions for the possibility of critique and not to a reality that exists indifferent to it. This is not to imply that injustice is *un*real or somehow "subjective"; it is as objective as things come. In chapter 5, I will argue that, as our language already indicates, it is in the very *nature* of objectivity that whatever is objective is also objectionable. The same conditions that make it possible to constitute an objective field of observation also necessitate that this field will reveal itself to us as either morally indifferent or morally flawed. Therefore, the world of critique is not unjust "by chance," nor will it be just so long as it is something objective. Injustice is not a matter of opinion, disposition, or whim but of demonstrable knowledge, but this is in part because the conditions that make something knowable also make it unjust. Since critique has positive stakes in knowledge and in the conditions that make it possible, it behooves it, if it cares for justice, to call itself, its desires, and its commitments into question.

The same ambivalent relation to injustice holds with respect to external authority, to power, and to the spectacle (from the theater, through Hollywood cinema, to social and digital medias). Critique exists in and through

the fight against the conditions that make it possible, and its drive to *win* the fight is also a drive to self-destruct. Thankfully, it cannot win (or self-destruct). This is the *aporia*: there is no end to critique, yet without a desire for such an end, there can be no fight and no critique. Tracing, underscoring, inhabiting this aporia dictates much of the ambience of the book: it circles, essays, and turns on itself, subject to repeated reversals, thrust from one side of an antinomy to the other. The *grounds* for this movement become more explicit in the second part of the book, "Architectonics of Critique." Here, the chapters explore the fundamental structures that undergird critique's preoccupation with the problems of the spectacle, of power, of injustice, and of external authority. The first two chapters of part 2 examine variations of critique's ontology, including the conceptions of being as presence, as objectivity, as actuality, as substance, and as possibility. The emphasis in the first of these chapters, "Moral Ontologies of Critique," is on how these ontological categories are bound up with a certain moralism and discontent—the link between objectivity and objection, between causality and accusation, between possibility and problem, and so on. The second chapter of part 2, "Political Ontologies of Critique," performs something like a deduction of political categories from the ontological structures of critique; these categories include the concepts of class, gender, race, right, authenticity, and universality. The last two chapters, "Topologies of Critique" and "Chronologies of Critique," explore the spectatorial constitution and experience of space and time respectively. The reason these chapters come last is that they take in the very fabric of the conceptscape—what Kant named "transcendental aesthetics"—within which the entire book, and the spectatorial orientation itself, orients. Taken together, the chapters of the second part aim to clarify the unchangeable parameters within which critique performs its reversals and changes its form (and its contents): with every uncovering of new or deeper foundations, the same architectural topology is reasserted; with every new turn or revolution, the progressive chronology is reaffirmed.

The book's conclusion returns to the place in which this introduction started—the present day and the current state of critique as I find it. The conclusion singles out three major developments as constituting what I call "betrayals" of critique. I name these betrayals "Total Critique" (a complete denunciation of the present world without any visible alternative), "Critique of All-against-All" (a proliferation of infighting and manifest lack

of solidarity among critics), and "The Activist Mystique" (the tendency to exalt practice and action and denigrate theory to the point of succumbing to an anti-intellectual posture). By *betrayal* I mean a form that discloses the essence of critique by *contradicting* this essence. In the first betrayal, opposition turns into defeatism; in the second, the unifying drive gives way to sectarianism; and in the third the revolutionary impulse succumbs to reactionary forces. One thing is constant in all these betrayals or contradictions: critique turns *uncritical*, dogmatic—an anticritique. Unlike the reversibility and aporias that I claim are elemental to critique, these betrayals are dangers that, while perennial, can be averted. I would go so far as to say that critique is more likely to betray itself the more *un*-aporetic or irreversible it becomes, which is partly the value of underscoring its constitutive aporias. Finally, I return to the claim that critique is one of (at least) three equally potent orientations of critical thought.

THE END

To sum up, then, the subject of this book is an orientation of being and thinking that I believe we often assume. We can recognize it in ourselves, in the contemporary zeitgeist, in our popular discourse and culture, and in our intellectual heritage. The book's task is to make this orientation recognizable through some of its manyfold entailments. In its standard form, the professed goal of critique is to enlighten or revolutionize, to acquire self-*knowledge*, to exit darkness and reach the light. A *critique of* critique does not set such goals for itself but puts them to question. My aim is not to impart self-knowledge but rather, to cite Nietzsche, "to make the individual uncomfortable" (Nietzsche 2016, 67). The value of this is twofold: first, discomfort and hesitation, like aporia, invoke heightened attention and self-awareness, which are conducive to recuperating critique *as* an orientation, reorienting oneself within it. The second is that discomfort can prompt serious consideration of alternative orientations of being and thinking.

OVERTURE

Basic Elements of Critique

> When an active individual of sound common sense perceives the sordid state of the world, desire to change it becomes the guiding principle by which he organizes given facts and shapes them into a theory.
>
> —MAX HORKHEIMER, "THE LATEST ATTACK ON METAPHYSICS"

Unpacking this epigraph—a statement about critical theory by one of the chief architects of the Frankfurt School—will be our entry point into the conceptscape of critique. My concern here is not with the context of this statement in Horkheimer's thought, or with that of the Frankfurt School, but solely with the statement itself, which I find particularly useful for introducing some of the basic elements of critique, as I understand it, and the logical connections between those elements. I call this opening chapter "Overture" because the motifs introduced here will be picked up again in contextual and textual variation and at different points and levels of elaboration. Recognizing and working out an orientation requires *time* precisely because it demands repetition, cumulative experience, and increasing discernment of the essential from the circumstantial.

Let me first break down Horkheimer's statement into its components before elaborating on each separately:

(a) There exists such a thing as *the state of the world*. There is, to be more precise, an entity called *the world*, and it is given in a *state*.

(b) The world's state is *sordid*.

(c) The active individual of sound common sense is in a position to *perceive* this state of the world.

(d) The perceived sordidness of the world inspires in this active individual a *desire to change* the world.

(e) This desire provides the guiding principle for a critical theory: *the organization of given facts*.

More schematically put:

(a) There is a state of the world.

(b) This state is sordid. →

(c) It is perceived as such. →

(d) This prompts the desire to change it, →

(e) Which provides the ground for a critical theory, as an organization of facts.

Let's consider these components one by one.

THE . . . STATE OF THE WORLD . . .

The phrase "state of the world" implies two main things: that *the* world is a unified whole and that it is somehow *static*. If by "the world" we understand the unified totality *within* which we exist at any given moment, it is unclear from what perspective we could ever perceive it. For the sake of distinction, I can grasp this room I'm sitting in as a unified whole despite the fact that I am in it, because I perceive its walls and its ceiling, and I have a conception and experience of what is outside it. The world, by contrast, whether we think of it concretely, as "the physical universe," or more abstractly, as "the human world" or "the present state of things," has neither walls nor ceiling, and I take it that none of us has ever been outside it. How is it, then, that we readily assume the existence of such a unified wholeness as suggested in the phrase "the sordid state of *the world*"? There are a variety of ways to account for this idea. Kant, for one, attributed it to the unifying operation

of our consciousness. Whatever my consciousness perceives is perceived as "in the world" in the simple sense that it is "in" my consciousness—my field of thought and vision. "The world" on this account is the field of thought and vision. The unity of the world is thus the unity of the active individual *whose* world it is. Kant says: "I am conscious of myself as identical in respect of the manifold of representations that are given to me in an intuition, because I call them one and all *my* representations, and so apprehend them as constituting one intuition. This amounts to saying, that I am conscious of . . . a necessary synthesis of representations" (*CPR* 155).

Synthesis, the original activity of consciousness according to Kant, is the activity of positioning things within a unified, interconnected whole, which is what consciousness does automatically—that is to say, unconsciously, or as phenomenologists call it, prereflectively. It creates concomitantly a unified "I" and a unified world. Heidegger radicalized this thought further by reminding us that the I is always situated *in* this world that it allegedly "perceives." The unity is thus not so much the operation of consciousness as it is a holistic structure of embodied experience, which Heidegger named "in-being" (*Inheit*). Wherever active individuals go, they generate around themselves, prereflectively, an *environment* (*Umwelt*), that is, an environing interconnected whole.

Whereas Kant and Heidegger take the idea that we all exist within a world to be a structural feature of experience in general, I would sooner argue that it is the product of an orientation. The unification of experience—subject and world—is among the essential operations of critique. Critique passes its judgment on the *whole*. This whole does not have to be the whole *world*; it can be a whole text, or person, or work of art. It is a mode of seeing and evaluating.

The way that the object of critique is unified is intrinsically related to its being in *a state*, which is the *temporal* aspect of its unity. When a critic receives a work of art for critique, she receives it as *finished*, as *done*, and therefore as static. Fellini's film *8½* (1963) illustrates this by playing out a scenario in which this is not the case. Fellini's ninth film, *8½* was intended to remain "unfinished": it is a film about a failed attempt at making a (whole) film. One of the characters is a critic who keeps analyzing the scenes we have just been watching a minute prior to his appearance, interpreting their symbolic meaning and calling out their flaws and absurdities. The comic effect of this underscores what we already know: that a formal critic only

enters the process once the work is *complete*. The critic, in that sense, is *not* the artist, and this distinction is crucial for both the integrity of the work of art and for the integrity of critique.

How does this stand in relation to the world? The world is also given to the critic—or to us, as critics—as something that *is* already there, in a certain state that needs to be evaluated as such. In general, this orientation, perceived in "the present," is the *end* of a process—not the *final* end but the end *thus far*. Our position as critics is thus comparable to what Hegel memorably termed the owl of Minerva, which "spreads its wings only with the falling of the dusk" (Hegel 1975, 13). As the thought of the world, philosophy, or philosophical critique, "appears only when actuality is already there cut and dried after its process of formation has been completed" (Hegel, 12). But rather than being a matter of completion, it is more a matter of stoppage. Our position as critics involves both a withdrawal from the object or field of critique, and its stoppage for the purpose of evaluation—inspecting it as a whole, just as, in the book of Genesis, God is said to stop and reflect about the work he has done at the end of each day.

. . . THE *SORDID* STATE OF THE WORLD

For the world-critic, the state of the world is categorically *sordid*. It can be argued that critique's view of the world does not *have* to be so glum, but what is certain is that it cannot be satisfactory. Dissatisfaction with the state of the world is the structural premise of critique: its raison d'être. Arthur Schopenhauer pointed this out in no uncertain terms: "If the world were not something that, practically expressed, ought not to be, it would also not be theoretically a problem" (Schopenhauer 1966, 579). That is to say, if the world were not sordid—where *sordid* is shorthand for "ought-not-to-be-as-it-is"—there would be no critical theory or room for critique. What makes for a theoretical problem in this sense is the disparity between what-is and what-ought-to-be. Whether due to a *flaw*, an *injustice*, or a *wrong*, something is not as it should be. Human history as a whole is thus a history of injustice and a rather sordid affair in that sense. Marx and Engels noted that the "history of all hitherto existing society is the history of class struggles" (*CM* 473). Given that these struggles have hitherto always involved the exploitation of a majority by a minority, the

wrong is not only moral but downright mathematical. This state of affairs is not right already in the sense that it is not *straight*; it is *uneven*. When you look at a picture hanging crooked on the wall, you instinctively feel it is not hanging as it should be; when you look at history and see the many living in abject misery under the yoke of the affluent few, you similarly feel that things are out of kilter. The most difficult question is, *Can* this picture be straightened? Can there ever be a just world or history, one that would "sit straight"?

It is on this question that the significance of the concept of an "orientation" hangs. If we were talking about mere facts, the answer would be simple: insofar as the injustice consists in class antagonism and the exploitation of the many by the few, the factual abolition of classes would put injustice to an equally factual end. A skeptic might argue against this that, thus far, all attempts to end class antagonism have resulted in nothing but new tyrannies, but such a factual objection would miss the point—that things should be *otherwise* than they have been. My suggestion is that the difficulty is not factual at all because injustice to *begin* with is not a fact but a structural premise of an orientation of thought, and if the orientation is not caused by concrete facts, it will also not be *altered* by new ones. This—and not the perceived failures of past revolutions—is the reason to doubt that classes can be abolished by revolution.

The fundamental antagonism that underlies class antagonism, and eventually necessitates it, is the one between what is the case and what ought to be the case. More precisely, it is the antagonism between justice, as what ought to be the case, and reality, as what is the case. Justice can be defined in different ways, but whichever way we define it, reality would fall short of it. The state of the world does not simply *happen* to be sordid; it is constituted as such in tandem with the critic's awareness of their activity. As critics, we do not passively wait for flaws to leap into our perception; we detect them. The more active and sophisticated our intellect, the more expert and methodic our processes of analysis and synthesis become and the more systemic and structural the flaws we detect.

WHEN AN ACTIVE INDIVIDUAL OF SOUND
COMMON SENSE PERCEIVES . . .

Critique is the last and the least of the orientations to appreciate the claim that it *is* an orientation, at least in the sense of being one among equals. There are a few reasons for critique's reluctance to acknowledge the partiality of its purview. One of these is its staunch *realism*. You just don't tell a critic that injustice is a product of the way *they* are oriented. Immediately, they will point you to horrific examples of radical evil and suffering, the kind that are indeed undeniable but here serve the rhetorical purpose of delegitimizing any possible retort, rendering the attempt to ask fundamental questions about knowledge and morality indecent. Suffering and violence can indeed shock the mind, leaving the victim thoughtless and speechless, which is part of what makes them horrific. The invocation of extreme suffering and violence in an argument seems to function similarly: to silence, to crush the opposition. *This* is true; *this* is real; they will prove you, and the only reason we are even able to sit here flaunting lofty conjectures about "reality" and "orientations" is that we're privileged enough to be spared the immediate force of violence—*this* kind of violence. Challenging the moral and epistemic authority of the critic (which is presented as an extension of the authority of reality itself, of the violence pointed to) immediately places the one challenging in a morally dubious position—the position of a culprit. If you do not acknowledge the realities of suffering and injustice, then you are in the best case naive, in the worst case complicit. The only choice you're given as "an active individual of sound common sense" is to be part of the problem or part of the solution to it. Well, which is it?

The underlying point is that perceiving, for critique, is *secondary* to reality, to what is already and evidently *there* to be perceived. Reality, by definition, is independent of its perception, just as objectivity is by definition *not* subjective. This book in my hands is in *reality*, not in my head. And this is *real* injustice; that is *real* pain. Perception is truthful to the extent that it accords with what is to be perceived. This truthfulness is knowledge, not whim. I don't get to know what I feel like knowing; that's not how it works.

The conviction that we critics have no hand in the abject world we perceive is nowhere more apparent than in the use of the phrase *common sense*: "When an active individual of sound common sense perceives the

sordid state of the world . . ." The invocation of common sense is among the hallmarks of critique. We appeal to it when we want to make the case that what we say is not the product of our own perspective or opinion and that it ought to be *self-evident* to anyone in their "right" mind. Minds, too, are like pictures on the wall; we can spot a crooked one when we see it. Sound common sense is also implicitly appealed to by mathematicians when presenting some of their claims as axioms or as common notions. Such claims are demonstrated by force of their own self-evidence, simply by being *stated*. They require and allow for no proof. They are not arguments, let alone theories, but pure *perceptions*. If the student cannot *see* the veracity of the axiom that is presented to her, there is little the mathematician can do to help. This is how rationality works. And this must be the starting point of any meaningful conversation. If you're not being rational, of sound mind, I can't argue sense into you.

In critique, the axiom is a *moral* one. It is not simply that such and such is the case but that it ought not to be the case. It is not that there is first a perception and then a judgment but that the perception—the truth-claim—is already moral. Our dispositional realism as critics is thus at the same time a dispositional moralism. What is moralism? Nothing but the conviction that morality—or rather, the wrong, the injustice—is grounded in, speaks from, and is authorized by reality itself. The world *is* in such and such a state, and this state *is* sordid. It is therefore the same soundness of common sense that impels me to perceive this fact *and* be morally moved by it. It does not make sense to "go about one's business" as if everything were all right. Perhaps this is the reason for which the fruit of knowledge in Genesis is the fruit of knowledge *of good and evil*. Perceiving the truth about the world renders the perceiver guilty, complicit, responsible, at least until something is done about this truth. The rhetorical role played by the appeal to examples of radical evil and abject misery is to establish this intrinsic link between reality and morality or, rather, between reality and evil, as if the appeal to such examples and the inclination to single out and generalize from some realities and not others were automatically justified, so justified, in fact, that it would be downright evil to question it. It is not only philosophically, but also socially, difficult to critique critique.

. . . DESIRE TO CHANGE [THE WORLD]
BECOMES THE GUIDING PRINCIPLE . . .

There is no freedom in perception. Perception is but the reflection of real-
ity itself in the clear waters of my mind. The more shocking and disturb-
ing the reality perceived, the more forceful and compelling the perception.
But where freedom *does* come to our rescue, as active individuals, is
in the fact that we do not have to *contend* with the world being as it is.
Freedom is born with discontent and disapproval. The first step is to accept
that things are the way they are. But the second step is to refuse to accept
that this is how they *must* be. It is only in the conceived possibility that
the world can be otherwise—and with it, the duty to at least *desire* that it
would be otherwise—that our freedom, and from critique's perspective our
humanity, lies.

Sound perception of sordid reality thus engenders a duty to change this
reality. To say that critique is realistic is not to deny that its theoretical en-
deavors are tendentious and desirous. Indeed, to the extent that a theory is
critical, it does not belong in the cold air of neutral reflection but is guided
and infused by the critic's desire and practical commitment to change the
world. If anything, world-critique is ablaze with righteous vengeance and
furious passion. This passion, as the capacity and inclination to be *moved*
to action, is a major aspect of what renders the critic an "active individual."
But it is equally crucial to note that the sordidness *of the world* is grounded
in the world's orientation, which is to say, it is grounded neither in critique's
desire (let alone in the theory that is itself grounded in this desire) nor in
the perception on which the desire is grounded.

To use Freudian terms, the "reality principle" stands here in the most
radical opposition to the "pleasure principle," for whenever reality is cor-
rectly perceived, its perception is *painful* to the morally decent person.
Within the field of perception, which constitutes the state of the world, the
suffering victim of injustice is the center of gravity and of the critic's vision;
the critic's moral pain reflects the victim's actual pain. Suffering, in turn, is
the ultimate standard for what counts as real, which means that the truest
perception is the most painful one. This can be formulated by the statement
that, although perception is visual and therefore necessarily removed
(vision requires distance), in *true* perception, reality *touches* the perceiver,

as it were, *moves* her. Reality in the final count is suffering, and the truth hurts. In a similar way, the innocence (purity) of the suffering victim is the reflection within the field of perception of the soundness, rightness, and righteousness (also purity) of common sense. Such is the reality principle.

The pleasure principle—namely, desire—is triggered in an oppositional response to reality: it seeks to alleviate the pain, to *end* it in oneself *and* in the victim, to save oneself or one's "soul" by saving the victim and the world. The pleasure principle has therefore as little to do with *pleasure* as the reality principle does. In fact, pleasure has little room in the house of critique overall (it feels almost indecent to think or talk about pleasure in a world so full of pain). What counts here as "pleasure," or the end goal of desire, is only the ending of pain, just as justice is the ending of injustice.

What is inscribed in the opposition between the reality principle and the pleasure principle, or between reality and desire, is a particular conception of desire: *desire-to-change*. This kind of desire is very different from libido, for it is not born of attraction or *jouissance*. The last thing libidinal desire wishes is to change something. What is unique about the desire-to-change is that it is *itself* a kind of pain or is experienced *with* pain and only for as long as the pain lasts. It is a painful desire.

The objective of this kind of desire is to establish the conditions that would put *itself* (the desire) to rest, not the conditions that would fulfill or increase it. It is a desire *not* to desire any longer. As such, it is, to use Freudian terminology again, significantly closer to a death-drive than a sex-drive. The desire that fuels us as critics can take on one of two forms: either as a duty, in which case it is rooted in a principle or law; or as pain, in which case it is rooted in compassion with the suffering. In both cases, the revolutionary impulse—the desire to change the world—is experienced as a *necessity*, not as a luxury or superfluous want. Marx identified this necessity as *passivity*, saying that revolutions need "a passive element, a material basis." Theory, he said, "is only realized in a people so far as it fulfills the *needs* of the people. . . . Emancipation can only be achieved by a call *forced* to it by its immediate situation, by material *necessity*" (CH 61, italics added). Such is the kind of desire whose essence is the need to change the world, and such is the sordidness in which this desire is rooted. Revolutionaries may sing inspirational songs, write their slogans across banners in fiery colors, yet the songs and colors are the honey in which bitter medicine is dipped.

Changing the world, for *this* orientation, is only a value for the army of the discontent, not for those libidinal, irreverent youth who are thirsty for creation and destruction simply for the sake of creation and destruction.

Dialectical movement as conceived by Hegel embodies the revolutionary kind of desire, the desire-to-change. As he described it, the entire journey of natural consciousness—the world spirit—through history is "the way of despair" (Hegel 1977, 49), a *via dolorosa*. We know as much from the book of Genesis: no sooner did Adam and Eve gain knowledge, no sooner did they lose the sweet and lying shackles of their infantile naivete, than they lost their place in paradise, fallen from nature and from themselves. Dialectics redeems this narrative, promising us that this fallenness, this way of despair, is nonetheless an ascension, a progress—that it is *good* to mature; that it is *better* to know, even if ignorance is an Edenic bliss in which we get to frolic about naked and unperturbed. Why? Because knowledge allows and prompts change and therefore freedom, whereas ignorance is conformity and therefore slavery. The Garden is the world of prisoners who do not yet know that they are in shackles.

In short, a critic is no happy soul. In a world full of pain, exploitation, and suffering, our intellectual activity is often imbued with guilt, the more so the more we recognize ourselves—as the ones who are in a position to think, judge, theorize, withdraw—as among the privileged.

. . . BY WHICH HE ORGANIZES GIVEN FACTS AND SHAPES THEM INTO A THEORY

Finally, we arrive at theory, critical theory, now revealed as fueled by pain and duty—pain at how things are, duty to change them. This renders the theory practically oriented. But what kind of *theory* is prompted by the desire or imperative to change the world? Silvan Tomkins described the intrinsic tendentiousness of theory, in particular what he termed *strong* theory, as one that leaves as little as possible for chance: it is "a highly organized way of interpreting information so that [whatever is] relevant can be quickly abstracted and magnified, and the rest discarded" (Tomkins, cited in Sedgwick 2003, 135).

Although conspiracy theories may not be the most rational or satisfactory examples, they are in many cases good examples of critical theory. A good conspiracy theory is one that (1) is extensively researched, supported by

a plethora of facts, numbers, observations, and insights, indeed, by knowledge and evidence; (2) shows that all the data it presents is interconnected, that everything is linked as in a causal chain or a geometrical proof; and (3) shows that everything points to the existence of a (malign) *agent*. Although they are often prefigured in critical theories as a group of people—as in big-business capitalists, or liberal-socialist academics, or the CIA, or other interest groups—the truth is that the agent need not be a person or a group of people. It can be an underlying rationale, cause, or purpose, unconscious to its proprietors but of discernible logic nonetheless. A strong conspiracy theory does what *every* strong scientific theory does, except on a moral platform—namely, identifying the causal mechanisms and laws underlying phenomena. The main difference is that conspiracy implies not simple lawfulness but malevolence or at least something reprehensible.

Conspiracy in this sense is nothing other than a moral synthesis (organization) of facts in a manner that is conducive to revolutionary practice. If you detect a conspiracy, you do not want any part of it; you want to expose and dismantle it. This conspiratorial leaning has caused some theorists like Sedgwick (2003), weary of the prevalence of critique in their fields, to note its affinity to paranoia. Indeed, the paranoid mind-set, often unusually intelligent, is one that is particularly attuned to the facts, one for which the given facts are always clues, signs, symptoms of hidden processes in a web of growing complexity and global complicity. Paranoia literally means what is beside (*para-*) the mind (*nous*). It is therefore another word for unreason. Yet in some sense it is nothing but a radicalization of rationalism's own tendencies. Common sense meets its opposite, in the dark. For rationalism is likewise the quest for patterns and links, especially those that are hidden beyond or beneath the surface appearance of things. "Reason" is the answer to the question *Why?* And this question already announces, if only implicitly, some moderate paranoia or at least skeptical suspicion. "What is going on here?" "Surely this cannot be by chance" "Who or what is behind this?" The question of whether the author of history is God or the devil follows almost inevitably from the tacit assumption that history must have an author, an agent, or a principle, and that the designs of this agency or principle are not self-evident. The drive to knowledge is thus often carried on the wings of anxiety.

Just as the mirror image of the critic's pained gaze within the field of perception is the ultimate victim, so the analogue of the critic's active

mind in the field of perception is the ultimate agent. Knowing the agent is the closest thing to *being* the agent, the closest thing to control. If I have a good grasp of the reason for which things are as they are, I am in the best position to change them. As Descartes phrased it, if "we could [only] know the power and the actions of fire, water, air, the stars, the heavens, and all the other bodies in our environment, as distinctly as we know the various crafts of our artisans . . . [we would be able to] make ourselves, as it were, the lords and masters of nature" (Descartes 2005a, 142–43).

We arrive at critique's idea, or ideal, of agency as free choice and self-determination. Anything short of this would not satisfy the question of reason, for if something is not the cause of its own actions, then those actions must be at least partially caused by something else. An agency worthy of the name, per this orientation, is a cause, not an effect. There is, however, a catch. While only true agency can satisfy the question of reason (*Why?*), the existence of such an agency also makes it impossible to answer this question, for such radical freedom and self-determination implies the ability (should we add, the temptation?) to act *ir*rationally, nonsensically, for no *good* reason—for instance, committing or perpetuating injustice. While changing the world requires agency, the prospect of agency is at once the possibility of evil. We are confronted with a paradox: insofar as rationality is a commitment to the idea of an ultimate cause by which to explicate (if not control) the world, it also condemns its possessor to live and navigate through a world that is not—at least not fully—rational and is therefore neither explicable nor controllable. A society of rational beings, as Kant for one perceived it, would potentially be the most erratic of all. This is not because reason gives no guidance. It can certainly tell us the difference between right and wrong; for instance, it is not right that the few should rule over the many. But this guidance of reason has no actual *force* to determine the choices of true agents. The idea and ideal of autonomy is thus doomed to crash in perpetuity against the shores of helplessness, mistrust, and fear of the unknown. Rationality, which is the power to explain and understand, is also what dictates perpetual bewilderment and alienation. The active individual of sound common sense is forced to admit that the world as it is, and perhaps the common run of people, *lacks* common sense if not sense altogether. No wonder, then, that in the final count it is not enough for the rational mind of the critic to understand or interpret this world; it must *change* it if the world is to become rational like unto itself, if

it is to become hospitable and safe.

If the true agent is always potentially a wrongdoer, a criminal, the critical theorist is always potentially a detective. The popularity of the genre of the serial killer—this most rational, premeditated, methodic of killers and at the same time the most exuberantly insane—tells us something deep about rationality as such. An intimate dialectical connection exists between the detective and the criminal—a deep ambivalence, a unity of opposites, a love mixed with hate, a fascination mixed with abhorrence. They understand each other best, the ingenious detective and the equally ingenious murderer, the Batman and the Joker; they motivate each other to exercise their skills to the fullest. In the figure of Hollywood's most notorious killer, Hannibal Lecter—the psychiatrist-turned-psychopath-turned-aid to the police—the two sides unite. He is a distorted, yet truthful, image of the dialectic of agency: the identity of rationality and madness.

The *Dialectic of Enlightenment*, Adorno and Horkheimer's celebrated book of essays that is itself a critique of rationality, provides an unusually somber look at our consumer society. In our culture, as they put it, "everything which is different, from the idea to criminality, is exposed to the force of the collective, which keeps watch from the classroom to the trade union" (*DE* 21). This anonymous collective is itself only a messenger, not yet the true agent. It "is merely a part of a deceptive surface, beneath which are concealed the powers which manipulate the collective as an agent of violence" (*DE* 22). Now let's go, critics, let's find those clandestine powers, expose them, hunt them down, bring them to justice!

REPACKING THE STATEMENT

To summarize the movement: Critique is committed to a staunch realism—the notion that reality is what it is, independent of its perception. And just as reality is independent of perception, perception is independent of desire. This means that the perception, if it is truthful rather than a wishful projection, is disinterested. It is not about what I want, desire, or hope. It has little to do with who I am at all, other than the fact that I am proactive and of common sense (i.e., that my mind is alert and capable). This order of things—reality → perception → desire—is crucial for sustaining the particular *nature* of critique's realism, namely, the conviction not only that reality is what it is but that it is not what it ought to be; it is *sordid*. For if

desire had any hand in the premise—if it somehow *projected* sordidness onto the world—the entire logic would evaporate. If critique becomes particularly cantankerous when such an implication is made, it is because this implication jeopardizes its entire worldview and shakes up the self-understanding of critics to their core. To undermine the sordidness of the world is, implicitly, to challenge the critic's sanity, and common sense.

Following the same logic, we saw that critique's desire is structurally a desire-to-change, a revolutionary desire, which is more akin to pain than to pleasure, to necessity or duty than to freedom. Unlike love or inclination, which cannot be imposed, this kind of desire can be demanded of everyone. Finally, while desire is *caused* by the rightful perception of a wrongful reality, it in turn fuels and guides the theoretical activity—the organization of facts—to constitute *a coherent, rational, causal account* of the wrongfulness that was intuitively perceived. So critique and the critic turn out to be the medium through which reality protests, articulating and broadcasting its sordidness in the demand to be changed or revolutionized.

Among other things, this logic entails that theory, which here names the activity of thought, is secondary and subordinate to the real. Critique posits an "already there" as self-evident "before all thought." Ironically, this makes critique particularly immune to *critique*—or to any self-examination, any suggestion that it might have something to do with, some mental investment in, the realities that so plague it. In short, the fusion of staunch realism and ferocious moralism (the wrongfulness of reality, the righteousness of the demand to change it) makes critique particularly authoritarian. Oppositional though it is, it is particularly intolerant to opposition. Critique, therefore, has a *structural* tendency to transform into or join hands with its enemy: dogmatism.

Part 1

APORIAS OF CRITIQUE

ONE

Critique of the Spectacle or the Spectacle of Critique

> Understood in its totality, the spectacle . . . is not a mere decoration
> added to the real world. . . . In all of its particular manifestations—
> news, propaganda, advertising, entertainment—the spectacle rep-
> resents the dominant *model* of life. . . .
>
> The spectacle that falsifies reality is nevertheless a real product of
> that reality. Conversely, real life is materially invaded by the contem-
> plation of the spectacle, and ends up absorbing it and aligning itself
> with it. . . . Reality emerges within the spectacle, and the spectacle is
> real. This reciprocal alienation is the essence and support of the exist-
> ing society.
>
> —GUY DEBORD, *SOCIETY OF THE SPECTACLE*

Guy Debord's *Society of the Spectacle*, one of the quintessential works of
critique in the second half of the twentieth century, ushers us into our first
theme: the world, or reality, as a spectacle. Debord takes this to be a historical
development: "the spectacle is both the *meaning* and the *agenda* of our
particular socio-economic formation"—namely, late-stage capitalism. "It
is the historical moment in which we are caught" (Debord 1995, 9). In this
chapter I make the case that the view of the world as a spectacle, or, for that
matter, the spectacular nature of reality, is not itself a historical development

tied to a particular socioeconomic formation but, rather, the product of an orientation. More important, I want to suggest that the ambivalence toward the spectacle expressed here by Debord is part and parcel of the drama of critique, for which the spectacle is native land, or native bondage, from which it always ventures to escape and to emancipate itself but upon which it always ends up falling back. Debord acknowledges as much when he notes that "in *analyzing* the spectacle we are obliged . . . to use the spectacle's own language. . . . We have to operate on the methodological terrain of the society that expresses itself in the spectacle" (9). The spectacle is our home as critics, yet we are never fully at home in it. Our alienated relation to the spectacle, and our sense that it is deceptive, illusory, or unreal, reflects the alienation intrinsic to the spectacle itself and to spectacularity as such. The critic and the spectacle are necessary to each other yet are never at peace.

A "CINEMATOGRAPHICAL MECHANISM OF THOUGHT"

It is fitting to begin an analysis of the spectacle with an *image*, and to counter Debord's historical claims about the spectacle, I begin with an ancient one:

> Imagine human beings living in an underground, cave-like dwelling, with an entrance a long way up that is open to the light and as wide as the cave itself. They have been there since childhood, with their necks and legs fettered, so that they are fixed in the same place, because their fetter prevents them from turning their heads around. Light is provided by a fire burning far above and behind them. Between the prisoners and the fire, there is an elevated road stretching. Imagine that along this road a low wall has been built—like the screen in front of people that is provided by puppeteers, and above which they show their puppets. (*R* 132–33)

So begins the famous allegory of the cave as told by Socrates to his friend and mentee Glaucon, who responds: "It is a strange image you are describing, and strange prisoners." This may be so, Socrates concurs, yet he assures Glaucon that they are just "like us."

This allegory is among the most iconic images in the history of philosophy and not by chance. Perhaps the best indication of its agelessness is its oft-noted anticipation of the cinema. As film critic Jean-Louis Baudry noted, "The arrangement of the different elements [in the film theater]— projector, darkened hall, screen . . . [reproduces] in a striking way the

mise-en-scène of Plato's cave" (Baudry 1974, 45). The cave itself anticipates the darkened cinema hall; the light that "is provided by a fire burning far above and behind" anticipates the film projector, which likewise looms above and behind the film audience; and the artifacts marched in line in front of the fire, casting their shadows on the wall of the cave, anticipate the unrolling of the still shots which make up the traditional film roll in front of the projector. What Plato does not tell us explicitly, but the cinema helps us understand, is that this apparatus is cleverly designed to generate the illusion of *movement*, hence film's original epithet: the moving picture, or "*movie*" for short.

If Plato's prisoners are "like us," as Socrates tells Glaucon, it is not because we are moviegoers but the other way around: we are moviegoers because we are like Plato's prisoners. We invented—*had* to invent—the movies because Plato was right. If the mise-en-scène of the cave anticipates the cinema, it is because both of them capture something essential about the structure of the present—of reality *as* "present"—presented to us as a spectacle. Etymologically, the present is that which is before (*pre-sent*). It is "before" us in both senses of the term: temporally, as *already there* before we see it, and spatially, as being *in front* of us. The present, as is also suggested by the conventions of our speech, is akin in this sense to a *gift*: that which is *given* to us, handed down or handed over. The spectacle "is the omnipresent affirmation of the choices that have *already been made*" (Debord 1995, 8).

Long before it is reduplicated in the form of the cinema, the present itself is "a moving picture." The philosopher who understood this best was Henri Bergson. He pointed out that we ordinarily think, speak, and represent time as a series of fixed points along a homogeneous and unmoving line—the so-called "timeline." This linear representation of time is taken for granted by most scientific and ordinary conceptions of Western history. Just consider the way we periodize geological eras, biological phases in evolution, and epochs in human history as consecutive segments of a single line, itself unmoving, which represents history. The same conception of time is reflected in mathematical analyses of motion, which the textbooks of modern physics usually depict as the purported "movement" (represented by a line or an arrow) of a solid object such as a cannonball or a train between two points, A and B, that are themselves fixed in space. Notably, these representations are not really of time but of *space*, itself static, immobile, like the page of the textbook or notebook before us. There is no real motion in this picture; the

analysis is entirely geometrical, and the page is just as fixed and flat as the wall of a cave or a cinema screen.

Bergson claimed that because of this essentially static conception of time, "we become unable to perceive the true evolution, the radical becoming," that he held to be true reality (Bergson 1998, 273). The "most striking of . . . illusions," he added, is our belief "that we can think the unstable by means of the stable, the moving by means of the immobile"—that we can think of *life* by means of years or a series of static stages such as infancy, childhood, adolescence, adulthood, old age. Suggestively, he named this illusion "the cinematographical mechanism of thought," since cinema likewise makes the semblance of movement out of a series of stills.

Bergson thus helps us see what Plato's allegory already intended to show: that our ordinary conception of reality is cinematographic—a moving picture that is, in fact, immobile. Like the art of photography, on which it is based, and the art of painting (over a flat canvas), out of which photography develops, the cinematic medium expresses a world-ontology—an underlying conception and experience of being and life. Martin Heidegger described this ontology as a "world-picture" (*Weltbild*), which, "when understood essentially, does not mean a picture *of* the world but the world [itself] conceived and grasped as a picture" (Heidegger 2013, 129). Ontologically speaking, the moving picture is quite simply the conception of time itself as a series of presents—a moving present, so to speak, or a "movie." Thus, on Wednesday we say that Tuesday *was* the present, that Wednesday *is* the present, and that Thursday *will be* the present. *All* days are present. Or, if we take the present to be the very substratum of this movement, we can say of the present: yesterday "it" was Tuesday, today "it" is Wednesday, and tomorrow "it" will be Thursday. The present thus becomes that "it" that is moving along, like a picture before a spectator.

Heidegger saw this world-picture ontology as an eschewed or reductive conception of time and reality, much as Bergson took the cinematographical mechanism of thought to be such. Plato's depiction of human beings as held *captive* by such a mechanism of thought further supports the impression that it is illusory, even adding an apparently malevolent aspect to it (considering how carefully orchestrated this whole apparatus seems to be and that the people subjected to it are kept in chains). But the difference between Plato and these later philosophers is that he endorsed rather than rejected the ontological prioritization of presence and immobility. For

Plato, the captivity is not the last word on this picture ontology; on the contrary, the captivity symbolizes the failure to properly recognize the ontology. The problem as Plato sees it is that we fail to recognize that the essential constitution of our world *is* in fact permanent, unmoving. Pace Bergson, the illusion that plagues his cave-dwellers' minds is not that of immobility but precisely that of *movement*, not the alleged permanence of Being but the alleged flow of Becoming. This is good news for Plato, since it renders true knowledge possible, despite the transient and perspectival nature of all sensory experience.

My concern is not with which of these thinkers is right. As far as I'm concerned, there is no such thing as a *false* ontology, just as there is no such thing as a false orientation. Ontology either is or it is not: if there is such a thing as a "world-picture ontology," then the world *is* a picture, has always been one, and always will be. My account therefore diverges from Heidegger's, for instance, which, in alluding to "*the age* of the world-picture" (*die Zeit des Weltbildes*), suggests that this ontology is a historical phenomenon. Clearly, however, it is only *under* the premises of a world-picture ontology that we can divide history into "ages" in the first place. If there is such a thing as "the age of the world-picture," it cannot be a time *in* history but a conception of history itself as a homogeneous totality that divides into "times," each of them before or after the others. That such a portrayal of history is both possible and prevalent (even within Bergson's and Heidegger's philosophies), no one, I think, can deny.

My claim that any possible ontology is truthful becomes more permissible once we allow, pace all the thinkers I have mentioned, the existence of *several* incompatible and equally fundamental (truthful, metahistorical) ontologies. The truth of the one does not disqualify the truth of the other, for each of them entails a different conception of what *truth* means (there will be more on this in chapter 5). Now, what I maintain here is that the ontology of presence, of the world-picture, or of the spectacle is part and parcel of the orientation of critique, which means that there can be no critique without such an ontology among its premises. Yet the interesting thing about critique is that despite being tied to the spectacle with a Gordian knot, it does not *like* the spectacle. Furthermore, it is not only particular spectacles, such as that of late capitalism (Debord) or the history of Western metaphysics and science (Bergson, Heidegger), that it does not like but the fact that they *are* spectacles, that they exhibit the reign of the spectacle. In other

words, beyond the specific, and indeed historical, spectacles it critiques, what critique objects to is *spectacularity*, and this spectacularity, in turn, is inseparable from the act of critique. The critique of the spectacle in that sense is always at the same time a critique of critique. Heidegger's critique of modernity, with its picture-thinking, and Bergson's critique of the habitual human tendency to represent time as space do not only oppose a way of envisioning the world; they oppose, or seek to withdraw and differentiate themselves from, *the world* that privileges this way of envisioning. But this is the world they inherit and in which they find themselves proximally and for the most part. It is *their* world, and in standing in opposition to it, as one stands before a (deceptive or inauthentic) spectacle, they are orientated as critics. Oriented this way, they confirm rather than undermine the hold of the spectacle over their own thought.

ENLIGHTENMENT (AFTER DARK)

Like a Hollywood movie, the allegory of the cave starts gravely and ends happily. If not all, then at least some of the cave inhabitants who start their lives as prisoners are eventually freed and return to free others. Once unshackled, the former prisoner *turns around*, first the head and then the whole body, from facing one end of the cave (the wall) to its opposite end: the opening. Plato opposes the visible world, symbolized by the interior of the cave, to the intelligible world, represented by its exterior. Climbing out of the cave, the former prisoner exits the visible realm and enters the intelligible; the ascension from the visible to the intelligible signifies the transition from captivity to freedom. The idea that one *exits* the visible realm may suggest that the prisoner's liberation means ceasing to be a spectator, but this is not the case. This liberation is a matter, rather, of recognizing and liberating oneself *as* a spectator, and we understand this as soon as we consider what the "intelligible" realm is like.

The terms Plato employs for the objects that populate the intelligible realm—*eidoi* and *idea*—derive from the verb *idein*, meaning to see. Usually translated as "form," *eidos* literally means the *look* of things. Like visibility, then, intelligibility involves looking. With Plato, the term *form* acquires a specific connotation: it refers to the conceptual framework that makes possible a thing's appearance, or its recognition, *as* this or that. For instance, a dog can be recognized as a dog only *in light* of the idea or form of dogness.

Absent this idea or form, no such thing as a dog could ever be *perceived*. Likewise, a just action can be recognized as such only in light of an idea of justness—some tacit definition or preconception of what it means to be just. Forms are therefore like illuminations or clearings within which things and actions can come to show themselves in certain ways. Doing so, they not only show themselves but also exhibit and exemplify the forms, much as a shadow at once shows itself and, indirectly, attests to the existence of that of which it is a shadow. The difference between the visible world of things and the intelligible world of forms is therefore not between what is visible and what is invisible but between two dimensions of visibility—the mere sensory appearance of entities, on the one hand, and that which makes this appearance possible and, indeed, intelligible, on the other. Although it may seem to us that sensory appearance precedes intelligibility, as though intellection were a superimposed act of studying the things of our senses, the true order is the reverse. As Heidegger put it, we "do not see because we have eyes; we have eyes because we can 'see'" (Heidegger 1998, 145). The second sense of seeing in this statement marks, he says, "the *foundation* for all physical, physiological, and aesthetic 'optics.' . . . It is what *allows* for [a visual] encounter with beings, things, animals, and other people, in the light" (146, italics added). If we can be said to have a world at all, this world must already be intelligible in some definitive ways.

This intelligibility is symbolized in Plato's allegory by the figure of illumination—the *light*. Notably, this figure reigns over both sides of the allegory: the cave is illumined by a fire, while the outdoors are illumined by the sun. If light thus reigns over the allegory as a whole, it is not by chance, for it reigns over the ontology of the spectacle whose layers and components the allegory breaks down for us. There is a difference between two kinds of illumination—fire and sun—the first is artificially set up whereas the second is natural. As all things artificial, the fire imitates the natural effects of the sun, reproducing them in a controlled environment. Thus, if the sun stands for what makes knowledge possible (the source of all intelligibility), the fire, as we will soon see, stands for education or indoctrination into specific *systems* of knowledge, which Plato calls "belief" (*doxa*). This education-into-a-belief-system *hides* intelligibility behind a particular worldview, which then passes as "natural"—namely, as the only and obvious way in which we can and ought to see the world. Another notable difference between the two symbols of light, besides the artificial/natural opposition, is that the sun

provides *complete* illumination, whereas the fire requires a surrounding darkness; just like a flashlight (or a projector), the fire can illuminate only *the dark*—hence the need for enclosure, whether in the form of a cave or a darkened theater. The enclosure further gives the illumination a *directedness* that the sun does not seem to have: the tunnel-structure of the cave— open at one end and closed at the other—serves to *stream* the firelight along a trajectory of *projection* and so to manipulate it for specific purposes. Thus, the cave generates a categorical opposition between a "back side" (a "behind-the-scenes") and a "front side"—an opposition that does not seem to hold outside the cave, where everything is out in the open.

The tunnel-like structure of the cave is a figural representation of the term *orthodoxy*, which literally means the "straight view" or the rightly directed (*orthós*) opinion or belief (*doxa*). Orthodoxy in this sense is a belief system that, like a film, is produced and directed—what in Marxist jargon is termed an *ideology*. Despite the alleged diversity of their experiences and perspectives, the members of a given society, just like Plato's prisoners, are habituated by the educational system, by religion, and by other socializing apparatuses to view things from one hegemonic and normalizing perspective. This communal perspective—the "common sense"—is essentially *monocular*. If the shadows reflected on the cave wall represent the specific contents of the ideology, the cave as a whole, including the fire, represents the means and conditions for the production of ideology, be they material, economical, or epistemological. While these conditions make possible a certain worldview, they at the same time make *themselves* invisible, hiding *behind* the worldview they project.

If the cave structure represents orthodoxy, we may assume that on exiting the cave, the former prisoners could see things as they *wished* to see them. This is not the case. The illumination of the sun outside, which represents the conditions for the possibility of acquiring true knowledge, is no product of the will, definitely not the wills of individuals. What makes for the freedom of the liberated prisoners is not that they can see or project what they would like to see but that they can now *move around* the objects of perception so as to grasp them more fully and truthfully, *less* subjectively. The view outside, in the intelligible realm, is therefore itself—as Plato often refers to it—an *orthodoxy*. If anything, it is the *true* orthodoxy: knowledge. It is this orthodoxy that ideology *imitates*, artificially and partially. The emancipation of the spectators is thus their entry into the realm of an even

more binding truth—one so binding that it compels, orients, and unifies not only their imagination, fantasy, and desires but also their thinking and wills. Whereas each society can have its own cave and its own spectacle, in the universal illumination of the sun, *all* can align themselves and unite, not just locally and parochially. There are many fires and many caves but only one sky and one sun. This understanding of emancipation as an entry into universal vision—which is among the emblems of critique—accounts for the familiar notion of "enlightenment." As the term suggests, *enlightenment* is not the acquisition of the capacity to walk, run, or dance but primarily the capacity to *see*—see well, see right, see straight.

As I have proposed, a major difference between the fire's illumination and the sun's is that the former is effective only against the backdrop of darkness, whereas the latter is complete illumination. But the idea of complete illumination is misleading, especially if we consider the drama of the allegory as a whole, as a *movement*, and not only its two sides ("the inside" and "the outside") in isolation. *Enlightenment*, after all, is a nominalized verb, which names an *event*. Considering this event, we see that just like the illumination of the fire, the sun's illumination also occurs against the backdrop of darkness—the darkness of the cave. As Plato's allegory illustrates effectively, enlightenment is *coming out* of darkness and *coming into* the light. Structurally speaking, this suggests that there can be no enlightenment without prior ignorance. This fact requires notice, for it does not go without saying that knowledge should be understood as the *ending* of ignorance. It does not go without saying that we are all *at first* "prisoners," figuratively blinded or deceived. Nor does it go without saying that history—individual or collective—is a revolution-paved *progression* from greater darkness to greater light. Yet this narrative is often recited. Besides Plato, we see versions of it in Christian theology ("I was blind, but now I see"), in social contract theories (the transition from a "state of nature" to a civilized state), in Enlightenment historiographies, and in the bildungsroman. Everywhere, the backward glance of the matured casts light on previous blindness, innocence, deception, captivity, immaturity.

It matters that these narratives are permeated by and structured around binary opposites: darkness and light, deception and knowledge, enclosure and openness, enchainment and freedom. Plato's name for this oppositional logic, used as such ever since, is *dialectics*. This dialectical logic is not only found in the opposition between the cave interior and the exterior; it

also rules the exterior, or the intelligible realm, itself. As Socrates routinely explains to his interlocutors in Plato's dialogues, an adequate grasp of a form *entails* the grasp of its opposite. For example, a proper definition of piety must at the same time define *im*piety as that which true piety completely excludes (*Eu* 5). Oppositionality—dialectical logic—spells out a totalizing and revolutionary ethos as well: it's all or nothing; you're either with us or against us, in the know or in the dark; there is no middle, only a complete *turnaround* (or complete unification). For critique, a slave is *completely* a slave while the master is *completely* a master, just as the oppressed is *only* oppressed and the oppressor *only* oppressing. The two are like the opposite sides of a coin; there can be no overlap, ambiguity, confusion, or hesitation. Dialectical narratives operate a bit like a springboard in that way: their beginning, and each subsequent stage of development, sets the ground for a somersault, a turnabout from one opposite to another.

THE CRITICAL TURN (FROM SPECTATOR TO JUDGE)

Enlightenment is not only a coming out into the light but also a turn within and toward oneself, from mere consciousness of the world to *self*-consciousness. At that, it actualizes one's being *as* consciousness, as spectator, and thus as the ground for the possibility of a spectacular world (or at least of its critique and revolutionization). Enlightenment reveals to me that I am not simply in the world like another cog in a machine but am the ground, or access to the ground, of this world's intelligibility. This kind of turn is called reflection. As Schopenhauer noted, "In reflection the spectator surpasses [his empirical self], becoming the transcendental spectator" (Blumenberg 1996, 61). This is achieved through a doubling: *looking at the looking*. Philosophical or true education, Plato claimed, "is the craft concerned with doing this very thing, this turning around (*periagoge* [περιαγωγή])" of the soul (*R* 1136). The term Plato uses to describe the logic of this turn, beyond its specifically pedagogical context, is *metastrophe* (μεταστροφή). The etymological sister of *catastrophe, metastrophe* means literally a turning (*strophe*) over (*meta*). It is also, or even more so, a turning *under*, for the *meta* in this context connotes the *sub*structure or *underly*ing conditions, which are themselves ordinarily covered *over* by all that they support and make possible, just as the electronic apparatus behind my screen is covered over by the screen itself and the contents projected onto it.

Plato's *metastrophe* anticipates what, centuries later, Kant would call the critical turn. Explaining the nature of this turn, Kant compared it to the Copernican revolution in astronomy. It is generally known that the sixteenth-century Polish astronomer Copernicus inverted the way we depict our solar system, from geocentric to heliocentric. But the true Copernican revolution, as Kant understood it, is something more fundamental, *transcendental*. To use the Platonic vocabulary, it is not only a revolution in the *visible* world but a move beyond or beneath this world altogether: it is not only a revolution in what we see but in the way we see, in the way we think or understand what we see. What enabled Copernicus's new empirical vision, according to Kant, was his discovery of *perspective* as what inevitably orients our understanding of the visible world in its entirety. The same empirical and mathematical data, Copernicus realized, undergoes radical transformation in its meaning according to how we conceive the position and movement of the spectator to whom this data is presented. Copernicus thus "dared, in a manner contradictory to the senses, but yet true, to seek the observed movements, not in the heavenly bodies, but in the spectator" (*CPR* 25n). Long before Albert Einstein and Thomas Kuhn, Kant made the case that all scientific revolutions worthy of the name abide by this same principle of *reflection*. A scientific revolution, perhaps any revolution at all, involves the theorist's recognition of her own influence on the theoretical field, her own agency as observer of that field and its objects.

Kant's analysis of the Copernican revolution reiterates a claim originally made by Plato. "Is knowledge a power?" Socrates asks his companions in the *Republic*. "It's a power [all right]," they answer, and "the [most powerful] of them all" (*R* 1104). Conceived as a power (*dunamis*)—or a "faculty," as Kant would call it—knowledge is not merely an accordance with the way things are; it is, rather, what *conditions* their appearance in the first place. Knowing thus becomes an *active* principle, and the critical turn is a matter of turning our understanding of knowledge (or theory) on its head, from the order of effects (empirical facts) to the order of causes (transcendental conditions).

Knowledge-as-power is nothing but the spectatorial position *understood* as active and, in this respect, "free" (self-determining). I italicize the word *understood* because the truth is that the spectatorial position is already active from the start. Without the spectator's cognitive activity, no spectacle would be possible, not even inside the figural "cave." Similarly,

without our succumbing to deception (our "naivety"), we could never be deceived or manipulated. The prisoners in Plato's cave are thus the agents of their own deception, and all it takes to free them is to show them that they *are spectators*. Kant described the advent of enlightenment: "[A] light broke upon all students of nature. They learned that reason has insight only into that which *it* [reason] produces after a plan of its own, and that it must not allow itself to be kept, as it were, in nature's leading-strings, but must show the way with principles of judgment based upon [its own] fixed laws, constraining nature to answer to questions of [its] own determining" (*CPR* 20).

Following such a critical turn, the spectator is no longer a submissive pupil of nature or society but their judge and critic. The world becomes a courtroom over which the judicious spectator presides. From here forward, the critic will take nothing simply or naively as a given but will inspect and suspect it. Behind every "so it is," she will seek the grounds, reasons, and causes: *Why* is it so? *How* did it become so? To what *end*? More important, she will ask: *Ought* it to be so? Is it *right*? And she will realize that *she* holds the power and the key, that the nature of *her* questions determines the kinds of answers that the "witnesses" (that is to say, anything admitted through the senses' gates) are allowed, indeed required, to provide. Enlightenment—the turn from passive spectator to critic—is a matter of properly recognizing our spectatorial nature and the spectacular nature of our world.

THE SIBLING RIVALRY OF THEORY AND THEATER

In his book on ancient Greek tragedy, Nietzsche tells us that Socrates represented a new type of person, "a type of existence unheard of before him . . . *the theoretical man*" (*BT* 94). Nietzsche sees the emergence of this new type as bringing along with it the *demise* of tragedy. Since tragedy was the original form of theater in ancient Greece, Nietzsche's suggestion is that theory, as represented by Socrates, *replaces* the theater. The truth is more complex. The very words *theater* and *theory* are bound together, sharing the Greek root *thea*, which, like its Latin equivalent *specere*, from which the words *spectator*, *spectacle*, and *speculative* stem, means "view." Both theory and the theater owe their being to the spectacle and thus to the presence of a spectator. This etymology helps us understand the intimate relation between critique and theory, and, as we will soon see, the intimate (if

fraught) relationship between critique and theater as well. It is not by chance that theory and the theater were born within the same (Greek) culture. As Hannah Arendt noted, the "passion for seeing [which precedes] the thirst for knowledge even grammatically in the Greek language, was the basic Greek attitude to the world" (*LMT* 130). Suggesting that the words *thēorein* and *theatron* are also etymologically related to *theos* (god), she added that, for the ancient Greeks, "whatever existed was supposed, first of all, to be a spectacle fit for the gods, in which naturally, men, those poor relations of the Olympians, wished to have their share" (131). Read the *Iliad* and you will see the human world as a Greek would have seen it: this epic poem tacitly positions its readers in Olympus, gazing down, with the gods, at the bloody yet glorious spectacle of their own history.

Greek society was a society of the spectacle. This is the culture that bequeathed us the Olympic games, amphitheaters, theatrical festivals, and other festive competitions (Greek theater was originally a competitive event; there were prizes for best playwrights and actors, somewhat like those reality shows where we watch live performances together with a panel of judges). It is also the culture that gave us philosophy, science, and Socrates, the "theoretical man." Although theory and the theater are siblings, daughters of *thea*, the relation between them, as Nietzsche observes, has always been antagonistic. Socrates locked horns with the tragedians, accusing them of passivating and manipulating the people with their emotional ploys, stifling their powers of judgment and critical thought. Centuries later we still find the cultural critic battling against the theater, as in the person of Jean-Jacques Rousseau, who complained that the theater spends up our natural capacity for pity on fictional characters, leaving none for our fellow humans: "daily in our theaters one sees, moved and crying for the troubles of an unfortunate person, a man who, if he were in the tyrant's place, would aggravate his enemy's torments even more . . . like Alexander of Pherae, who did not dare attend the performance of tragedy lest he be seen [sobbing] . . . whereas he listened without emotion to the cries of so many citizens murdered daily on his orders" (Rousseau 1964, 131). And as the theater gives way to other forms of popular public spectacle, from Hollywood cinema through television to social media, the critic is always there, ready to charge. Peter Sloterdijk suggestively describes the rivalry between the two registers as a kind of "media contest": "the resistance of the books against the amphitheater, and the opposition of the humanizing, patient-making,

sensitizing philosophical reading against the dehumanizing, impatient, unrestrained, sensation-mongering and excitement-mongering of the stadium" (Sloterdijk 2009, 16).

But if the theater and its technological descendants are common targets of critique, it is only because they are emblems of a spectacular world. In this respect, too, Plato's cave, which is structured like a theater, is evocative. Since the cave represents the visible world in its entirety, the latter can rightly be called *theatrum mundi*: a world-theater. If, as Shakespeare put it, "All the world's a stage / And all the men and women merely players" (Shakespeare 2014a, 683), then *theater critic* is but another name for world-critic. The irony is that, since theory is just as much a child of this world-theater, it is just as much a subject to the wrath of critics. Francis Bacon, early modern philosopher and one of the founding fathers of modern experimental science, coined the term *idola theatri* (idols of the theater) in reference not to theatrical but to *theoretical* works. All past philosophies "that men have learned or devised," he averred, are but "so many plays produced and performed which have created false and fictitious worlds" (Bacon 2000, 42). Bacon's critique of his theoretical predecessors (theater directors in disguise) anticipates later critiques of early modern philosophy itself, including Bacon's own. As these later critics will argue, Bacon and his contemporaries are promoters of false idols and theatrics, working to conceal their political, cultural, economic, gendered, and racial biases behind a facade of theoretical impartiality and self-knowledge.

As critical theorists, then, we attack all things theatrical, and fake, including theory itself (except our own). But we would be wrong to assume that in this "media contest" the theorists are the only agitators. The polemics between theory and theater, between critic and artist, have always been reciprocal. If the original critic (Socrates) attacked the tragedian, it was only to be attacked by the comedian (Aristophanes) in turn. We have a famous instance of such reciprocal contestation between artist and critic in Paul Gauguin's response to a critique of his work by André Fontainas: "Criticism of today," Gauguin wrote, "when it is serious, intelligent, full of good intentions, tends to impose on us [artists] a method of thinking and dreaming which might become another bondage" (Gauguin 2002, 20). Gauguin expressed his wish that the critic would consider minding his own business and leave painting to the painters. "A critic," he wrote, quoting Mallarmé, "is someone who meddles with something that is none of his business" (20).

But this, of course, was Mallarmé's point: meddling-in-someone-else's-business *is* the critic's business; as critics, we have no other "business" to attend to. Although few would deny that the great theorists have their own mediums, their own art form, this does not detract from the structural truth that the theorist—especially the critical theorist—*needs* completed works ("someone else's business") as substance for critique, material for her art. What we see in the case of Bacon—a modern philosopher who critiques ancient philosophies only to be critiqued by late- or postmodern philosophers in turn—is that the positions are relative and shiftable: what in one context counts as theoretical work, counts in another as art and thus an object of theoretical scrutiny. But relative and shiftable though they are, the structural opposition between critique and art, theory and theater, remains unchanged.

If it is true that theory is somewhat parasitic on the theater, it is also true that the theater feeds on theory in turn. As Nietzsche saw it, to his dismay, Socrates not only "meddled" with Greek art; he deeply transformed it. We observe such transformation in Nietzsche's portrayal of Euripides, the last of the great tragedians. By the time of Euripides, tragedy was already a well-established institution, of which Euripides, searching for his own artistic identity, became increasingly critical. As a young man, and still a member of the audience, he would watch the tragedies of his predecessors with consternation: "how dubious [their] solution of the ethical problems remained to him! How questionable the treatment of the myths! How unequal the distribution of good and bad fortune! Even in the language of the Old Tragedy he found too much pomp" (*BT* 80). For years he "sat in the theater, pondering uneasily . . . as a spectator" until one day, emboldened by an alliance with a similarly minded critic, Socrates, Euripides finally found courage to "venture from his solitude [and] to begin the tremendous struggle against the art of Aeschylus and Sophocles—not with polemical essays but as a dramatic poet who opposed his conception of tragedy to the traditional one" (*BT* 80). This narrative calls to mind France of the 1960s, where similarly frustrated (and ambitious) film critics, taking learned and moral issue with existing cinema, decided finally to drop their pens and pick up the camera themselves, creating the first truly *theoretical* cinema, which we now call the New Wave (*La nouvelle vague*).

There are other cases of a theoreticalization of theater, perhaps the most monumental of which is found in Shakespeare, in whose Hamlet the

"theoretical man" becomes not only a director but also a character—the protagonist—of the play. This most self-reflective, indeed Socratic, of tragic heroes, takes it on himself to produce and direct a play within the play and then, sitting in the audience, proceeds to observe the reactions of the other spectators (one spectator in particular) around him. In this metareflection or series of reversals, we witness the theater reflecting back to the spectators their own spectatorial being while at the same time reflecting on the spectacular being of the theater itself. This is tragedy undergoing a critical turn and beholding its own (tragic) downfall as it does:

> . . . the native hue of resolution
> Is sicklied o'er with the pale cast of thought;
> And enterprises of great pith and moment,
> With this regard their currents turn awry,
> And lose the name of action. (Shakespeare 2014b, 755)

The truth is that theater was never far removed from theory, not even in the heyday of the Old Tragedy. A structural symmetry, a dialectical unity of opposites, was visible from the start. Aristotle's account of tragedy makes tragedy's own dialectical features all but explicit, as it underscores the role played in all tragedies by *discovery* (enlightenment) and the subsequent *reversal* "from one state of things . . . to its opposite" (*P* 1465). Case in point is Oedipus's discovery of his true identity: he was blind, but now he sees, his enlightenment all at once killing the deception that had grounded his sense of self and agency. The ironic difference is that instead of the higher vision promised by theoretical enlightenment, Oedipus's tragic enlightenment results in yet another blindness, except that this one is real rather than metaphorical, and is self-inflicted.

BETWEEN SCOPOPHILIA AND SCOPOPHOBIA

So theory and theater dance their war dance, turning first against and then into each other, and if it is true that in the *theatrum mundi* "all the men and women are merely players," it is no less true that they are all potential *critics* of the play and of their world. One could even say that the increased sophistication—indeed, the "enlightenment"—of modern cultures has rendered critique, no less than spectatorship, something of a natural attitude. Plato's prisoners grow up naive and susceptible; ours

grow up critics. And if one expects that such thorough entrenchment of critique in the fabric of our culture might finally help it overcome its spectacular nature, or at least its cave-like enchainment, one will be in for bitter disappointment (again). Spectacularity, propelled by and propelling technological advancements, seems only to intensify with each critical and revolutionary turn along with the fury of its critics. Not only are new media and imaging technologies continually devised, but the very structures of visibility appear to be revolutionized in the process, undergoing their own reflective/critical turns, as if the dialectical progress of our critical maturation were continually checked by a parallel progress in the means of our subjugation. Bernard Harcourt tells us just such a story. In modernity, he narrates (following Michel Foucault), the grand spectacles of ancient cultures were turned "inward," manifesting in increasingly intricate modes of surveillance such as the prison, hospital, asylum, school. Now, in our *post*modern condition, this structure is once again reversed, this time turned "outward," as state-sanctioned surveillance gives way to the obsessive self-recording, self-exposing, and selfie sharing of the social media. We have thus entered what Harcourt calls the age of "virtual transparency":

> Today, a new digital way of life dominates in most advanced-capitalist liberal democracies and in many other places around the globe . . . a rich social, professional, personal and political circuit of text messages and e-mails, digital photos and scans, PDFs, Skype calls, Facebook, and Twitter, a world of Google and Bing searches, and pings, and Snapchats, of digital subscriptions, Flickr photos, Vimeos, and Vines, of Instagrams, YouTube videos, and webcams. . . . It is a new world in which we expose ourselves and our most intimate desires and every activity. (Harcourt 2018, 377)

On the face of it, the availability of and free access to ever-growing mountains of information are an important step in the enlightenment of the general populace—the invention of the internet serving the same role as the invention of print did some centuries ago in spreading and democratizing knowledge. But for the critic, ever the scopophobe, this transparency only conceals a deeper, oppressive essence: "Google collects and mines our g-mails, attachments, contacts, and calendars. . . . Twitter tracks our Internet activity on all the websites that carry its icon. . . . And . . . the NSA has practically free access to all of this information." The "scope of

surveillance" and the "possibilities, reach, and amounts of data are simply staggering" (Harcourt 2018, 377–78).

In these lines we witness the familiar rivalry between the critical theorist and the chieftains of the world-theater, but more important, we come face to face with the critic's structural *ambivalence* toward the spectacle. At the same time as he critiques the practices of exposure, Harcourt *enacts* them: *he exposes,* lays bare, brings into view what is hidden. Critical theory, as a critique of the spectacle, turns the spectacle on its head, as one turns a rock over to see what lurks underneath. By doing so, critique does not put an end to the spectacle (or the tragedy) but *radicalizes* its visibility. The scopophilic fantasy that reigns over both sides of this dialectical campaign is of complete visibility, transparency, light. The dream is to finally make visible even, or especially, that which is structurally invisible.

TWO

Critique of Power or
the Power of Critique

He who wishes to know the truth about life in its immediacy must scrutinize its estranged form, the objective powers that determine individual existence even in its most hidden recesses.

—THEODOR ADORNO, *MINIMA MORALIA*

Not the gods, not nature, but only man himself can be this alien power over man.

—KARL MARX, "ECONOMIC AND PHILOSOPHIC
MANUSCRIPTS OF 1844"

The previous chapter explored an ambivalent relationship toward the spectacle that is inherent to critique: critique's native ground is the spectacle, which it needs to overturn as one turns over a rock to expose what lies beneath. This motion of exposure, like the theoretical creed, is itself spectacular. In the end, as critics, we are always spectators and can have no other reality but the spectacle, to which we stand in a relation of opposition and exposition. But what is it like to *live* in this spectacular world? We now turn from spectacle to spectator and from the spectator's ambivalence regarding the world to her ambivalence regarding herself. The spectatorial self, the

self of the critic, is always split, redoubled. Self-estrangement produces a feeling of powerlessness, even with respect to the inner recesses of the self— one's own desire and will. At the same time, this estrangement ushers in a longing for unity, autonomy, self-control. Since the opposition of the self and to the self cannot be overcome, unity is only achievable if one side of the self takes over—reigns over—the other. This, too, is a dance, a never-ending choreography of reversals.

THE VISIBLE SELF AS LACANIAN IMAGO

To broach the problematic of the spectatorial self, let us return to the cave and consider the prisoners' sense of themselves. Noting that the prisoners in the cave might be able to converse with each other, Socrates asks Glaucon, "Don't you think they'd suppose the names they [use apply] to the things they see passing before them? . . . And if their prison also had an echo from the wall facing them, don't you think they'd believe the shadows passing in front of them were talking whenever one of the carriers passing along the wall [behind them] was doing so?" (*R* 1133). Socrates acknowledges that the prisoners themselves are speaking, yet, oddly, he seems to attribute the echoes from the wall only to the voices of the "puppeteers" behind them. This probably betrays a limit to how far this metaphor can be extended to sustain the phenomenon it needs to represent. The difficulty pertains to the way the prisoners situate *themselves* within the theater of shadows. Insofar as they are unaware of their condition and equate reality with the spectacle before them, they must attribute their thoughts, perspectives, desires, and conversations to the shadows as well. More specifically, they would have to identify themselves with certain shadows. How is something like this possible in the "real world"? It is not hard to imagine that the things I see before me and believe to be real are only shadows, but in what sense am *I* a shadow? What am I a shadow of?

The psychoanalyst Jacques Lacan is an instructive guide in considering this riddle. Lacan saw the emergence of something like a spectatorial orientation in what he called the mirror stage, the stage in which "the human child, at an age when he is [still] outdone by the chimpanzee in instrumental intelligence, [begins to] recognize his own image as such in a mirror" (Lacan 2007, 94). Playing and experimenting with their mirror-selves, infants jubilantly assume their "specular image," although in truth they are

"still trapped in [their] motor impotence and nursling dependence" (94). The mirror stage may pass, but selfhood is forever doubled, split between the self that looks (consciousness) and the one that appears, and neither of the sides is in full self-possession. On one hand, the latter has the advantage of *appearing* whole, but it is only an appearance, an image. Like the mirror-image it is "activated" by the looker. The looking self, on the other hand, has the advantage of owning the look and of being the activator of the image but is itself disembodied, disconnected. Suggestively, Lacan says that the specular image of the self becomes "the *threshold* of the visible world" (94, italics added). This means that our access to the visible world is mediated by this proxy, this messenger inside, which connects us to the world, but at the same time marks our permanent sense of removal from it. With respect to the "visible world," the self is consigned to a limbo between identification and alienation.

Lacan refers to the specular-self as *imago*. Living, working, and moving in the world, this self is always being overlooked or enacted as if by someone else, almost like an avatar in a computer game or a "residual self-image," as it is referred to in the Wachowskis' film *The Matrix* (1999). The sense that the *true* self (consciousness) is somehow a puppet master of the visible one can perhaps explain our elaborate practices of playacting and self-decoration (clothing, makeup, tattooing), as if we were living dolls and action figures. It also accounts for our relatively loose attachment to this particular image and for our capacity and even tendency to identify so deeply with other images, like the characters onscreen or onstage. I remember how, as kids, coming out of a Jackie Chan film, my friends and I would immediately proceed to kickbox the trash bins outside the theater. It is as if our bodies became extensions of the bodies on the screen, activated by some external impulses. Jean-Louis Baudry (1974) and other critics of the French New Wave noted that this deeply visceral identification—which meets us at the very core and threshold of our subjectivity—is responsible for the unusual ideological sway that theater and the cinema hold in shaping our sense of self and, with it, the values and ideals through which we see and understand the world. Movies are powerful shapers of consciousness, ideological machines. Technological developments and improvements do not change the essence but only deepen the hold of the artificially directed spectacle.

While the visible self can take up and shed forms, and is more or less easily manipulable by spectacular means like the cinema, the invisible, dis-

embodied self acquires a sense of *absolute* freedom and untouchability. The doubling of the self makes possible the assumption of a critical distance from the entire set of conditions in which the visible self is inevitably caught up: historical, cultured, gendered, sexualized, and racialized. (As critics like Mulvey [2009] and Yancy [2016] have shown, gendering, sexualization, and racialization apply not only to the *visible* self but to the *threshold*—to the very relation between the one looking and the one looked at. There is a whole politics of visibility whereby, even within the spectacle, some "imagos" are designated as the owners of the gaze while others are consigned to be the objects of the gaze, a dynamic that constitutes a "transcendental gaze"— omnipresent, invisible, disembodied—which is nevertheless gendered and raced, that is to say, male and white, and we could add able-bodied and other traits that are not truly transcendental. But this politics of the gaze cannot be understood without prior consideration of the constitutive split of the self and the image of power to which it gives rise. We will get to this later in the chapter.) Along with its isolation, and perhaps loneliness, the disembodiment of consciousness, or the onlooking self, also makes possible, in principle, the assumption (in both senses of the word) of a universal position: impersonal, unconditioned, and unbiased. In turn, the visible, situated self becomes the object of intensive theoretical analysis. "I have placed myself above the human within me and I study it," says one of the characters in a story by Jean-Paul Sartre (Sartre 1969, 41). The human condition is thus split between the observer and the observed, that which studies and that which is studied.

The doubling of the self and the alienation/identification structure imply the perennial power to be or become *otherwise*. If, as Sartre put it, I am never what I am and am always "what I am not" (Sartre 1993, 67), then no identity I assume would *authentically* represent me. Within this recognition lies a dissatisfaction, a sense of self-betrayal or falling short, and an imperative to change myself, or to *become* myself. And since this visible self that I must change is the threshold to the visible world, this task at the same time involves the need to change the world.

Especially suggestive is Descartes's portrayal of the human being— defined as a "thinking thing"—as a perpetual *dreamer*. Descartes ascertained that for consciousness, it is roughly the same whether its contents are real or oneiric; our dreams can feel dauntingly real. But what is it that makes a dream a dream and a dreamer a dreamer? Dreams are

only loosely governed by the causal imperatives of reality and history. They take their materials from reality, but, like the painter, they often radically transfigure them. Descartes's suggestion that we are somehow essentially dreamers and our world essentially a dream carries within it the promise of our becoming the (re)creators of our world. Indeed, it is only a dreamer in this metaphysical sense who could utter such revolutionary words as these: "I have a dream that one day every valley shall be exalted, every hill and mountain shall be made low, the rough places will be made plain, and the crooked places will be made straight. . . . And when we allow freedom to ring . . . we will be able to speed up that day when all of God's children— black men and white men, Jews and Gentiles, Protestants and Catholics— will be able to join hands" (King 2003, 219–20).

The dreamer is free to dream; her vision is bounded neither by existing social hierarchies nor even by natural disparities, like those between the valleys and the mountains. To know that humans are dreamers in this sense, it suffices to look down from the window of a plane shortly after takeoff on a bright day with good visibility. Look at how we modify our environment for better and for worse, how we transform entire landscapes into tapestries of geometrical shapes. We are potentially self-determining and, by extension, nature-determining. Only the spectator, the disembodied visionary, can feel this kind of power and responsibility, and only with respect to a spectacular world, an envisioned one, a world that is always between reality and dream. Behold, then, the two extremes in which the spectacular self is caught up: on the one hand, a shape-shifter, a shadow, or a puppet; on the other, a potential master, a lord of almost unbridled power and freedom. For the exact same reason that the cinema- or theatergoer can be manipulated to assume certain values and personas, she can also take charge of her own life and world, assuming other values and personas. There are two very different kinds of "dreamers"—those who live like they are sleepwalkers, entirely immersed in the spectacle, and those who are visionaries, those who actively dare to dream.

This opposition presents an alternative: who controls whom? Am I a creature of something or someone else, some external power, or am I a creator? As Kant put it, the question is whether the subject is to remain "in nature's leading-strings" (CPR 20) or rather turn this relation *around*, putting nature and one's animal self within it in one's *own* leading-strings. Kant termed these two alternatives *heteronomy*, which means being subject to another's

law, versus *autonomy*, which means giving oneself the law. Notably, both alternatives involve *a law*. One way or another, the spectatorial self is placed under constraint, under control, even if this control is its own. This explains yet another eternal truth in Plato's allegory—namely, the relationship between spectatorship and *captivity*. Why is it that enlightenment must be portrayed as coming out of captivity? Why is it that the spectator-critic must begin her career as a "prisoner"? How is the spectatorial position, and by extension the orientation of critique, linked to the problematic of captivity and liberation? We can explain this link on two different levels: essential and inessential. The inessential link between spectatorship and imprisonment pertains to the precritical state of being a *passive* spectator, naively sold on the *idola theatri* of the day. This link is inessential because it is the one that the philosopher-critic can and must fight to overturn. The spectator can become active and has the power—the power of knowledge—to achieve this transformation. But there is also an essential link that remains irreversible, as it belongs to the very constitution of the spectatorial position. Just as the spectator remains a spectator even after liberation (as we saw in chapter 1), there is a sense in which she likewise remains *captive* even after liberation. At least a part of her must always remain in the cave and in chains. Just as the reality of the spectator maintains an intrinsic relationship with fantasy or dream, so her freedom is bound up with captivity. This is at least one way to understand the timeless words of Jean-Jacques Rousseau: *L'homme est né libre, et partout il est dans les fers.*

MIND OVER MATTER?

Greek mythology tells us of a horrible Sphinx, a she-monster with the body of a lion and the wings of an eagle, who was in the habit of harassing travelers to the city of Thebes. The only way to get past the Sphinx was to solve her riddle, but anyone who ventured to do so and failed would be promptly eaten by her. Desperate to free themselves of this menace, the Thebans offered a handsome prize: whoever solves the Sphinx's riddle will become king of Thebes. One visitor, named Oedipus, was brave enough to take up the challenge and was confronted with the following riddle: "What goes on four feet in the morning, two feet at noon, and three feet in the evening?" The answer is a human being, he said: in the morning of life he crawls on fours, in the noon of life he walks on two, and in the evening

of his days he is assisted by a third leg—a cane. This answer was correct, causing the Sphinx, who was not one for half measures, to commit suicide and the Thebans to herald their new king. I wonder if the moral behind this riddle and its solution may be that the human being is *not* defined by the number of its legs (say, as a bipod) but by its vision and thought. We are spectators morning, noon, and night: we become spectators before we can walk; we remain spectators when we begin to walk; and the spectator in us often outlives the walker. The dissonance between our legs (representing our footing *in* the world) and our eyes (representing our transcendental grasp *of* the world) is a tragedy unto itself, which might explain the fact that no matter how wise Oedipus was, and how adept at solving riddles, one thing that remained hidden from him was the preset trajectory of his life, including the fact that a stranger he had previously killed was his father and that the queen of Thebes, whom he was about to marry, was his mother.

Just as the "moving picture" is at the same time immobile, so we as spectators remain "immobile" in an existential sense even when we are moving about. This immobility can again be illuminated through Lacan's account: he argues that because the human animal is born prematurely—that is, prior to developing the capacity to stand, walk, or have motor control— there is "a certain dehiscence at the very heart of the organism, a primordial Discord [already] betrayed by the signs of malaise and motor uncoordination [of the infant]" (Lacan 2007, 96). This is the original charm of the mirror image since, unlike the disjointed mess of sensations that the infant must be feeling, its mirror self seems surprisingly "together." Responding to the infant's cues and transforming its awkward, half-voluntary jerks into an impressive show of finesse and self-containment, the "ideal-I" in the mirror, as Lacan calls it, serves to placate the infant's malaise at being helpless. An important aspect of Lacan's account is the claim that the ideal-I retains this placating function as we mature. The infant's jouissance vis-à-vis its mirror self remains a fertile breeding ground of fantasy life, nurturing a host of fantasies and fetishes—oneiric, cinematic, pornographic, and others—all involving visual pleasure associated with a sense of dominance and control. But this sense is illusory. In truth, immobility reigns on both sides of the equation: the imago can only be moved by the real self, and the real self can only "move" via its imago. The imago is but a puppet on strings, and the strings are held by the hands of an all-too-human limited puppeteer.

Schopenhauer conceived of the sides of this duality as will (*Wille*) and intellect (*Intellekt*). The tragedy of the human condition, per Schopenhauer, is that these two can neither agree nor even properly communicate with one another. Ever the supplier of memorable images, he portrayed the relationship between them as a "strong blind man carrying [a] sighted lame man on his shoulders" (Schopenhauer 1966, 209). While the will has the legs (moving power), the intellect has the vision (awareness and reason). Just picture the two of them: the diminutive Intellect, seated on the Will's broad shoulders, yelling its heart out, kicking and striking its carrier to no avail. "Stop!" the Intellect commands; "Why don't you obey me? Why won't you listen to reason? Can't you see you are walking us straight into a wall? We will both suffer and die if you don't come immediately to your senses!"

This image is of course exaggerated. The will is not stupid; it has designs of its own. But the feeling of lacking control over one's own desires and impulses, and moreover, failing to understand one's desires and impulses, and even one's behavior, is, I think, a familiar, and a rather daunting, one. The estrangement of the will is one of the central expressions of the spectatorial orientation. Although the Greeks did not quite have a concept of the will, the struggle out of which the modern notion of the will was born was hardly foreign to them. In another of his timeless allegories, Plato likened the soul to a chariot pulled by a pair of winged horses driven by a charioteer. To distinguish the nature of *our* chariot—the human soul—he contrasted it to that of the gods. Whereas their horses and charioteers are "all good and come from good stock," ours are a motley crew. For one thing, our charioteer is "in charge of a pair of horses" rather than only one, and, to make things worse, "one of [our] horses is beautiful and good . . . while the other is the opposite and has the opposite sort of bloodline" (*Ph* 524). Plato's image thus complicates Schopenhauer's, turning the soul into a trilogy rather than a duology. Instead of one will, we have two conflicting *kinds* of desire. One of them—a white horse named *Thumos* (passion)—represents our potentially noble desires, those that we share with the gods and that elevate us above other animals; the other—a dark horse named *Eros* (or *Epithumia*)—represents our baser desires, our libido and appetite, that bespeak our lack rather than plentitude. Since a chariot cannot move in two directions at once, the question is which of the two horses gains the upper leg (or the upper wing as the case may be). This intervention is the job of the charioteer, who stands for reason—*logos*, or elsewhere *nous* (intellect). Our

poor charioteer is charged with the task of overseeing and mitigating two potentially opposing pulls. It therefore stands to reason that chariot driving in our case is "a painfully difficult business" (*Ph* 524).

One fascinating aspect of this image is the fact that the horses, which perhaps anticipate what psychoanalysis calls "drives," are not the ones doing the *driving*. The essence of the chariot metaphor is the insertion of a driver *behind* the drives. Nietzsche saw in this a Socratic innovation: "While in all productive men it is instinct that is the creative-affirmative force, and consciousness [is only there to act] critically and dissuasively, in Socrates it is instinct that becomes the critic, and consciousness that becomes the creator—truly a monstrosity" (*BT* 88). Consciousness is thus positioned *behind* the deed not as a seer but as the agent par excellence—the only kind of agency worthy of the name. This idea anticipates our notions of choice and deliberation.

Unlike the figure of the charioteer in the *Phaedrus*, Socrates's self-portrayal in the *Apology* seems more in line with Nietzsche's idea of what consciousness *truly* is and ought to be. There, he presents his relationship to the city of Athens as that of a gadfly to "a great and noble" horse, one "somewhat sluggish because of its size." In this image, not only is there only one horse, but reason as the "gadfly" is not tasked with *driving* the horse but, on the contrary, with stirring it up, rousing, persuading, and reproaching it all day long (*A* 28). One sluggish horse and a gadfly, two winged horses and a charioteer, one strong blind man and one small lame man—whichever image we choose, and whichever way we choose to configure the power dynamic among the agencies, what remains constant is the oppositional relationship between reason/consciousness and its other, which it must rein in or, at least, must try to do so. The duality of and opposition between the white and black horses in Plato's chariot image is not a deviation but an alternate development of the same oppositional logic. True to the dialectical form, it complicates the primordial opposition between reason and desire by locating the opposition on one side (that of desire) and rendering the other side (that of reason) an opposition *to* opposition, establishing the unity of opposites. Reason is allotted dominion *over* a scene of opposition and strife, rendering its position that of a third—a reconciler or arbitrator. Reason is thus an opposition to opposition, a double negation. Intelligence is the overseer, that which stands opposite to reality itself in that recusal of the observer that is the hallmark of visibility.

Christian theology is profoundly Platonic in this sense: foregrounding the spectatorial orientation, it is forced to grapple with the same primordial opposition. The Platonic antithesis between the nobler and baser parts of the soul becomes in Christianity a war between "flesh" and "spirit." No one in the Christian tradition managed to convey this inner dissonance and alienation more powerfully than Saint Paul, who lamented: "I am carnal, sold under sin . . . for what I would, that do I not; but what I hate, that do I." He then immediately qualified: "it is no more *I* that do it, but sin that dwelleth in me" (Romans 7:14–16, italics added). Later, paraphrasing Galatians 5:17, Saint Augustine narrated the consequence of original sin, wherein "the flesh [began] to lust against the Spirit in which strife we are [all] born, deriving from the first transgression a seed of death, and bearing in our members, and in our vitiated nature, the contest or even victory of the flesh" (*CG* 380). Acknowledging this strife impels the deeply introspective—personal, psychological, existential—self-examination that is Augustine's *Confessions*. "Assuredly Lord," he writes there, "I toil . . . within myself" (*C* 202). "I have become a question to myself: and that is my infirmity" (*C* 217). We recognize here something akin to the duality of "horses" within the soul, which becomes a decisive moral opposition between evil and good—between lustful desire and the wholesome passion of the spirit. What diminishes in this Christian tradition is the role of reason and the very idea of *balance* or arbitration. One side must win, and "sinfulness" is the name for the perverse situation in which the essentially baser evil side overcomes its better.

This doctrine acquired a secular form in Kantian ethics, which modified the terms of the opposition while retaining the oppositional dynamic. Human motivation is split between duty (*Pflicht*) and inclination (*Neigung*). Although we can experience both strongly as *internal* dictates, the former follows from the autonomous, universal decrees of reason, and the latter stems from animalistic, pathologically conditioned, or otherwise selfish interests. Kant's view of the human condition is by no means as pessimistic as Paul's, since we are not born in sin but in a state of relative dependency or immaturity that, as rational beings, we have the power to check if not control. One way or another, though, the message is the same: moral life is caught in oppositional strife. Whatever shape it takes, the dialectical vision of the human condition as steeped in strife and opposition—reason against instinct, noble against base desire, spirit against flesh, will against

inclination, intellect against will, and so on—betrays the malaise of the spectatorial orientation: the severance of eyes from feet. Running through these oppositions like a thread is an opposition between the ruling and the ruled: the *unity* of these opposites is the opposition, dialectical reason, itself. Freedom, as conveyed in the idea of autonomy, is conceived almost necessarily as an *over*turning and, in turn, a ruling-*over* the self, a reign that, even if attainable, can never be final or secure, always subject to upheaval.

POWER OVER POWER

Implicit in the foregoing discussions about the split of the self and the struggle for rule is the problematic of power, which I now take up more explicitly. Along with its dialectical logic and split sense of self, critique conceives of power as sovereignty—a rule- or power-over. As I see it, this conception of power arises from the *powerlessness* involved in the splitting and alienation of the spectatorial self, be it individual or communal. Consciousness, while it fosters the illusion of absolute freedom and control, lacks "feet" in the world and is in that sense constitutively powerless. It therefore experiences power in and through opposition, in terms of a struggle, a relation to be overturned.

Although power can manifest in different ways and spheres, its paradigmatic ground is political. So if the previous discussions focused on the struggles that plague the individual soul of the spectator, the following discussion of power requires a collective framework of consideration. A sociopolitical analogue of the strife between intellect and will is that between the critic (revolutionary, progressive) and the powers-that-be (antirevolutionary, reactionary, conservative). The former wants change, equality, justice, which ought to be the *common* interest. The latter, ever nearsighted, wants nothing but to maintain its power, its habits, its traditions, and its direction at all costs, even as it marches straight into a catastrophe; and "the people," the body politic, similarly blind, lend their support to those in power even as they abuse and mock them. Schopenhauer's image is as evocative here as elsewhere: if we take his "strong blind man" to stand for the public ("the will of the people"), then the small lame one seated on his shoulders is the critic, reproaching and cajoling to no avail. With this image in mind, we would do well to acknowledge that the Left (anarchist, socialist, or liberal) does

not have monopoly over critique. The conservative Right is often oriented in the same way even as it is faced in the opposite "direction." In its own mind, *it* is the one that stands on the side of reason in opposition to the will of the people, including the multitudes of unmotivated poor, not to speak of immigrants, gang members, and potential terrorists—a will that is capricious, inscrutable, and unpredictable. And if for the socialist critic there is a cabal of capitalist elites who manipulate the will of the people in favor of its own interests, for the conservative critic there is a cabal of cultural elites, including the left-leaning critics, doing the same. The very opposition of Left versus Right is generated by the orientation of critique, reflecting an oppositional splitting of the people (the collective subject) in its attempt to control itself.

Much depends, of course, on where we situate ourselves as critics within this dynamic. It is often the case that, rather than wholesale identification with one of these oppositional poles, we regard the entire "political" scene with some dismay. Even more generally, we have a conflicted relationship to power as such, regardless of who is "in" power. In many cases the tacit assumption is that power is mindless; hence, intelligence is powerless against it. Power thus becomes the enemy, the main target, of critique.

As we saw in Plato's chariot image, the primary opposition between the charioteer, representing reason, and the horses, representing desire, is mirrored and redoubled in a secondary opposition between the horses, or desires, themselves. In a similar way, the primary opposition between critique and power is mirrored and redoubled in an oppositional conception of power itself. As suggested by Plato's choice of image, power is understood as a matter of *reining*, as one would rein in a horse. Two things are implied here: first, that power is essentially a power-*over*—namely, a matter of control if not oppression or suppression. As such, power is necessarily two-sided—the reining and the reined, the oppressor and the oppressed. Second, *reason*, and, as we will now see, *judgment* and *justice* as well, is itself a figure of power and rule, although its role will be to reign over, or rein in, power itself. I name this function of reason and justice "power over power."

One of the emblems of the mythical figure of Themis, the goddess of justice, is the scale, which signifies the tacit assumption—again intimated in Plato's portrayal of reason as a charioteer—that justice is essentially a matter of arbitration between warring sides. The image of justice as a scale posits the existence of oppositionality and antagonism not simply as a matter of

fact but of structure. A scale is an apparatus with two sides, one of which is elevated when the other is lowered, and vice versa. *Elevation*, like *reign*, is a term of comparison: one side of the scale is "higher" *because* the other is "lower" and vice versa. The symbol of the scale also conveys the identification of justice with *equity*. As a measuring instrument, and an exact one at that, the equity of the scale calls for comparison to a mathematical equation, which likewise has as a matter of structure two opposing sides. There are two possibilities: either one side, x, equals the other, y ($x = y$), or it doesn't. If the sides are unequal, we again have two opposing possibilities: either x is lesser than y ($x < y$) or greater than y ($x > y$). Like the pillar from which the scales hang, the mathematical symbols ($=$, $<$, $>$) belong to neither of the sides; the symbol is strictly a term of comparison, making explicit the *relation* between the sides. This is also the place of reason—a place of neutrality, of the ratio (reason originally means "to count"). The good judge, like the mathematician in this regard, does not (or is not supposed to) pull weight in favor of any side but rather exercises reason to tell whether the sides are equal or unequal, lower or higher. Justice is thus closely associated with correctness, and the apparatus of the scale provides a visual illustration of this link as well, specifically, of the meaning of justice as "right." *Right*, which shares the same root as the word *straight*, is the state of *equilibrium* (literally, "equal weight"), in which the two plates are level and aligned. This alignment or straightness *is* justice, in the same way that the lines on this page are "justified" on both sides.

In her other hand, the goddess of justice carries a sword. The sword of justice is not a sword of war (unless it is a just one) but a sword of peace. Yet peace, as Michel Foucault put it, is "a form of war" (Foucault 1984, 65), insofar as it does not undo the opposition itself but marks the state in which the opposing sides are not at each other. So Themis's sword is the one to break all other swords or, rather, to ensure they remain in their sheaths, for all other swords but hers imply war, and war (unless justified) means that one side overpowers the other. Justice has only one enemy: injustice, and injustice, as disequilibrium, is power-over, one side having too much power. Her sword is a symbol of power but a power over and against power itself. And just as peace is a form of war, Themis's sword is a constant reminder that power can be (*ab*)*used*, and, in fact, since power exists as power-over and imbalance, it paradigmatically manifests itself in forms of abuse and oppression.

There can be other ways to envision power, for instance, as productive or creative. But the image of power operative in critique is oppressive on the one hand and, to use Foucault's terms, *negative, juridical,* and *prohibitive* on the other. In Foucault's view, this conception of power can be traced back to the institution of monarchy in the Middle Ages. He tells us that in the absence of empire and in face of the existence of multiple principalities with conflicting interests, monarchy was instituted out of a need for an arbitrator, an essentially neutral but supreme authority. This institution "presented itself as a referee, a power capable of putting an end to war, violence, and pillage [and to] struggles and private feuds"; it thus "made itself acceptable by allocating itself a juridical and negative function" (Foucault 1984, 63). Monarchy was not *itself* an interest, or not a positive one at least; rather, its function was to mitigate all interests, creating an image of the *common good*. In subsequent eras, this institution came to inform political theory's conception of power itself, as it comes to bear in the concepts of sovereignty and the rule of law and as extended by the theories of right.

Suggestive though it is, I would take this history with a grain of salt, at least as far as the *origin* of the conception of power and justice go. My earlier discussions about the soul's inner struggles, whose portrayals reach as far back as antiquity, indicate that what we are exploring here are psychological, theological, political, and institutional *manifestations* of a fundamental orientation of being and thinking, to which this oppositional-antagonistic conception of power and justice belong. And since it is a product of an orientation, the origin of this conception of power and justice is not historically localizable. A couple of examples from ancient mythology may suffice to suggest that the representation of justice as monarchic rule, and of monarchic rule as juridical, does not first surface in the Middle Ages. A much earlier monarch-judge is the biblical King Solomon, who is said to have been divinely inspired and the wisest of men. He was wise enough to ask God to make him wise: "Give . . . thy servant an understanding heart to judge thy people, that I may discern between good and bad, for who is able to judge this thy so great a people?" God, duly impressed by his request, said unto him, "Because thou hast . . . not asked for thyself long life; neither hast asked riches for thyself, nor hast asked the life of thine enemies; but hast asked for thyself understanding to discern judgment . . . I have given thee a wise and an understanding heart. . . . And I have also given thee that which thou hast not asked, both riches, and honor" (1 Kings 3:9, 11–13). It matters

to this story, of course, that Solomon is not driven by private interests but by the public good. What makes him both a good monarch and a good judge is his dispositional impartiality: he is not motivated by or for power. Only such a man can truly make for a genuine sovereign, representative of God on earth. In Hesiod we find a similar image of the king as divinely inspired with the powers of judgment:

> When the daughters of great Zeus ... honor a [king]
> Whose lineage is divine, and look upon his birth,
> They distill a sweet dew upon his tongue,
> [So that] from his mouth words flow like honey. The people [then]
> All look to him as he arbitrates settlements
> With judgments straight. He speaks out in sure tones
> And soon puts an end even to bitter disputes.
> A sound-minded ruler, when someone is wronged,
> Sets things to rights in the public assembly,
> Conciliating both sides with ease. (Hesiod 1993, 63)

Here we again find the notions of "straightness" and "soundness" and setting things right, as well as the divine lineage and inspiration that set the king apart from other mortals, in the position to judge their affairs fairly, without taking or being a side.

Another instructive portrayal of monarchy in Greek mythology is found in Plato's *Gorgias*, where Socrates tells us of three great kings who preside over the crossroads between life and death: Rhadamanthus, Aeacus, and Minos. Two opposing roads converge into the crossroads, one from the East (from Asia) and the other from the West (from Greece). Two other roads lead out of the crossroads: one goes to heaven, the other to hell. At the crossroads sit the three kings, and "each of them with staff in hand renders judgments" (G 867–68). Rhadamanthus, king of the East, faces eastward, welcoming the souls arriving from Asia. Aeacus, king of the West, faces in the opposite direction, welcoming the souls of the departed Greeks. The two kings bring these souls "to a halt and [study] each ... without knowing whose it is" (G 867). Their nescience of the soul's identity—analogous to Themis's blindfold—helps ensure their judgment is just. A righteous king— ironic though it may sound—must be status-blind; whether the soul he's judging belongs to a pauper or to a great ruler ought not to make any difference. Somehow, these statuses do not apparently have any impact on

their *souls*, which alone concern the king in judgment. He "doesn't know a thing about [a person] except that he's somebody wicked [or] one who has lived a pious life" (*G* 868). Meanwhile, the third king, Minos "oversees" the other two, transcending even the opposition between East and West. Like reason, or justice itself, he is a king over kings and a judge over judges.

In these mythical portrayals, we witness the same irony that Foucault means to invoke in his history of the monarchy—the king-judge, who has so much power he has rule even over life and death, is allegedly *beyond* power, blind to power, or rather in judgment *of* power. The contradictions that ensue from this abound: the kings are status-blind, but their own status and authority is as uncontestable as a divine lineage and inspiration. True knowledge of good and evil is somehow bound up with ignorance, while true vision is prefigured as blind. Such is the monarchical image of justice and right, of truth and knowledge. The despotic rule of objectivity is equally indifferent to all subjects and all interests. Such also is the "sound common sense," which is apparently authorized by no one in particular yet bestows on the few who are wise or fortunate enough to possess it the last authority to judge. Here we have the notion of an authority so supreme it is not an authority at all, simply an extension of the way things are or ought to be.

We recognize this power-over-power, or righteous power, in the moral and epistemic superiority we assume as critics, who not only place the common good above our own but also find ourselves in the position to *know* what the common good is and *personify* it. We regard our sense as commonsensical, even if it is anything but common. And although what makes power problematic on this orientation is that it is a power-*over*, an imbalance and excess, the power of reason, judgment, and justice is itself a power-*over*, as all power in this orientation must be; it is still comparative and antagonistic. There is even something potentially *un*just about it, to the extent that good judges are the few rather than the many. Consider, for example, that if the vocation of the critic is to expose, it is only because the truth is commonly hidden. This is also the reason why we commonly associate the label and function of "critic" with that of the connoisseur or expert, and indeed, an authority—a position acquired through training and accreditation. Yet this expertise is regarded as the mark of achieved neutrality, the capacity to rise above one's narrow, private interests and judge things objectively.

It would perhaps not be too much of an overreach to recall that the prac-

tice of *pollice verso*—the turned thumb, which was adopted by film critics and more recently became the signature emoji of Facebook—was started in the Roman amphitheater, which often featured spectacles of bloodshed. The emperor would turn his thumb (sometimes by the prompting of the crowds), deciding on a gladiator's fate: thumbs-up he lives, thumbs-down he dies.

I am suggesting that the affinity between critic and emperor is not incidental but structural. But the superiority of the critic is often wishful. It is a superiority over society rather than *in* it, and a presumptive superiority over reality rather than anything real. It is perhaps little wonder that our feeling of righteousness as critics is often coupled with a two-pronged indignation—at the corruption of power that we see everywhere, and at our sense of powerlessness to change it.

THREE

Critique of Injustice or the Injustice of Critique

> He who does not understand how brutal and unintelligent history is
> will never understand the stimulus to make it intelligent. . . . What
> amount of rationality can we expect to find arising out of . . . veiled
> and blind existences as they work chaotically with and in opposition
> to each other?
>
> —FRIEDRICH NIETZSCHE, *WE PHILOLOGISTS*

> Only through time time is conquered.
>
> —T. S. ELIOT, *FOUR QUARTETS*

As we saw in the previous chapter, there is a split at the heart of the specta-
torial self that induces a conflictual relationship to the will. In *Thus Spoke
Zarathustra*, Nietzsche paints an interesting picture of this predicament.
Zarathustra, surveying the war zone we call human existence, sings to his
disciples a melancholy tune: "Truly, my friends, I walk among human beings
as among the fragments and limbs of human beings! This is what is most
frightening to my eyes, that I find mankind in ruins and scattered about as
if on a battlefield or a butcher field. And if my gaze flees from the now to the
past, it always finds the same: fragments and limbs and grisly accidents—but

no human beings!" (Nietzsche 2006, 110). Zarathustra introduces a crucial aspect to the story: *time*. This, truly, is our predicament as spectators, for in relation to time, he says, "the will itself is . . . a prisoner. . . . Impotent against that which has been, [the will] is an angry spectator of everything past. . . . It cannot break time and time's greed. . . . That time does not run backward, that is its wrath. 'That which was'—thus the stone is called, which it cannot roll aside" (110–11).

The will is constitutively caught up in a contradiction. As the English word suggests, the will looks forward, at what *will* be; but alas, the current of time, with its defiant "it is" and "it was" insists on flowing *backward* against the will, paralyzing it, cutting its wings, rendering it useless, wishful, or in denial at best. But the will is nonetheless a will, and it can will itself differently. According to Zarathustra, it can either remain an "avenger" and a hater of life, or it can overcome itself and become "redeemer." The secret recipe for this overturning, per Zarathustra, is the capacity to will *backward* instead of forward.

Although the irreversibility of time first appears to be an emblematic expression of our powerlessness, time and history, as conceived under the spectatorial orientation, carry the promise of ending the alienation that plagues the spectatorial soul, the promise of unification and agency. Hegel argued that the actuality of history exists in hindsight. Only in retrospect can we conceive the whole and the purpose that has been driving the process from the start. History thus reveals itself as rational, purposive action. This opens a way to address the difficulty outlined in the previous chapter, namely, how to overcome the split within being and thus satisfy the aspiration to complete vision that is inscribed in critique's orientation. Without such unity, there can be no agency or self-possession—precisely the kind of power and rule *over* (the self) to which critique is committed.

This chapter argues that the possibility of self-unification involves the postulation of sin or injustice. This claim introduces yet another aporia at the heart of critique's orientation. If injustice is a necessary condition for the attainment of a sense of agency, what does it mean for the agent's fight *against* injustice? Addressing this question, I will draw a link between historiographic critique—in the style of Hegel and Marx—and the practice and tradition of confession. To this end, the chapter begins with Saint Augustine.

CRITIQUE AS CONFESSION: FROM ORIGINAL
SIN TO ORIGINAL INJUSTICE

The main premise of Augustine's *Confessions*, and of the practice of confession in general, is the doctrine of original sin. On the face of it, the sin is "original" in the simple chronological sense of being the *first*—the initial transgression of our ancestors in Eden, which, like a big bang of sorts, set human history on its fallen path. But the sin is original in a metaphysical sense as well, as the constitutive structure of human existence. This sense is suggested by Augustine in the opening statement of *Confessions*, when he declares that our very mortality is both the outcome and the evidence of our primordial sinfulness (*C* 3). In "Thy sight," he says to God, citing *Job*, "there is none pure from sin, not even the infant whose life is but a day upon the earth" (8). Birth itself, and the life that follows, leading to inevitable death, is a crime; suffering, labor (in both senses of the term *labor*), and awareness of death are the punishment for this crime of being human. The biblical narrative illustrates this fact: we have fallen from the Edenic eternity *into time* only *because* we have sinned, which means that, far from a specific event that happened *in* time, sinfulness is the condition for the possibility of our temporal existence. As I will argue, it is also the condition for the possibility of *overcoming* time, along with sinfulness.

To be sure, we do commit particular sins, and every confession commences with recalling and naming them. In Augustine's case, the first major sin he recalls is a childhood episode in which he and some friends stole unripe fruit from a neighbor's orchard in the middle of the night. When I first read this, I recalled a similar event in my own childhood, when I conspired with some friends to steal popsicles out of an ice-cream freezer on the front porch of a small store in our hometown. When the store was closed, the porch was sealed behind a barred fence. Our arms were skinny enough to reach through the bars and into the freezer. Like Augustine, I remember well that it was not the popsicles that motivated our escapade so much as the excitement of the theft, which was a bonding experience. "We carried off an immense load of pears, not to eat—for we barely tasted them before throwing them to the hogs. Our only pleasure in doing it was that it was forbidden. Such was my heart, O God, such was my heart" (*C* 27). Such, I guess, was my heart as well. It is remarkable, isn't it, that this parallel experience is shared by people separated by millennia: the biblical Adam and Eve in

the Garden of Eden, the late antique Augustine and his friends in North Africa, I and my friends in Israel of the late twentieth century. And this shared experience always involves theft, always food, always collaborators. Why? We can give this pattern psychological and sociological accounts, but Augustine's point is ontological or, as I would say, orientational. There is something about the *seeing*, the coveting, and then transgressing, reaching out to the other side of "the screen" (the fence in my case), snatching, and finally interiorizing—literally, *digesting*—what is there, which suggests the dawn of a spectatorial sense of agency. Devouring the barred spectacle, we unite with it and with each other.

More important than the act of stealing, however, is the act of confession. For the purposes of confession, the precise nature of the sin is secondary. The question for the Catholic confessor is not whether she has sinned but only whether she *acknowledges* her sins, repents for them, and confesses them in search of atonement. While the sins to which we confess—the *contents* of each confession—must be concrete and specific down to minute details, our *being sinners* is a preconfessional premise. We have already encountered a similar structure in Horkheimer's statement that I unpacked in my overture and restate here: "When an active individual of sound common sense perceives the sordid state of the world, desire to change it becomes the guiding principle by which he organizes given facts and shapes them into a theory" (Horkheimer 1975, 161–62). As is the case with original sin, the injustices that critical theory exposes must be specific and concrete, down to the minute details. But the unjust*ness*—the sordidness of the world—is a pretheoretical premise. Perceiving unjustness instigates the *drive* for the theoretical activity, just as acknowledging sinfulness instigates the drive for confession. It is not far-fetched to argue that if the premise of the confession is an original sin, that of critical theory is an *original injustice*.

If the failure to acknowledge and confess to one's sins is *itself* a sin, or further evidence of one's sinfulness, the failure to perceive and expose injustice is itself an injustice—an acquiescence if not complicity. A symbolic expression of the fact that it is a sin not to confess is that the Catholic confession begins by stating how long it has been since one's last confession. The truth is that one cannot possibly confess frequently enough, as that would mean confessing all the time, leaving little time to do anything else, including committing sins about which to confess. This conundrum further illustrates the structural nature of sinfulness and, moreover, its intrinsic

connection to the nature of *time*. The sin, and arguably any action that merits the name, is always in the *past*; it is only adequately recognized for what it is when it reaches completion, through reflection and recollection. It needs to be *exposed* (by confession or by some theoretical act) because there is an essential hiddenness to it at the time of committing it. There is an old Chinese saying that if the deer knew how fast it was running, it would stumble and fall. It is the same with any action, which must be unreflective if it is to be carried out with conviction and to its full effect. Nietzsche wrote:

> We are unknown to ourselves, we men of knowledge. . . . Present experience has, I am afraid, always found us absent-minded: we cannot give our hearts to it—not even our ears! Rather, as one divinely preoccupied and immersed in himself into whose ear the bell has just boomed with all its strength the twelve beats of noon suddenly starts up and asks himself: "what really was that which just struck?" so we sometimes rub our ears *afterward* and ask, utterly surprised and disconcerted, "what really was that which we have just experienced?" and moreover: "who *are* we really?" and, afterward as aforesaid, count the twelve trembling bell-strokes of our experience, our life, our *being*— and alas! miscount them.—So we are necessarily strangers to ourselves, we do not comprehend ourselves, we *have* to misunderstand ourselves, for us the law "Each is furthest from himself" applies to all eternity—we are not "men of knowledge" with respect to ourselves. (Nietzsche 1989, 15)

One does not truly *know* that one is sinning, and this fact is part of what renders the action sinful: "My sin was all the more incurable because I thought I was not a sinner" (*C* 86). But this is also because knowledge itself, as Nietzsche suggests, requires hindsight, an ex post facto realization of what at present lies behind a veil of ignorance, unconscious. Consciousness ("knowledge" in Nietzsche's account) is thus belated, a delayed effect, always catching up after unconscious deeds and experiences. Initially, or originally, there is no doer *behind* the deed; the doer only comes after, inserted through guilt. "What did I just do? And why did I do it?" This, then, is the premise of the original sin: one is always a sinner as expressed in the fact that one *exists over time*, temporally disjointed. Consciousness itself, in the mode of reflection, is therefore always in some sense a confession, and the structural impossibility of a full confession is the impossibility of full transparency, or indeed unity, before the self, others, and God.

The homology between critique and confession does not stop at the postulation of sin or injustice. Horkheimer's statement makes clear that while injustice is the impetus for it, the desire *to change* the world serves as the organizing principle for theory. There can be no doubt that the same holds true of the confession: the desire to change one's life and, in the case of Augustine's publicized confession, to change others' lives as well, is the organizing principle of confession. There is no point in confessing for confession's sake, in simply acknowledging one's sins. The point of a confession, to paraphrase Marx, is not only to *interpret* one's life but to *change* it, to *convert*. We can therefore give a Catholic rendition of Horkheimer's statement: When an active individual of faith realizes the sinfulness of her life, desire to change it becomes the guiding principle by which she organizes past events and shapes them into a narrative: the confession.

The acts of conversion and confession are therefore intrinsically bound up with one another, and it is not an accidental feature of the *Confessions* that its author was himself a convert. He was a "pagan," a Manichean, who relatively late in his life (at the age of thirty-one) converted to Christianity, making it his special mission to convert others. His *Confessions* could have equally been titled: *Why and How I Converted to Christianity (and Why and How Everyone Should Do the Same).* Even though those who are baptized and raised as Catholics may attend confession as a matter of course and never experience something like conversion, just as those who are born in a communist state may not experience anything like a revolution, the conversion or revolution remains the organizing principle. Each act of confession commemorates and reconfirms the original conversion. More precisely put, conversion is the structural *telos*—the end or purpose—of confession, just as the sin is its structural *genesis*, the beginning; and, in the order of speculative or dialectical reasoning, the *telos* has precedence over the *genesis*. The end makes sense of the beginning.

This, I take it, is the true or structural meaning of "conversion"— reversing time, installing the end in the beginning. We saw versions of it in the first chapter, in the metastrophic turning around of souls in Platonic education and the critical turn in Kant. In all these cases, we are dealing with the need to turn passivity into activity in the alchemy of the soul, making consciousness the cause rather than the effect, the judge rather than a witness. Augustine asks his soul: "Why, O perverse soul of mine,

will you go on following your flesh? Rather turn, and let it follow you [*Ut quid perversa sequeris carnem tuam? Ipsa te sequatur conversam*]" (*C* 64). The wordplay in this passage is on the terms *perverted* (*perversa*), which describes the sinful condition in which the order of things is the opposite of what it should be, and *converted* (*conversam*), which describes the straightening up of this condition, putting it *right*. What makes the existing heirarchy perverse in this sense of being upside down is that "the part that rules" (the flesh) *ought* to be "the part that serves" and vice versa, because the latter (the soul in this case, spirit in others) is not only better and truer but stronger as well (*CG* 258). Only under the guidance of spirit can the soul rise above the antagonism between its warring "parts." But note also that all of this happens *in* the soul. The entire confession is the soul's soliloquy, taking stock of its different parts and the relations among them. "I toil . . . *within myself*" (*C* 202, italics added).

Conversion is therefore not merely the empirical event of "becoming Christian" but the soul's assertion of its unity, taking stock, and thereby ownership, of itself. This is not a onetime occurrence but a recurrent logic and progressive movement that runs through Augustine's *Confessions*: his narrative proceeds through a *series* of microconversions that, until the final one, keep falling back and getting overturned. "My soul turned and turned again, on back and sides and belly, and the bed was always hard" (*C* 114). This is what it feels like at the time, but in hindsight, the soul is constantly learning, growing, and becoming stronger and wiser in the process, closer to itself. The "bed" of time remains hard, but with each turn, the metastrophic logic of the *turning* becomes increasingly transparent, recognizable to itself, and to the reader as well. Each turn increases self-consciousness, along with the sense of unity of self and narrative and clarity of purpose. The condition of time—mortal (and thus sinful) existence—is in the process of being overcome or overturned through the recognition of something that is not subject to it.

If the guiding principle of this confessional historiography is sin or injustice, it is because sin and injustice are *the seeds* of autonomous agency, whether individual or communal. "I have become a question to myself: and that is my infirmity" (*C* 217). It is also the key to your salvation. Sin is nothing but autonomy and community in a perverted state, the state of looking backward, which in its very structure demands, and makes possible, *conversion* into straightness—determining itself consciously and

in advance. This principle works as follows: the act of confession generates a split between a before and an after, a past and a future, rendering the present not simply the future of the past but its *end* or *telos*. The end of the process (the confession) is the process itself seen *as* a process; as such, the end is the process internalized, digested, rationalized. This is what every theory does. It organizes facts and events that would otherwise be dispersed or disconnected into a coherent and unified account of cause-and-effect. The confession is no innocent "retelling" of one's life; it is an organized and principled *theory* of life and the conditions for the possibility of self-possession and power over life. The confession makes a properly human form out of "fragments and limbs and grisly accidents" (Nietzsche 2006, 110).

We now need to directly confront the connection between sin and agency or power. As soon as sin is acknowledged as such, the misery of mortal life turns from a series of grisly accidents and meaningless facts— indeed, meaninglessness itself, a life without reason, purpose, or cause— into something reasoned. In *City of God*, Augustine describes the nature of mortal life: "In the whole course of this life (if life we must call it) its mutability tends towards death . . . daily becoming less and less; so that our whole life is nothing but a race towards death, in which no one is allowed to stand still for a little space, or to go somewhat more slowly. . . . [Man] begins to die so soon as he begins to live. . . . Man, then, is never in life from the moment he dwells in this dying rather than living body" (*CG* 377). Life, he adds, is but a "train of evil, which, with its concatenation of miseries, convoys the human race from its depraved origin, as from a corrupt root, on to the destruction of the second death, which has no end" (380–81).

Everything changes as soon as this life is seen as *sinful*. Sin implies agency. Whose agency? Mine. Sin makes life mine—my doing, my work, even if at the time I had no idea what I was doing and could have done nothing else. In confessing, we only *own up* to an already existing agency. "Is this boyhood innocence?" Augustine asks looking back at his life, and he answers: "It is not, Lord" (*C* 20). It is not even boyhood, not from where we sit. Like many biographies and autobiographies, especially those in the tradition of the bildungsroman, confession is a matter of arranging one's life and history around the guiding principle of becoming-agent. In the beginning, this agency is implicit, dormant, latent, unconscious. But this seeming innocence is but a failure to know what the writer and readers

know and is therefore guilt. It is not that this "wretched soul of mine" was not *there* but that it was not in control or in a state of self-knowledge. Just look at it, through the window of your memory: how it lets itself be led astray, not even realizing as much. We look back at it, calling it, and it looks away from us. It doesn't hear; it doesn't see; it doesn't know we're there, this wretched soul.

The upshot of this mode of self-narration is that if the suffering, the "train of evil" that is this life, is essentially one's own doing, it can be *forgiven*; what is "perverted" can be straightened, for conversion is already inscribed in its designation as perverse. There is no forgiving suffering—you do not choose it and cannot unchoose it—but *doing* can be forgiven and thus forgotten or overcome, at least it makes the suffering just, deserved, sensible—a punishment. Time itself is punishment for a primordial *deed*. If the genesis of a confession is a sin, its telos is forgiveness: "*Forgive* me, Father, *for* I have sinned." He who has sinned, and furthermore confessed his sins, will be blessed. "We have no fear," Augustine writes, "that there should be no place of return merely because *by our own act* we fell from it: our absence does not cause *our home* to fall, which is Thy Eternity" (*C* 72, italics added). So if sin is the origin of time, the reason for our temporal existence, then atonement opens the promise of eternity. "For the wages of sin is death; but the gift of God is eternal life" (Romans 6:22–23). Sin, and following it time, is thus like the ladder that must be climbed only to be tossed aside as soon as we have reached our goal—the return to our proper abode.

THE COLLECTIVE CONFESSION:
FROM AUTOBIOGRAPHY TO HISTORIOGRAPHY

Let's look at "perversion" once more. How does the weaker part manage to subjugate the stronger? The key to answering this question lies in the fragmentation of the self, or of the soul, which, lacking unity, is unable to pull itself together and gain control. To begin with, life appears to be a scattering of moments, experiences, events, desires, forces. Recall Lacan's comments about the infant who is uncoordinated and lacks control over its own body, all but literally dismembered. By the time we gain some form of self-consciousness, there are already multiple immemorial influences branded so deeply in our body and mind that we can never fully distinguish

outer from inner, poison from cure. We are reminded of this fragmentation, this lack of control, each time the flesh rebels within our soul, as we suffer involuntary movements and sensations, unwanted flow of liquids, and all sorts of infirmities, discomforts, and pains. In Augustine's lament: "Man is a great deep, Lord. . . . The hairs of his head are easier to number than his affections and the movements of his heart" (*C* 67–68). It is in this "deep" that Augustine's *Confessions* wallow, tossed about in the stormy waters of his childhood and youth, searching, aimlessly at first, for the lighthouse symbolized by a distant *Thou*. This "Thou" is God, but implicitly it is just as much the adult, converted, Augustine, the narrator himself who awaits his wayward doubles—his older selves, or aborted attempts at a self—to reach up to him, culminate in him, result in him. He is, initially, a distant lighthouse, dim and far. To be "lustful, that is darkened, in heart, is to be far from Thy face" (*C* 19). "You . . . [see] me far from You stumbling in that slippery way, showing amidst much smoke some small spark of honor" (*C* 55–56). We must have faith that he ("Thou") is indeed waiting there with tender face and open arms for the errant narrative threads to enter his embrace. The narrator knows this moment is coming because he has already lived it, but the protagonist(s) of the narrative do not, nor do the readers. They are still (unknowing) sinners, stumbling and blind, but, as such, they also elicit our compassion—so many antlers of a poor soul, lost to itself in the night. How can one not have mercy on this soul? How can one fail to forgive or to perceive its lostness as its own worst punishment?

The lack of unity of self is at the same time a lack of purpose, for the purpose *is* the unification. The good thing is that this purpose does exist, since this is life-confessed, and, as such, it is started from, and guided by, this purpose. The purpose is there but not yet in view; this is the meaning of lostness. Augustine also describes this lostness as being *turned-around*, not simply *lacking* direction but searching in the *opposite* direction. We thus read about "the crooked ways of those who walk with their backs towards You and not their faces" (*C* 28), and we learn that "when we are *averted* from Thee we are perverted. Let us now *return* to Thee, O Lord, that we may not be overturned" (*C* 72, italics added). The connection between these two aspects of waywardness—fragmentation and being turned-around—lies in the fact that the "opposite direction" just *is* the direction of multiplicity rather than unity. This includes, for example, the effort to please others, whose demands are conflicting and shifty, or to satisfy one's sexual impulses, which are the

same. Thankfully, this perversion is structurally disappointing, since it is never possible to please everyone—people do not agree in their judgments and wants—or to satisfy all of one's desires, since they are conflictual among themselves. The increased disappointment therefore motivates an increased desire for a more meaningful, cataclysmic, change.

Recognizing this dialectic of the many and the one at the heart of the notion of lostness and perversity is a good point to transition from individual confession to collective confession, as expressed in the dialectical historiography of Hegel and its adaptation by Marx. The *collective* confession is, in fact, the higher form, since it not only collects the warring parts of a self but warring selves, selves that are helpless and lost because they fail to recognize their essential community. Like the individual confession, the collective confession is a tale told from the vantage point of the end, of its completion; like so many Hollywood films, it is a tale of woe and conflict foreshadowed by a looming resolution and a happy end, a purifying, curative tale. In Hegel, the "wretched soul" is the soul of the world, which he called *Geist*. The problems of Geist are similar to those of Augustine's soul. It needs to wrestle itself out of dispersal and helplessness in a natural state and restore its more proper abode, which it has lost. As Hegel poetically put it: "Being-at-home-with-self or coming-to-self of [*Geist*] may be described as its complete and highest end. . . . Everything *that from eternity* has happened in heaven and earth, the life of God and all the deeds of time simply are the struggles for [*Geist*] to know itself, to make itself objective to itself, to find itself, be for itself, and finally unite itself to itself" (Hegel 1995, 23, italics added).

Like the confession, the narration and commemoration of history enacts an *introspective* inversion, rendering inner and spiritual what was originally experienced as outer, physical, incidental, haphazard, imposed. To emphasize this, Hegel plays on the German *Erinnerung*, which connotes "remembrance" and "recollection" but literally means "inwardizing": "The *inwardizing* in us of the Spirit which [in past ages] was still [only] outwardly manifested" (Hegel 1977, 456). Spirit is nature inwardized, made conscious, then self-conscious. Remembering the dead and the past itself—by story, art, writing, study—turns a mere corporeal and transient existence into something that endures, in principle, to perpetuity. There is always an expiration date on the body—as in the words of Paul, "To be carnally minded is death" (Romans 8:6)—but there is no expiration date on spirit.

Whereas the German *Erinnerung* suggests inwardizing, and thus sheltering and conserving, the Latin "recollection" suggests the *collecting* of disparate moments into unity. Commemoration, or collective memory as we now call it, is indeed a matter of community building and the construction of a community consciousness, the consciousness of *a people*. Outwardly, corporeally, we may be disparate and apart, but inwardly, in terms of our consciousness, shared memories, perceptions, and values, we are a collective. The recollection is thus both historical—collecting the moments of the past—and present-political—collecting the members of the community. Such recollection of the shared past, or rather, such retrospective generation of a shared story, sets the ground for an equally collective projection of a common future, as well as for collective action and self-governance.

In both the Hegelian and the Marxist dialectical narratives, historical progress is a matter of humanity gradually making its way toward unification and self-governance, maximal freedom from our natural state of being externally governed by forces, inner or outer, that are outside our understanding and control. Moreover, we are progressing toward recognition of this very progression, a proper understanding of our history *as* progressive. On the face of it, human history shows us no such (com)unity of purpose but, at best, a disparity among different groups and, at worst, antagonism, war, enslavement, oppression, exclusion, and mean-hearted exploitation of one group by another. But just like the confession, this study of history, while it focuses its attention on conflicts and injustices, shows the consistently dialectical *patterns* and logic of historical developments and thus allows us *to see past* these antagonisms into a greater unified whole and process. Specifically, it exhibits a purposeful (teleological) and progressive movement toward the conditions that enable inclusion, equality, collective action, and communal self-governance, as in the apparatus of the modern state and constitutional monarchy for Hegel or global communism for Marx.

The point of historical recollection is to recognize community not only among the slaves of the past, and certainly not only among the lords, but across *both* sides of the antagonism—the part that served and suffered and the part that ruled and inflicted suffering. They are *parts* of the same soul, or spirit. Without such recognition, there is no true meaning to "injustice," because injustice presupposes justice: a unified essence that the warring sides fail and betray. Justice, as suggested in the previous chapter, is a straightening up—like the conversion of a perversion (of justice).

The dispersed and conflicted groups of the human community, and their multiple ventures of conquest and subjugation, may appear to be arbitrary expressions of mutual hostility if not human evil. But dialectical historiography shows this dispersal as occurring on the basis of a self-ignorant, lost human *community*. Dispersal is in that sense not actual; it is merely apparent to the parties dispersed who fail to recognize their community as humans. The historiography thus collects the (apparently) disparate moments of the past and, at the same time, the apparently disparate members of the human community, showing the progression between the moments and the common motives of the members, of which they are ignorant. The perpetrators of history's atrocities are thus not the puppeteers but the marionettes on the strings of progress. This must be the case, for otherwise they would not *be* perpetrators. Injustice, like sin, is necessarily the result and evidence of ignorance; it is justice perverted, turned upside down. In effect, in their search for power, these perpetrators only *dis*empower themselves and disaggregate the human community to which they belong; they are turned in the opposite direction, the direction of dispersal rather than unity. But even with their backs to their true purpose, they are moving toward it (toward *us*, as the self-actualized community awaiting them at the finish line). After all, what is conquest if not the drive to globalization, toward unification? All those despots, those who enslave and murder their own kind (not knowing that they are their own kind), know not what they do. That they are misguided, wrongly turned, is clear from the fact that their despotism is short-lived and bound to be overturned, but also from the fact that it *is* despotic, one-sided, blind not only to its transience and finitude but to the essential community with those they oppress, *in whose realization alone can this finitude and mortality be overcome*. The bed of history stays hard, but with each minirevolution, with each new sociopolitical order, the true conditions for satisfying these needs becomes clearer and nearer.

Observing the confessional structure of critique's historiography, we should not be surprised that the young Karl Marx saw the task of "critical philosophy" as essentially a matter of (a collective) confession. Concluding a letter to his partner Arnold Ruge, in which he laid out his vision for their newly founded *Yearbook*, Marx wrote: "We can express the trend of our journal in one word: the work of our time is to clarify to itself the meaning of its own struggle and its own desires. . . . It is a matter of confession, no

more. To have its sins forgiven mankind has only to declare them to be what they really are" (LR 15).

It follows from this logic that the crime, *the injustice, is never simply or strictly of a particular cast of people* but of humanity as a whole, resulting precisely from its failure to recognize and then actualize its essential community. "The reform of consciousness consists *only* in enabling the world to *clarify* its consciousness, in waking it from its dream about itself, in *explaining* to it the meaning of its own actions" (LR 15, italics added). And it is not merely ironic that the downtrodden—those who have hitherto been most passivated—are in a much better position to recognize the collective agency of humanity and its historical march than the privileged ones are. The latter—engulfed in *illusions* of autonomy, agency, and control—are bound to dream on until forces external to them come to wake them. Needless to say, the critic or philosopher cannot achieve a reform of consciousness alone, any more than they can achieve collective action or revolution alone. "It can be only the work of united forces" (LR 15), but the critic can confess on behalf of the world, call out and explain its sins for what they are—being lost, dispersed, and turned around.

First Hegel, and later Marx and Engels, thus saw in their own work the culmination of a world-historical process. As such, their historiographies are not merely the products of their own situated perspectives but the work of Geist, or the human community, through them. They tell the story of how *we*, citizens of the modern state, or members of the Communist Party, and essentially all rational (conscious) members of the human species, have come to be, or will soon come to be, self-conscious and self-actualized as a collective. On this kind of posture, a disapproving Nietzsche commented: "High and proud he stands on the pyramid of the world process; by placing the keystone of his knowledge on top he seems to be calling to nature listening round about: 'we are at the goal, we are the goal, we are the completion of nature.' Overproud European of the nineteenth century, you are mad! Your knowledge does not complete nature but only kills your own" (Nietzsche 1980, 50). Perhaps we are all a bit "mad" in this way. Whether or not we see ourselves as the *goal* of history, we certainly conceive ourselves at its *end*. Who could possibly deny that they exist at the "front end" of their life process (if a process it is)?

Some may opine that I too easily conflate an ideological historiography such as Hegel's with a material-economical one such as Marx's. It is

undoubtable that the conditions for the possibility of progress and the understanding of its successive states differ significantly on these two registers, just as both differ significantly from Augustine's religious practice of confession. But the rationale and motor of the movement toward community and autonomy remains the same, even if for Hegel history has already reached its apex and for Marx it is only "the *pre*history of human society [that has come] to a close" (*CCPE* 5). It is in bad faith to highlight the Marxist claim that historical progress is contingent on the concrete development of material conditions while suppressing the premise that history exhibits a rational progression from implicit to explicit unity of species, a premise that doubles as the (desired) conclusion. The question is not what conditions make progress *possible* or impede it, but what constitutes "progress" in the first place. There is little point in denying that "material" economy and historiography involve *moral* commitments, even if they can be "determined with the precision of natural science" (*CCPE* 5). These moral premises, including the valorization of unity, agency, equality, and rationality, moreover, presume universal validity and cannot themselves be historical. The very task of critical historiography is to demonstrate that these principles *govern* history throughout.

A collective autohistoriography, and the postulation of progress (rather than, say, decadence), is not an indispensable feature of critique in all its iterations, but it is paramount for understanding its orientation and its aporetic relation to time. If time is a kind of illness—the condition of helplessness in reversing the deeds of the past and helplessness in predicting the deeds of the future—then salvation, as the ultimate objective of every confession, individual or collective, religious or secular, means overcoming time. A salvific historiography needs to establish that history is not a random series of occurrences or microhistories, that history is one and that it is not a mere story (*mythos*) but a rational progress (*logos*). Herein lies the secularized meaning of "eternal life": the desire to actuate, in theory, practice, or both, a timeless, universal moral knowledge under conditions that are neither timeless nor universal nor nearly as moral or as rational as we would have them be.

LEAVING NO SCARS BEHIND

By way of conclusion, let me rehearse the logic described in this chapter:

(a) The central problematic of confessional historiography is the structural belatedness and disjoint of consciousness and the apparent lack of unity or coherence in life and history. The problem, in other words, is that consciousness is *in* time, not before it. The confession interiorizes the external, converting life or history from something that has been suffered into something that has been done and is to be done—taking possession and ownership of it.

(b) The ultimate conversion is from the condition of a latecomer, who receives and perceives the world and the self as already there, to that of an agent, who rules or at least *knows* the rule (or that there is a rule): the cause and logic of her world. Confessional historiography is thus agentification, an assertion or insertion of subjectivity or substance "behind" the unceasing flow, transience, and groundlessness that is time.

(c) The postulation of sin or injustice (which ipso facto sets up the conditions for forgiveness) is the Archimedean point in which time is overturned. Thus understood, confessional historiography is *justification*, in the literal sense of *making just*, converting misery into sin or injustice by giving it meaning, and then sin or injustice into justice, given that justice is inscribed in injustice, just as conversion is inscribed in perversion.

(d) From the vantage point of the end—true enlightenment and conversion—we see that the true motor of history, including the history of injustice, is justice itself in search of self-actualization.

(e) Hegel admonishes the "beautiful soul" of those critics who stand stubbornly in opposition to a history of injustice, refusing to reconcile themselves to what they perceive as evil and irrational. It is only a matter of time before the "hard heart" of such a critic is broken and he joins the chorus of existence. "The breaking of the hard heart, and the raising of it to universality, is the same movement which was expressed in the consciousness that made confession of itself. The

wounds of the Spirit heal, and leave no scars behind. The deed is not imperishable; it is taken back by Spirit into itself, and the aspect of individuality present in it, whether as intention or as an existent negativity and limitation, straightway vanishes" (Hegel 1977, 407). Once it is understood that recognizing injustice is the necessary premise of a just or justificatory history, the injustice is not simply overcome but retroactively *vanishes* from the same vantage point that first posited it. This is why "no scars are left behind": in the broader scheme of things—the universal, the teleological—there was *never* any sin, only the limited perspective of individuals, groups, leaders who do not and cannot have proper grasp of the significance of their deeds, for they are puppets on the strings of progress. They are destined to die in the service of a spirit that marches on. This is one way of understanding the words of Jesus: "Father, forgive them; for they know not what they do" (Luke 23:34).

(f) The bed of history is hard. It is not possible to unify history, in practice or in theory, without committing violence. It is a kind of theft to interiorize the world. But when we apply the lessons learned by confessional historiography to the present and the future rather than the past, how can we blame a revolutionary or a missionary for making some human or other sacrifices or for committing local sins and injustices for the end of communal salvation? By the end, it will all have been worth it, confessed to, and explained; time will heal the wounds that time created and will leave no scars behind.

Critique of External Authority or the External Authority of Critique

EVODIUS: Now that you have pushed me into admitting that we do not *learn* to do evil, tell me: How is it that we *do* evil?

AUGUSTINE: You are raising a question that hounded me while I was young; when I was worn out it caused my downfall, landing me in the company of heretics. . . . And since such pains were taken in my case to set me free from that question, I shall guide you on the same route that I used to escape. God will be at hand and make us understand what we have come to believe. . . . [This is] the course prescribed by the prophet Isaiah, who says: "Unless you believe you shall not understand."

—AUGUSTINE, *ON THE FREE CHOICE OF THE WILL*

The postulation of an original sin, and by extension an original injustice, allows one to insert oneself retrospectively as the agent or cause of one's own suffering, as subject of one's own life. With this in view, we can say that the point is never to establish guilt so much as to establish agency. When agency has been established, one is good and ready to be "forgiven" for one's sins, just as once one has climbed a ladder, one can toss the ladder aside. A similar logic is conveyed in different ways in the various iterations

of critique: a negative trope such as captivity, sin, injustice, or ignorance is posited as a springboard for the effectuation of turning it around. In an oppositional logic, the positive is always achieved through the negation (overturning) of a negative. Thus, for instance, the first step of all critical theory, as taught memorably by Socrates, is to come to know that you do *not* know—to become disillusioned, disenchanted, alienated by the spectacle and the prevalent belief system. Regardless of how committed critique is to knowledge, the critic is always first and foremost a skeptic. Skepticism is the springboard for true knowledge.

In this chapter I want to examine how this principle works in a pedagogical relationship. It is one thing for a person to become a skeptic or undergo a critical turn, but how does one effect the same transformation in another? What is the critic like as a teacher? More specifically: since the value of autonomy, and the suspicion, if not downright rejection, of external authority, are intrinsic to the ethos and epistemology of critique, how does the critic as teacher or as missionary posit or justify her own external authority vis-à-vis the student or the person to be enlightened or converted?

IGNORANCE IS BLISS

Nowhere has the primacy of doubt in the quest of true knowledge been more emphatic than in the work of René Descartes, who, looking back, recounted the birth of his philosophical consciousness, or philosophical *conscience*: "Some years ago, I was struck by the large number of falsehoods that I had accepted as true in my childhood, and by the highly doubtful nature of the whole edifice that I had subsequently based on them. I realized that it was necessary, once in the course of my life, to demolish everything completely and start again right from the foundations if I wanted to establish anything at all in the sciences that was stable and likely to last" (*M* 12). Descartes confessed to being guilty of what is, in fact, a typical vice of the critic—procrastination: "But the task looked an enormous one, and [I] put the project off for so long that I would now be to blame if by pondering over it any further I wasted the time still left for carrying it out" (12). Once and for all, he must set about demolishing the edifice of his opinions so as to hit rock bottom and start rebuilding from there. This, of course, is no mere personal anecdote but a principle. Knowledge is in principle achieved in this order:

(a) Confessing to having allowed oneself to be deceived by the outside world and external authority (accepting falsehood as truth) →

(b) doubting everything one thought one knew →

(c) establishing *oneself* as the sole authority and ground for the possibility of building up true knowledge.

This logic is lifted right out of the *Confessions*, where we hear Augustine:

> I was ignorant. . . . The anxiety as to what I should hold as sure gnawed at my heart all the more keenly, as my shame increased at having been so long tricked and deceived by the promise of certainty, and at having with a rashness of error worthy of a child gone on spouting forth so many uncertainties as confidently as if I had known them for sure. That they were false, I saw clearly only later. Yet already I was certain that they were at least uncertain, and that I had taken them for certain . . . in [my] blindness. (*C* 99)

In Augustine it is also evident that the problem of ignorance is never only epistemological but also moral. If the epistemological order leads us from deception, through doubt, to knowledge, the moral-theological one leads us from sinfulness, through self-doubt, to faith. But whether moral or epistemic, the confessional device is unmistakable: the acknowledgment of deception already plants the seeds of knowledge precisely because it is a confession of *guilt*. It was *I* who accepted falsity as truth, *I* who allowed myself to be deceived. The implication is that there can be neither truth nor falsity without an "I" at the gate to admit or refuse an opinion, and *this*, as we saw, is the point of all confession—namely, the insertion of a subject and with it, an implicit assertion of power, authority, and agency. The eventual turnaround revolves around the axis of "ignorance," changing its meaning from passive (*not knowing*) to active (*ignoring*). The turn from one to the other involves a double confession that not only was I ignorant (blind) but that I was *willingly* if not knowingly so, even if only half-consciously: "already I was certain that they were at least uncertain, and that I had taken [these convictions] for certain" (*C* 99). It is thus not that I was passive but that I failed to act. I was not blind so much as I turned a blind eye. I was not innocent but feigned innocence. Above all, my ignorance pertained less to this or that fact than to my own agency in ignoring. The built-in irony is that this active ignorance is the very thing ignored, and we see here

the characteristic doubling of reflection that is constitutive of the critic's sense of self: looking at oneself looking, ignoring (or recognizing) oneself ignoring.

How is it that one can be the agent of one's own ignorance, even of being deceived? To understand this is to understand critique's conception of thinking as an essentially active mode of being. Descartes employed the hypothesis of a "malicious demon" to illustrate this point: "I will suppose . . . that not God, who is supremely good and the source of truth, but rather some malicious demon of the utmost power and cunning has employed all his energies in order to deceive me" (*M* 15). The upshot of this hypothesis is that, even if "there is a deceiver of supreme power and cunning who is deliberately and constantly deceiving me . . . [I must] exist, if he is deceiving me; and let him deceive me as much as he can, he will never bring it about that I am nothing so long as I think that I am something. So after considering everything very thoroughly, I must finally conclude that this proposition, *I am, I exist*, is necessarily true whenever it is put forward by me or conceived in my mind" (*M* 17). The implication of this argument is that there is a veritable gulf between the contents of my opinions, which can indeed be erroneous, and my existence itself, the fact that I am the one *having* and endorsing these opinions. The latter—my existence—is the holy grail; not even a god or a demon can penetrate there. No one has access to my being other than myself; therefore, no one can force me to think this way or that, to admit something *as* true if I refuse to.

The thinker, then, retains exclusive access to and authority over the interiority, the enclosure, the privacy of her mind. With respect to what presses itself from without, the thinker can always refuse entry, while whatever stems from within, from the mind itself, is strictly and wholly under her control. No one can *think* for me or in my stead, regardless of how much power they have and how much power I have. It is a matter of principle, of *being*, not of *power*; this, I take it, is the point of the omnipotent deceiver hypothesis. In that sense, the mind is akin to a cave, one's own private cave, and we can consider Plato's cave as an allegory for the soul or mind, except that this introduces a new problem: who are the "puppeteers," the deceivers within the privacy of my cave? Who are these malicious demons? For Socrates, the answer seems clear: what truly keeps the prisoners of the cave "in fetters" is the force of their own desires, their own attachments, their ethical and epistemological *commitment* to the spectacle and the petty plea-

sures it involves. Consider the truth of this: How many times have you been annoyed at someone who "ruins" a film for you, whether by loudly eating popcorn behind you or telling you, or the person sitting next to them, what is about to "happen"? What is it that they ruin if not the illusion, the immersion? Is there anything sweeter than illusion, than being deceived?

Marx and his followers pointed out a variety of emotional shackles that keep us fettered to and enamored by ideological deceptions. These include "religious fervor . . . chivalrous enthusiasm . . . philistine sentimentalism . . . egotistical calculation" (CM 475), and as per later Marxists, there is a whole industry of entertainment, consumption, and manufactured consent, including the cinema and its ever-proliferating extensions. Less than like shackles, they function like opioids: on the one hand desensitizing people to their and others' plight and, on the other hand, exhilarating them, inspiring them with the relentless urge and urgency typical of all kinds of addiction. In the words of Adorno and Horkheimer, "The pernicious *love* of the common people for the harm done to them outstrips even the cunning of the authorities" (DE 106, italics added). Ideology, in short, is not a simple falsehood but a veritable *charm*. But if this is so, then the actual deceivers—the crafters and propagators of ideology—may well be mere people of service. Rich, powerful, and self-interested though they may be, they fulfill a social function larger than themselves and their interest. They are cogs in the deception-machine they help craft and sustain. If "Big Business" or soulless billionaires did not exist, someone would have to invent them or take on their role. Not the directors and producers but the spectators and consumers of ideology are its true agents; this hypothesis recapitulates that of the original sin: it's on us.

But why? Why is ignorance such "bliss"? Why does it *appear* to be bliss, or why do we pretend and lie to ourselves about it being so, if it really is misery? The answer, as I see it, lies in critique's understanding of desire and its role in the construction of our image of the good. As we have seen, ignorance or deception, being sinful, is not merely lack of knowledge but lopsided, *perverted* knowledge, one that constitutes evil *as* the good. This kind of false knowledge comes with moral investment; one does not simply commit or participate in injustice but is committed to it, takes pleasure in it. It is this fact that makes one's sin, as Augustine claims, "incurable." You cannot cure a person who does not feel sick, even less so one who actually feels *good*. Here, the critic, or the one who wishes to enlighten or convert

others, encounters *resistance, opposition*, not a "captive audience" but one that is held captive by the enemy.

We have already seen that critique has a troubled relationship to power and will. Let us take this opportunity to consider further its conception of desire. *Natural* desire on this orientation has a special proneness to addiction. What is addiction? Taking pleasure in what harms one; investing energy in what keeps one dependent, in chains. It is a *self*-destructive, self-deceptive urge. From an epistemological standpoint, what holds true of natural desire holds true of sensation as well. Our own senses, as Descartes noted, routinely show us what is false as what is true. The senses insist, for example, that the moon in the sky is the size of a large pie. They show us as moving what is, in fact, standing still. And they do not do it casually, lightly; the senses are utterly compelling. We believe nothing more readily than that which we can see and hear with our own eyes and ears. Not unlike a malicious demon lodged within, or always knocking at the gate, they lie to us constantly. And if sensory perception is vivid, how much more so are the other senses? Consider, Descartes beckons us, all those cases "when someone is tricked by the pleasant taste of some food into eating the poison concealed inside it" (*M* 58). While this can be due to innocence or lack of knowledge—after all, "what the man's nature urges him to go for is simply what is responsible for the pleasant taste, and not the poison, which his nature knows nothing about"—there are cases that are less benign: "Those who are ill, for example, may desire food or drink that will shortly afterwards turn out to be bad for them" (*M* 58). This type of illness is precisely what Paul and Augustine call the sinfulness of the flesh—namely, a perversion of our "affective barometer," whereby what is bad for us, or for our soul, feels good for us, and vice versa. All of this may suffice to alienate a person from their own body and desire, calling them to mistrust their own instincts. Yet it doesn't always effect such alienation, and when it doesn't, an intervention is called for.

THE RETURN OF THE CRITIC AND THE PAINS OF WITHDRAWAL

If ignorance is bliss and ideology is charm, if humans are born in sin and in a state of captivity to their own senses and desires, then how does one ever break out of this vicious cycle? What motivates one to undergo or undertake the "critical turn" out of a self-imposed passivity—that is to say, a false

sense of agency that is in fact a passivity (an agency that is ignorant of itself as such)? This is one aspect of the story of the cave that we have yet to tackle: the role of the critic or philosopher. To recall: once the prisoners shed their fetters, exit the cave, and see the light of the sun, they *return* to the cave to help others do the same. Then begins their ungrateful task of bursting the bubble of fake bliss and—as in every intervention for the addicted—informing people who claim to be content, or are at least self-assured, that they in fact have a problem. They are addicted, and they don't even know. To break out of the vicious cycle of dependency on dependency, to awaken the sleeping agent to its self-destructive tendencies, a foreign agent must intervene. Plato writes his allegory for future philosopher-critics, just as Augustine writes his *Confessions* for future converts and confessors, and Descartes writes his *Meditations* for future scientists. All these writers in their writing are performing a symbolic *return* to the cave of their own youthful ignorance and sinfulness to expose it for those who are still benighted, to help them out. The process is this:

Being held captive → Being liberated → Returning to liberate
others from their captivity

But this is no easy task. In fact, it is dangerous if not fatal. Plato observed, most likely with the fate of the historical Socrates in mind, that, initially, "anyone who tried to free them [the cave prisoners] and lead them upward [out of the cave]" would get *killed* if only the prisoners "could get their hands on him" (R 1134). This is how strong the force of illusion and perverted desire is over minds and souls; you cannot tell your benefactor from your opponent. In view of this force—and its violence—it is no wonder that our ungrateful job as critics, namely, helping others see what is best for *them*, requires a good measure of emotional violence and the exertion of a seemingly arbitrary authority on our part. It is, if you will, a preemptive violence, a just and justified violence. Surely, they will thank us later (although, to be honest, we're not doing it for pay or gratitude). Socrates asks us to consider the necessity of this violence:

> Consider . . . what being released from their bonds and cured of their ignorance would naturally be like, if something like this came to pass. When one of them was freed and *suddenly compelled* to stand up, turn his head, walk, and look up toward the light, he'd be *pained and dazzled* and unable

to see. . . . What do you think he'd say, if we told him that what he'd seen before was inconsequential, but that now—because he is a bit closer to the things that are and is turned towards things that are more—he sees more correctly? . . . Don't you think he'd be at a loss . . . ? And if *someone compelled him* to look at the light itself, wouldn't his eyes *hurt*, and wouldn't he turn around and *flee* [back] towards the things he's able to see, believing that they're really clearer than the ones he's being shown? . . .

And if someone [nevertheless] *dragged him away from there by force*, up the *rough, steep* path, and *didn't let him go* until he *had dragged him* [all the way] into the sunlight, wouldn't he be *pained and irritated at being treated that way*? (*R* 1133, italics added)

By Zeus, he would be irritated! Who wouldn't be? Note how each step on the rough, excruciating drag upward, toward the light, requires the liberator to exert more force, inflict more pain. But there is a difference, as we critics are assured, between the violence that we perpetrate against our would-be pupils or converts and that committed by malicious deceivers. Ours is a *counter*violence; ours is the sword of justice. Benevolent violence.

What is it that drives us, as critics? The intervention of the critic, or of the critical (rational) part of the soul for that matter, represents a kind of desire that differs from the erratic, sinful one with which we are plagued by nature. Whereas the latter is a perverted desire, the former is a *straight and moral* one—a desire for truth and righteousness. In some of critique's iterations, such as Kant's, Paul's, and possibly Augustine's, a true duality of desires is posited; in others, such as Plato's, Descartes's, and Hegel's, the two desires are regarded as one and the same, once in a perverted or ignorant state and twice in a converted or enlightened one. On this last view, the desire itself is good, or aimed at the good to begin with; it is just turned in the wrong direction so that it mistakes the good for its shadow. In either case, if the perverted desire has all the features of addiction (love of what is harmful), the rightful desire—curative, admonishing, preaching—arrives with all the adverse symptoms of withdrawal. This moral desire is at least initially, perhaps essentially, oppositional, combative. The difficulty, and apparent inferiority, of this oppositional desire is that it has little *good* to offer or, at least, to *show*. After all, it is a long and steep road to exit the cave, and it is a road one must travel, or be dragged through, before one is rewarded, if that ever happens at all.

It is symbolic in this respect that Socrates always gets squeamish when asked by his interlocutors to say something explicit about the mysterious "good," which he regards as the highest of all forms, as represented, for example (but only *represented*), by the figure of "the sun" outside the cave. Glaucon pleads with him: "By god, Socrates . . . don't desert us with the end almost in sight. We'll be satisfied if you discuss the good as you discussed justice, moderation, and the rest." The teacher responds, "That, my friend . . . would satisfy me too, but I'm afraid that I won't be up to it and that I'll disgrace myself and look ridiculous by trying. So let's abandon the quest for what the good itself is for the time being, for even to arrive at my own view about it is too big a topic for the discussion we are now started on" (R 1127). While Socrates's reticence about the good has more to do with its status as absolute (like the Jewish God, the good is omnipresent and therefore defies representation), in Marxist and critical theory a similar reticence often bespeaks a *temporal* necessity. Just as what-is at present is not what ought to be, so, too, what ought to be is not *yet* present. This is why we often name the end of critical theory *utopia*, which literally means "no place." Justice is almost definitionally not present; it is promissory, teleological, ever ahead.

The temporality of the confessional genre as employed by both Augustine and Descartes is particularly instructive in this respect: a confession is always written in hindsight, as if by a messenger sent to us from the future—*our* future. They used to be like we are now: "I was blind," says the missionary, the convertor, the teacher, "but now I see" (John 9:25). And by implication, *you* (our readers) are now blind (so blind you don't even know that you are), but like us, you will see. Trust us, take our word for it, you *will* see, and oh will it be better! Sponsorship in Alcoholics Anonymous groups maintains a similar logic. The sponsor speaks with hindsight knowledge: because she has been there, through the highs and lows, she exemplifies and can testify to the *possibility* of a future, which is her present—though she cannot experientially (in terms of sensation, desire) *demonstrate* it. This structure is also in place in various self-help and empowerment groups that involve a process of initiation. Those who were initially the initiated later become the initiators. This mentorship stage is not an afterthought but is the thing itself, just as in Alcoholics Anonymous, sponsorship is not just about helping others but about keeping oneself clean, having a purpose. So the ultimate goal of rehabilitation is to become a rehabilitator: a (willful,

knowing) *return* to the cave is in many ways the very meaning of being "outside" of it. Acquiring the mission of converting others is the very meaning of the good.

Those who return into the cave or are enlightened have this specific advantage: they know *both* what the illusion feels like (it feels like knowledge and bliss) and the truth about it—that in fact it is a lie and a misery. The philosopher or critic is therefore more sober and unselfish than the addict-cum-sponsor could ever be. Returning to the cave of illusions, they have no desire left for all those "honors, praises, or prizes" that the cave dwellers bestow on each other for being "sharpest at identifying the shadows as they passed by" (*R* 1134). None of this excites or allures the critics; they have grown cold and immune to such charms and do not "desire these rewards or envy those among the prisoners who were [thus] honored and [hold] power." Quite the contrary: borrowing the words of Homer, Socrates affirms they now feel "that [they'd] much prefer to 'work the earth as a serf to another, one without possessions,' and go through any sufferings . . . than share [the prisoner's] opinions and live as they do." They "would rather suffer *anything* than live like that" (1134, italics added), so convinced are they.

Critique thus opposes more than it poses, negates more than it affirms, prohibits more than it offers, promises more than it can deliver, at least in the short run. This is why a moment of *crisis*—a crackup, becoming lost, ungrounded, mistrustful of one's own body and senses—is a ripe ground for the critic's arrival. If one has already hit bottom, one's only way is up; if doubt has already instilled itself in one's heart, the *promise* of knowledge is already something to latch on to.

THE MASTER AND THE MIDWIFE: THE APORIA
OF SOCRATIC EDUCATION

If we now return to the formula, "Being held captive → Being liberated → Returning to liberate others from their captivity," we can see that the end of this sequence is, in fact, the true beginning. For the imprisoned do not even know they are imprisoned *until* they have been liberated, and who liberates them? One who has already been liberated and, therefore, had been held captive. In other words, *consciousness* of imprisonment *postdates* the consciousness of freedom, yet the consciousness of freedom presupposes a past

of imprisonment. A dilemma announces itself: how does this cycle begin? In Plato's allegory, we are never told how the *first* prisoner gets liberated and who it is that drags this prisoner out. Christianity has an apparent response to this question: it is Jesus, who is in turn dragged up by God, who has *always* been "outside" the cave. God liberates his son so that he can liberate others simply out of compassion, or grace, a goodness that is always pure. There is no good parallel to this in rational varieties of criticism because no one is allowed the kind of moral-epistemic superiority attributed to God. Critique tends to be suspicious if not hostile to such absolute authority. Because of that, the circle seems vicious and introduces an aporia at the heart of critique's conception of education and enlightenment, as well as in its conception of agency. *Aporia*, the Greek word for impasse (as in "nonporous"), has come to connote the existence of a dilemma or a double bind, a catch-22. The aporia of Socratic education, as I will call it here, stems from the conflict between a pedagogical commitment by the mentor to the autonomy of the pupil and the necessity for the mentor to *coerce* the pupil, at times even con and delude them, into *actualizing* their potential, dormant, autonomy. The first step is to instill doubt and skepticism in the pupil in her own sense and sensibilities. But how can a soul that has grown so deeply mistrustful of itself be expected to place its trust blindly in the authority and moral-epistemic superiority of a teacher?

We have seen that Socrates's conception of *periagoge*, the art of true education or enlightenment, hinges on the claim that the student already *has* the power of vision but that it is not yet activated; or in Plato's metaphor, it is "turned the wrong way," in the opposite direction, and held there by force of erratic desire, ignorant of its rational basis. Thus, the art of turning souls around is not a matter "of putting sight *into* the soul," Socrates insists, and this fact is what distinguishes Socratic or true philosophical education from the ordinary kind of indoctrination that is habitually termed *education*. Ordinary education is a matter of initiating all of us into, and aligning everyone to, a monocular, hegemonic worldview (*doxa*)—be it scientific, religious, or both—in order to make us faithful bearers of tradition and efficient tools at the hands of the powers that be. This kind of education—the kind we undergo in elementary school and high school, sometimes continuing in college—presupposes we know nothing. We arrive to class like a clean slate that needs to be filled with information that the teacher already knows but that we do not. Education is therefore one of the things that

the apparatus of the cave symbolizes—the educators, like the puppeteers behind the wall, project shadows on the walls of our cave and call them "knowledge." They *bestow* vision upon us, telling us what and how to see. Socratic education, in stark contrast, "takes for granted that sight *is [already] there* but isn't turned the right way, isn't looking where it ought to look" (*R* 1136, italics added). This education's task is not to *give* us sight, let alone supply us with the determinant contents of knowledge, but to redirect our inborn sight in such a way that it can actually *see* for itself.

Such a "redirection" of sight requires the exertion of some force if not strategic manipulation on the side of the master, and *master* is the right word for this intimate kind of education, an education that is in direct contact with the student's soul. Let us note the dilemma once more: this educational model is defined by its opposition to orthodox education's manipulation and passivation of pupils. In my experience of teaching Plato, many students—especially the more "critically" inclined—find Socrates rather off-putting; *condescending* is a word I have heard a few use, "cavesplaining" if you will. They seem to spot an irony other than the Socratic plaguing Plato's dialogues: how is this person, who claims not to know, or to have the sole advantage of *knowing* he doesn't know, come across as such an authoritative figure? One student suggested that Socrates is a "humblebrag." The Socratic educator, like the missionary, the converter, and the revolutionary critic, asserts—albeit duplicitously—a moral and epistemic superiority over her listening public. The idea of "knowing that you do not know," like that of knowing you are a sinner or a recovering addict, demonstrates the duplicity, for it at once asserts and denies one's authority. In contemporary critical discourse we can recognize a similar type of duplicity in the act of white or wealthy people, for example, confessing to their "privilege." Such confessions manage to exhume moral righteousness in the very gesture with which they proclaim a moral flaw.

We would be remiss, however, if we reduced a logical impasse, an aporia, to a mere case of hypocrisy. We have seen from a variety of angles that the metastrophic turn implies a transition from passive to active being, from being the sufferer and recipient of life, history, or education to becoming their agent—first retrospectively, confessionally, theoretically, then projectively, practically. The *constitutive* difficulty in envisioning such a metastrophic turn, the aporia at the heart of the very notion of such a radical turn, is to account for what *instigates* it. This dilemma is inscribed in the op-

positional logic of critique and is therefore insurmountable. If oppositions are mutually defining, it is only because they are mutually exclusive: they have nothing in common. As Spinoza phrased it, with an eye to the body-soul dichotomy, "When things have nothing in common one cannot be the cause of the other" (Spinoza 1992, 32). To explain any form of relationship, interaction, or exchange between oppositions, therefore, we need either the support of magic, some form of alchemy, or else some "third" or mediating figure. But conceptual logic can no more provide such a "third" than it can allow for magic. Owing to this impasse, conceptual or oppositional logic becomes the fertile breeding ground for the most persistent problems and debates in the history of philosophy and ideas: the relation between mind and body, individual and community, reason and senses—the list can go on indefinitely. The question is always, What comes before what, and how does the one turn into the other? In an aphorism titled "Chemistry of concepts and sensations," Nietzsche wrote, "Almost all the problems of philosophy . . . pose the same form of question as they did two thousand years ago: how can something originate in its opposite, for example rationality in irrationality, the sentient in the dead, logic in unlogic, disinterested contemplation in covetous desire, living for others in egoism, truth in error?" (Nietzsche 1996a, 12).

Here, I think, lies the need for and the rationale of *conversion*. At the heart of rationality there is something that cannot be reasoned, namely, the radical turn that has to be experienced and undergone but cannot be adequately explicated, represented, or described. In the case of education, we may phrase the dilemma in the following terms: given that the starting point is imprisonment, how does one *become* free? Or, given that the starting point is passivity, how does one *become* an agent? Such a turnaround can happen either actively (that is, autonomously) or passively (that is, heteronomously, by force of deliberate, external coercion). In the first case, we place the horse behind the cart, for the question is how one *becomes* active, and this cannot be explained by positing that one *already is* active (though this appears to be the premise of all confessions, with their postulation of injustice or sin). The second case only reiterates the problem: how can one *passively*, by imposition from without, become active? Things that have nothing in common cannot be the cause of one another. Dialectical reasoning from Plato to Hegel to Marx purports to solve the dilemma by recalling that the oppositions do, in fact, define one another, which suggests

a deeper community between them, the unity of a *common (though initially hidden) ground*. In Hegel, for example, an implicit "We" of the human community that is working itself out through history underlies historical antagonisms between groups; these antagonisms *are* the working of Spirit on its laborious and agonizing way toward self-actualization and unification. Applying this dialectical principle to our dilemma, we would need to trace a common ground underlying the opposition between master and pupil, showing that the agency and authority of the former is in fact an extension of the agency and authority of the latter. One of the images Socrates uses to describe himself is a "midwife." As a midwife, his activity is merely that of a *facilitator* of a process that is otherwise natural. He is therefore no more or less passive than his "pregnant" interlocutor—the one who is about to give birth to her own *in*sight. The common ground is thus the truly active principle—let's call it "the good." Socrates, to modify his midwife metaphor a bit, is to his interlocutor's mind what the broody chicken is to its eggs. His actualized wisdom provides an atmosphere in which the interlocutor's potential wisdom can hatch under his example and tutelage.

Similarly, as critics, we only ever *expose* things as they are and ought to be. The scientist is likewise a midwife, and so is the Freudian psychoanalyst, who does not impose anything on the patient but simply allows unconscious voices and urges *within them* to be heard. The power-differential, what would appear to be an arbitrary and external authority, is thus downplayed in favor of a common deference to a deeper substratum and a higher goal, a common passivity if you will, which is the flip side of a deeper activity: the activity of reality, or the concept, or the unconscious. Kant's contribution, while much derided by subsequent philosophers, is distinctive in that he insisted that such dialectical resolutions are *illusory*—"dialectical illusion" (*dialektischer Schein*) was his term for it. In his work, the dilemma, or *antinomy* as he called it, is to an extent irresoluble and inevitable. He will not shy away from it. We see an interesting expression of it in his account of the Copernican revolution (discussed in chapter 1). While Kant credited another philosopher—David Hume—with "awaking him out of his dogmatic slumbers," it is noteworthy that his description of the logic of scientific revolutions portrays them rather as solitary and epiphanic. He has different phrases for the *eureka* experienced by the great scientific revolutionaries in mathematics, physics, astronomy, and so on: a "happy thought," a "flash of light," a "break of light" (*CPR* 20). All these terms convey a suddenness, an

abrupt and *inexplicable* dawning of insight, about which Kant is explicit. Now, this kind of suddenness is what the Greeks called *pathos*—a suffering, or passivity. Indeed, the very insight involved in Kant's own critical turn— the light that suddenly "broke" in his cave—is that *reason* has been the agent and cause of nature or reality all along, although it was hitherto unaware of the fact. In other words, through the critical turn, one actualizes or activates one's own essence *as* a rational, thus essentially *active*, being—yet this very realization is passively effected by a sudden and inexplicable "break of light." Why there? Why then? What or who causes it?

To reiterate, the only way this aporia can be resolved without magical, divine, or otherwise external intervention is by relativizing or overcoming the passive/active, converter/converted, master/pupil, critic/society oppositions, rendering the "critical turns" part of a broader "axial" or spiral movement that characterizes human history from the very beginning. It is not clear, however, that transcending the passive/active opposition in this manner can be done without postulating some form of agency *behind* it, which in order to actualize itself must first passivate itself and then realize that the passivation has been its own doing all along and, as such, is unreal. Subjugating itself to external forces, this primordial self-passivating agent would need to wait patiently and trustingly for the contingencies that would allow for its self-actualization as active. Pedagogically speaking, the Socratic master who calls himself a midwife may, perhaps, be an instance of such a contingency. Or perhaps the dilemma must remain, teasing out an inner conflict in the self-image of the critic—at once exerting and denying her own power and will to power. The pupil's natural resistance must be broken by force just so that she can actuate her freedom. Pupils, that is, must turn into judges, judging everything—and, above all, themselves— except for the master or critic.

Either way we cast the dilemma, a leap of faith is needed—some deference based on faith and trust. "If I do not the works of my Father," says another famous midwife to his disciples, "believe me not. But if I do, though ye believe not me, believe the works: that ye may know, and believe, that the Father is in me, and I in him" (John 10:37–38). Or, in the words of the prophets: "If ye will not believe . . . ye shall not be established" (Isaiah 7:9). In short, prior to knowledge, there must not only be deception and doubt but also a great deal of patience and faith in the authority and righteousness of the masters and their "works." Perhaps one initially follows the prophet, the

missionary, the critic, or the teacher based on arbitrary authority. Perhaps they are even institutionally beckoned, perhaps charismatic or gifted with rhetorical flare. The important thing is that *once the turnaround has been accomplished* as promised, once the light has finally and suddenly broken, the righteousness of the teacher will have been demonstrated and the semblance of arbitrary authority would retroactively dissolve. The promise will have been fulfilled. The turn will have shown itself as having been motivated *immanently*, impelled by one's own interest and desire all along. The master, now proven to be no more than a midwife, a servant even, will have been more than deserving of our trust, motivated not by any personal interest or an erroneous desire of her own but by the common interest we share. Her apparent authority might as well have been that of the Father, of the good, or of knowledge itself.

THE MISSIONARY CREED OF THE CRITIC

"My soul was in misery," Augustine confesses to God, "and You pricked the soreness of its wound, [so] that leaving all things [behind] it might turn to You [*converteretur ad te*]" (C 101). Augustine pays the favor forward, pricking the soreness of other people's wounds. If ignorance is bliss, truth is painful if not cruel. When you prick the soreness of people's wounds, some of them, especially if they are oblivious to their own true interests, may turn hostile. The cave dwellers would sooner kill their benefactor than accept his moral and epistemic superiority. No matter. The greater the resistance, the more patent is their need for help and the benevolence of their helpers. The governing pathos behind this missionary creed is compassion and charity. If the world appears "sordid" to me, it is because the many are miserable. As critics, we have the obligation to tend to those less fortunate—the more so, the more privileged we are. With great power and great knowledge comes great responsibility. With enlightenment comes the obligation to enlighten others; enlightenment *is* this obligation. Exiting the cave and seeing the good *impels* the liberated to return inside. These are not even separate moments but two aspects of the same turn: knowledge, as we have seen repeatedly, is inherently *moral* for critique. Truth is but the midwife for the good. So a missionary creed is inherent to the orientation of critique. This creed is as insatiable as it is utopian. A revolution will never be successful unless

and until it is global—this is the case for Catholicism as it is for Marxism.

Why is this so? Why must the revolution be global? Why must every single one, every single consciousness, be included, converted, enlightened? This is but another version of Augustine's question: "Why, O perverse soul of mine, will you go on following your flesh?" (C 64). Evidently, in a just and reasonable world, the spirit would rule the flesh (and the soul), just as the intellect would guide the will, and the right would be conceived as the common interest, which it obviously is. So why is this *not* the case? Why is the state of the world sordid? The problem of the cause of evil in a God-created world has always plagued Christian theology. The riddle is even more pressing in the historical-materialist iterations of critique, where the problem is the apparent irrationality in a world that ought to be rational. Here, what appears to defy common sense is that a small minority should succeed in controlling and oppressing the majority. The few have so much power, influence, and resources that they don't know what to do with it all, while the many have so little they can barely survive. Humanity and justice aside, such an imbalance borders on defying the laws of physics and mathematics. So why?

The answer, as seen in Augustine's *Confessions*, is dissolution, and the antidote is unification, (re)collection, inclusion, inwardization, universalization, education—the missionary drive. "I collect myself out of that broken state in which my very being was torn asunder because I was turned away from Thee, the One, and wasted myself upon the many" (C 25). In Marxism it is even clearer that the problem of the "broken state" or dissolution adheres to the principle of "divide and control." If the minority can govern the majority, it is because the majority is divided and reduced to so many minorities. In such a state of division, the majority cannot actualize its potential and its natural (physical, material, numeric) superiority—its *right* to rule. The "false consciousness" of the oppressed, as Marx called the illusory attachments to the reigning ideology, not only prevents them from uniting but even prompts identification with their oppressors, for all the contradictions and self-destructiveness this involves. Resolving this state of division is therefore the task of true education and critical theory (as is the case with Marx's proposed *Yearbook* and subsequent writings), whether in bringing all under the one true faith or uniting the workers of the world under the one true imperative. What enables such unification is knowledge,

which is absolute, since the truth is by definition impartial—one for all. Division, on the contrary, is partiality and presupposes impulsive near-sighted or one-sided self-interests along with susceptibility to all types of manipulation and deception.

Of the many paradoxes that beleaguer the orientation of critique, the most bewildering one is this missionary, unifying, universalizing drive. How is it that such an inclusionary imperative produces so many exclusions? How does the unconditional love of humanity produce so much violence and war wherever it asserts itself? And how else does one describe the history of Christian expansionism, the unprecedented scope of its imperialist and colonialist conquests, its flagrant suppression of any other faith, culture, or way of life, the systematic programs of exile, persecution, and torture of those who would not yield? "May God protect me from those who love me," Voltaire once quipped, providing what could easily serve as a motto for all the forcibly converted of this world, all the forcibly saved. Marx and Engels only reiterated the inclusionary, expansionist credo already found in Paul the Apostle, whose missives to the different church communities he established can be read as blueprints for a communist manifesto: "There is neither Jew nor Gentile, neither slave nor free, nor is there male and female, for you are all one in Christ Jesus" (Galatians 3:28).

Part 2

ARCHITECTONICS
OF CRITIQUE

FIVE

Moral Ontologies
of Critique

Let's start with a general question: what is ontology? In the technical sense, it is the science (*logos*) of being (*on, ontos*), just as biology is the science of life (*bios*). In a more general sense, however, it is a tacit set of assumptions about what it means to be. Heidegger argued that humans are "ontological" beings in that we have a relation to being in general, apart from particular entities and apart even from our own immediate existence. This does not necessarily mean that we *know* what being is but that we care about this question and that we have a tacit understanding of being, which he termed "preontological" (*vorontologisch*) (Heidegger 2008a, 32). This understanding and concern for being beyond the mere business of survival is one of the main reasons we develop languages, name things, and study them. And while for practical purposes it is rarely necessary to turn our preontological understanding of being into an explicit science of ontology, it is impossible to overstate the importance of this understanding for any kind of thinking: critical, political, moral, or scientific. As Heidegger also noted, when asking any question, no matter how fundamental—what is nature? what is life? what is politics? what is thinking? what is critique? what is success? what is happiness? what is justice? and so on—a certain understanding of what *is*

means and what it means to be is not only implied but plays a determinative and restrictive role with respect to the kinds of answers we are capable of reaching.

Heidegger exemplifies this in a commentary on Descartes (Heidegger 2008a, 123). He argues that, when Descartes asks, "What kind of thing am I?" and responds, "I am a thing that thinks," he already presupposes that *to be* means *to be a thing* (*substantia, res*) that is distinguished from other things by some definitive property—in this case, the property of thinking. This is a robust ontological commitment that, according to Heidegger, Descartes—the great doubter of all things—never doubts but at most explicates. Moreover, it is this very substance-property ontology that dictates Descartes's method of doubt, as it allows him to isolate the substance (his existence) and its essential property (thinking) from all things inessential. Not only the answer Descartes comes up with, then, but his very question and method of questioning are informed by an ontology.

The force of ontological assumptions lies in the fact that no empirical study can challenge them, since, by determining what *counts* as an "entity," these assumptions already frame the entire study. Wittgenstein made a similar claim, using the metaphor of a mesh or a fishing net to explain the operation of the natural sciences. He argued that the consistency, predictability, and accuracy of the results of scientific observations often tells us as much "about the net [as it does] about what the net describes" (Wittgenstein 2001, 83), which means that it is not that there are no other fish in the sea, only that such fish cannot be caught because of the parameters of the explanatory apparatus (as represented in his metaphor by the size and shape of the holes in "the mesh"). These ideas received a more robust theoretical account in *The Structure of Scientific Revolutions*, where philosopher and historian of physics Thomas Kuhn introduced his notion of "paradigm shift." According to Kuhn, the acceptance of certain paradigms, which are essentially ontological frameworks, gives the scientific community the conviction that "it has acquired firm answers to questions like the following: What are the fundamental entities of which the universe is composed? How do these interact with each other and with the senses? What questions may legitimately be asked about such entities and what techniques employed in seeking solutions?" Kuhn's account emphasized the role played by educational and training programs, textbooks, and other apparatuses of the profession, to which he gave the name "normal science," in entrench-

ing the paradigm. Normal science does not question a paradigm but, on the contrary, works to sustain and refine its parameters. The answers to fundamental ontological questions provided by a scientific paradigm thus become "firmly embedded in the educational initiation that prepares and licenses the student for professional practice," and, "because that education is both rigorous and rigid, these answers come to exert a deep hold on the scientific mind" (Kuhn 2012, 4–5). We only come to realize that a paradigm is at play when, and if, an accumulation of observations or unforeseeable circumstances cause a crisis, and a paradigm is no longer sustainable. And, Kuhn argued provocatively, when a paradigm does change, as has occurred not many but several times in the history of physics, "scientists [come] to see the world of their research-engagement differently. . . . We may [even] want to say [they] are responding to a different world" (111).

Although Kuhn was referring to physics specifically, there can be little doubt that the notion of paradigm applies to other sciences as well. In the context of political science, for example, German jurist and philosopher of law Carl Schmitt wrote, "Every political idea in one way or another takes a position on the 'nature' of man and presupposes that he is either 'by nature good' or 'by nature evil'" (Schmitt 2006, 56). These fundamental positions about human nature, Schmitt added, "can only be clouded by pedagogic or economic explanations," because such explanations would only serve to justify the positions they seek to "explain": if your assumption is that human nature is evil, that is what your analysis of history will demonstrate. We can radicalize Schmitt's claim further by adding that these "political ideas" about the goodness or evil of human nature, antithetical though they are, share a common ontology, because, prior to deciding if human nature is good or evil, we must first assume that there is such a thing as human nature, which implies a species-unity, immutable essence, and a homogeneous conception of time, among other things. Similarly, the idea that "nature" can and must be *either* "good" *or* "evil" discloses a moral ontology—an assumption that "good" is defined in opposition to and in exclusion of "evil." However common and unproblematic these postulates may seem, they are so bombastic that no empirical evidence could possibly validate or invalidate them, though evidence can certainly be gathered on their basis. Political sciences have their "normal science," too.

Arendt had something like normal science in mind when she wrote that the "sciences can only illuminate, but neither prove or disprove, the

uncritical preliminary understanding from which they start" (Arendt 2005, 311, italics added). What if critical theory has its own kind of normal science? I would argue that it is almost inevitable that it does—even more so as it becomes increasingly professionalized and part of an educational program, with its own textbooks, training, conferences, and traditions. And just as Kuhn says that any questions, let alone answers, that do not conform to the norms of normal science are either "relegated to another science or declared entirely 'unscientific'" (Kuhn 2012, 103), the same applies to critical thought, which can be quick to deem what does not conform to its assumptions and expectations as "uncritical." The issue, for me, does not simply pertain to paradigms or their normalization. *Orientations*, as I understand the term, are more fundamental than paradigms, in that orientations do not rise or fall historically. To claim otherwise would be to postulate a historiography that is independent of orientation, that is not itself oriented, which would be more dogmatic than acknowledging that our thinking, and indeed our histories, are always framed and therefore limited by orientations. An orientation concerns the possibility of having and living in a world, having a sense of self, of purpose, certain sets of commitments, *within which* we can live and think critically (or uncritically). We cannot do without ontological assumptions. Whatever it is we call "world," or any field of investigation, would disintegrate into randomicity and incoherence without them. This does not change the fact that such assumptions can be recognized and that there can be more than one *coherent* "world" in that sense—more than one orientation. The most extreme form of dogmatism, as I see it, whether in critical theory or any other kind of thinking, is not the one that makes unverifiable ontological claims, such as "being is a substance with one definitive attribute" or "human nature is good," but the one that *denies* making ontological assumptions at all and whose world is therefore least amenable to any sort of fundamental crisis or reorientation.

THE ONTOLOGY OF PRESENCE

Critique belongs to the spectatorial orientation, which entails a certain ontological framework. This framework, however, is not monolithic. Ontologically speaking, critique can be monistic, dualistic, or dialectical, just as it can be idealistic, materialistic, or transcendental. Its variants include

an objectivist ontology that equates being with "concrete" presence; an ontology of actuality that regards true being as the active principle or cause; an ontology of substance and its properties; and an ontology of possibility that regards being as fundamentally contingent. Some of these ontologies are complementary, some incompatible, but to observe them as *variants* of the same ontology is to point out an underlying commonality—a *fundamental* ontology, to borrow a Heideggerian term, which can be called an "ontology of presence." (Since I'm using this Heideggerian term, I should qualify that, as I take there to be more than one orientation of thought, I also consider that there must be more than one fundamental ontology, which is not Heidegger's position. Heidegger did not consider the ontology of presence as a fundamental ontology but, on the contrary, as a derivative and essentially deficient one; I argued against this stance in chapter 1). The ontology of presence means that being is conceived as presence. It does not have to be *material* presence; if I say, for instance, "God exists," I mean that God is present but not that I can see him or that he has any specific shape, form, or substance. God *is* (present). This seems so general as to be obvious and redundant, but we can begin to see the work this assumption about being as presence does in terms of what it excludes or what, under its auspices, comes to be considered as *non*being. In spatial terms, presence is opposed to absence; nonbeing is what is not present, and so, to be is to be perceivable or conceivable—being is whatever is, or can be, present to my senses or thought. In temporal terms, presence is opposed either to past and future, as what is no longer present or not yet present, or to time in general, as what is always transient and therefore never truly or fully present. Time, as I suggested in chapter 3, has always been a fundamental problem for the spectatorial orientation, ontologically as well as morally.

The fact that the ontology of presence is not monolithic is exemplified in Descartes, who was an ontological dualist himself. This means that, for him, there were two fundamentally different kinds of being, two different ontologies: the ontology of matter, which consists entirely of taking up and moving within space (*extensio*), and that of mind or consciousness, which consists entirely of the activity of thinking (*cogitatio*). These two kinds of being are mutually exclusive: what thinks does not take up space, and whatever takes up space does not think. Yet both kinds of being are *present*—one as act, one as spatial extension—and both are substances with one immutable attribute or essence (extension and thinking respectively) that

survives and determines whatever change they are capable of undergoing.

Descartes's dualism exemplifies the variability of critique's ontology—namely, the fact that we do not have to *decide* whether being is matter or idea. Whatever understanding of presence we endorse, critique orients the world and the self in a way that is spectatorial and oppositional, and as such, it constitutes being as presence and as determinate, meaning that it is given to a monocular (unified or unifying) perspective. Entailed in this ontology is a certain epistemological framework as well—that is, a certain conception of truth and knowledge. The epistemology of critique adheres to some form of certitude and precision, an unequivocality, which can be loosely described as a "*realistic spirit*," as expressed, for example, in phrases like "*true* being is form"; "*true* being is matter"; "what is *really* going on are changes in material conditions and relations of production"; "they think they are following some moral precepts, but in *truth/reality/essence/at base* they are simply afraid to die." True being, in this epistemology, is what lies *at bottom* or at *the core*.

In each case, this monocular orientation is dictated by a certain *orthodoxy*, which, as we saw in chapter 1, literally means the "right" or "straight" *view* (*doxa*). But the orthodoxy's "rightness" is often a matter of convention and (more or less arbitrary) power. It dictates how things are *commonly* viewed, which leaves open the question of how they *ought* to be viewed or whether they are viewed this way *by right*. Orthodoxies therefore shift historically, as do scientific paradigms, and may vary culturally. The dual nature of orthodoxy—the fact that it is, on the one hand, relative and contestable and, on the other hand, presents itself as supreme and absolute—is the reason for which critique plays such an indispensable role in the spectatorial world. Critique is the defender of the integrity of orthodoxy. It is *anti*doxic in the sense that it challenges the *existing* orthodoxy, the powers *that be*, yet this challenge is inscribed in and, in a way, necessitated by the very *claim* to orthodoxy. What critique challenges, in other words, is not the *form* of orthodoxy—the assumption that there *is* a "right" view or truth—but its *content*, namely, what the right view is. It challenges the existing orthodoxy's claim that it is the *true* orthodoxy, just as paradigm shifts in science do not question science itself, or even normal science, but only whether the existing normal science is a true and good science, if it ought to be the normal science. Thus, for example, Luther's critique of Catholicism, which gave way to Protestantism, asserted a truer or more authentic view

of the pillars of Christian faith, which he claimed the Catholic institution had lost sight of. If this operation initially established a heterodoxy, it was by no means the intent: Protestantism quickly asserted itself as a new, or rather competing, kind of orthodoxy, literally at war with the old one over dominance and truth.

Often, critique would take issue with the exclusions, partialities, and blind spots of the existing orthodoxy. But when, as critics, we challenge orthodoxy, we do not seek to replace it with a multiplicity of possible views, let alone with relativism. On the contrary: critique attacks the *arbitrariness* of the reigning ideology; it shows that it is not *truly* universal or universalizable and thus has no *real* authority or *intrinsic* legitimacy. The only thing that could legitimize orthodoxy is true knowledge, some grasp of being (that is to say, presence) as it *is* and not as it is portrayed from some perspective that caters to the interests and biases of some group. If no true knowledge of the sort exists, critique may endorse an epistemological skepticism. But even this kind of epistemology would not question whether being *is* presence, only whether we can have a true grasp of it *as such*.

In view of critique's capacity to entertain different, and sometimes incompatible, ontologies, I title this and the following chapters in the plural— "*ontologies* of critique"—and devote each section of these chapters to a different ontological variant or emphasis. The variants can be more or less compatible with each other, and their number is by definition indefinite. In other words, I do not mean to exhaust the possibilities of the ontology of presence, because I do not think they are exhaustible; I mean, rather, to inspect enough variations to make both the overarching commonality and the inner heterogeneity of this ontology apparent. I also differentiate between "*moral* ontologies" and "*political* ontologies" in this and the following chapters respectively, though this distinction is more organizational than essential. In my understanding of how orientations operate, every orientation has ontological, epistemological, moral, *and* political entailments. The link, or entailment, between the ontology of presence and a morality and politics of presence consists in the assumption that, just as there is a right *view* (knowledge), there is, or ought to be, a right *way* (ethics and politics). Both kinds of judgment disclose the judgmental structure of critique's orientation. The realist spirit of critique's epistemology and the moralist spirit of its ethics and politics are bound up with the oppositional relation that constitutes being as presence in opposition to absence or time, and the good

or right in opposition to evil or wrong. A subtext cutting across these two chapters is the suggestion that, despite the commitment to presence, a long, dark shadow stretches behind and beneath whatever is present, making it impossible to make full peace with it or accept it as it is.

OBJECTIVITY AND OBJECTION

The first variant of a critique-ontology we venture into is the idea of being as objectivity, or the objective world. As Heidegger described it: "Nature and history [are understood as] the objects of [a] representing that explains," and only "that which becomes object in this way . . . is considered to be in being"—that is, to be *real* (Heidegger 2013, 127). When thus oriented, science and philosophy experience "beings as objects," Heidegger said, underscoring the German word for "object," *Gegenstand*, which literally means "standing-against": "It is through and for perception that [being] comes to be a 'standing against'" (Heidegger 1985, 82). Elsewhere he wrote, the "orientation which lets something take up a position opposite to . . . [forms] the horizon of objectivity in general" (Heidegger 1962, 123).

The *ob-* of *objectivity* can mean either "against" or "before," and the before, as we have seen, has both a spatial and temporal configuration. The objective world is revealed *before* a spectator in a spatial sense, just like a movie is, but also in the temporal sense that it is *already there* independently of the viewing experience. Spectators can be judges or critics, but they are not the *makers* of reality insofar as it is objective; they *perceive* the state of things as they are given and present themselves—the "given facts" as we call them. Whether the spectator perceives this state truthfully or untruthfully, adequately or illusorily, objectively (knowingly) or subjectively (opiningly), judiciously or prejudicially—these questions, and the answers to them in each case, are epistemologically important but ontologically derivative. We only get the opposition between truth and illusion (or deception), knowledge and opinion, essence and appearance, if our thinking is based on the ontology of the spectacle. These oppositions are at once the indicators and products of this orientation.

That objectivity is conceived as that which is *already* present, as "the given," is probably the reason for which our relationship to objects consists primarily in the activities characteristic of latecomers (colonizers, inheritors, redesigners)—not so much creating or recreating but analyzing,

synthesizing, naming, classifying, arranging, redistributing what is there. Within this generally posterior, noncreative context, *objecting* to the way things are—saying *no* to their being *as* they are—is among the most active modes of thinking and being. For instance, it is often the case that when a student is assigned a text, especially one that is challenging and foreign, her instinct is to take a stance against it or identify shortcomings, omissions, improprieties, and flaws—in short, to discuss what is *not* there rather than what is. This may be the consequence of perceiving the text as something that is already there, already made, and thus lacking other means to *actively* engage it or assert one's own subjectivity and independence with respect to it. Alternately, the student may take a less independent stance and simply *describe* what she sees before her. In either case, the text, like being in general, is experienced as something objective, as an object.

Nietzsche described consciousness as an instinct that "condemns existing art as well as existing ethics." Wherever consciousness "turns its searching eyes," he wrote, "it sees lack of insight and the power of illusion." Above all, it exposes "the *essential* perversity and reprehensibility of what exist[s]" (*BT* 87, italics added). I would argue that this kind of "existential negativity," as Lacan called it (Lacan 2007, 99), is not merely psychological but ontological. Our language testifies to this fact: the verb *objecting* appears to literally mean making-objective, as if as soon as I perceive something as objective, I already have an objecting relationship to it. The same goes for the English *against* or its German correlate, *gegen*: we use the same term to designate being before something ("I stand against the wall") and being opposed to something ("I stand against this view"). Similarly, when sitting in front of each other, we are *con*fronting each other—the same term describing a simple sitting arrangement and a *confrontation* or *affront*. In all cases, that which is before me is also (potentially) antithetical to me. Our language tells us that whatever is objective is at the same time objectionable.

As Hegel explained in his own discussion of the "original sin" or "the Fall," the withdrawal of the spectator, or the subject, from the field of objects necessarily empties the latter of the good or at least underscores what is evil (Hegel 1977, 471–73). The good, as the standard of judgment and the assignment of value, is always on the side of perspective or is postulated by the perspective. Now, if the critic does not perceive herself to be *within* or *at one with* the object of judgment, or as otherwise having full knowledge,

ownership, and control over it, the object is bound to remain severed from the good. It is thus that the very opposition between the critic and the object of critique—already at the orientational, positional level (of "standing against" or "before" it)—renders the field of objects as negative, or the subject as its negation, which is but the other side of the same relation. This, too, is demonstrated by our language: "Opposite" is both a spatial designation ("I am on the opposite side of the road") and a moral one ("I am in the opposition"; "I oppose this verdict"). The object stands to the subject as the positive does to the negative, or vice versa.

Ludwig Wittgenstein, in his "Lecture on Ethics," made a claim that would prove fateful, inspiring a whole philosophical movement called Logical Positivism. He offered a thought experiment:

> Suppose one of you were an omniscient person and therefore knew all the movements of all the bodies in the world dead or alive and that he also knew all the states of mind of all human beings that ever lived, and suppose this man wrote all he knew in a big book, then this book would contain the whole description of the world; and what I want to say is, that this book would contain nothing that we would call an *ethical* judgment or anything that would logically imply such a judgment. (Wittgenstein 1965, 6)

The book of *facts* is thus void of ethics; facts are not "values," if by value we understand *ethical* value. There is, in other words, no factual basis on which to differentiate between the judgments that "X is a good person" or "Y is a good deed" and the judgments that "X is a good tennis player" or "Y is a good meal." Wittgenstein explains:

> If for instance in our world-book we read the description of a murder with all its details physical and psychological, the mere description of these facts will contain nothing which we could call an *ethical* proposition. The murder will be on exactly the same level as any other event, for instance the falling of a stone. Certainly the reading of this description might cause us pain or rage or any other emotion, or we might read about the pain or rage caused by this murder in other people when they heard of it, but there will simply be facts, facts, and facts but no Ethics. (Wittgenstein, 6–7)

Facts, facts, and facts, but no ethics: thus looks an objective world, and one may not be altogether surprised that this *very world*, in its entirety, inspires rage. This was perhaps Wittgenstein's point about ethics:

that it pertains not to the details (the *particular* facts, insofar as they speak for themselves) but to the whole, and to the principle, and above all, to the moral judge who is nowhere to be found *within* "the book." This categorical opposition of (amoral) facts to (moral) values notwithstanding, Simone de Beauvoir insisted on the inherent connection in critical thought between realism and its claim to objective knowledge, and moralism and *its* claim to objective knowledge: "Critical thought," she wrote, "sets up a superior, universal, and timeless value, objective truth. And, correlatively, the critic defines himself positively as the independence of the mind. Crystallizing the negative movement of the criticism of values into a positive reality, he also crystallizes the negativity proper to all mind into a positive presence" (Beauvoir 2018, 68). Beauvoir saw this posture as duplicitous, an attempt to hold the stick on both ends—inserting the negative *into* the positive and the positive *into* the negative, making moral values into facts and moral judgments into verifiable truths. Since the critic places himself in a transcendental position (outside of and at a distance from the object), he thinks that he himself "escapes all earthly criticism. He does not have to choose; he understands, dominates, and rejects, in the name of total truth." But, Beauvoir insisted, "the independent man," the man withdrawn into his position against the object, "is still a man with his particular situation *in* the world, and what he *defines* as objective truth is [in fact] the object of his own choice. His criticisms fall into the world of particular men. He does not merely describe. He takes sides" (68, italics added).

Beauvoir thus sees that to object is to make-objective, in the very act of taking a stance, and not simply, as the critic would have it, a matter of objecting to what is *already* objective, as if the objectivity preceded the objection and the objection could be justified by it. Nietzsche made a similar point in his vitriol against "the realists": "You sober people," he wrote, you "hint that the world really is the way it appears *to you*. As if reality stood before you only, and you yourselves were perhaps the best part of it" (Nietzsche 2001, 121). For Nietzsche the very claim to objectivity reeked of hypocritical self-aggrandization. He thus called us to "guard against the snares of such contradictory concepts as 'pure reason,' 'absolute [spirit],' 'knowledge in itself,' [which] always demand that we should think of an eye that is completely unthinkable, an eye . . . in which the active and interpreting forces, through which alone seeing becomes seeing *something*, are supposed

to be lacking" (Nietzsche 1989, 119). Gadamer likewise maintained that one is always found "standing in the stream of tradition . . . conditioned," and this "has nothing to do with the expert who 'objectively' studies the norms from the outside but rather with a person already imprinted with these norms: a person who finds himself already within the context of his society, his epoch, his nexus of prejudices, his experience of the world. All of this is already in effect and is determinative whenever we confront a particular perspective or interpret a doctrine" (Gadamer 2016, 19).

I am not entirely ready, however, to dismiss the critic's claim to objectivity and the objectionable nature of the objective state of things in favor of an equally authoritative historicism or perspectivism. There is a truth to the critic's stance that demands our acknowledgment. It is true that critics take sides; it is also true that, especially in questions of justice, they *take issue* with the objectivities they assess. But at the same time, it is absolutely crucial to the integrity of their standpoint that their objection pertains to what *is* objective, what is *in* the object itself as they find it and expose it for all to see. What Kant said about aesthetic judgment applies here, too: critics may be justified in *demanding* universal consent *de jure*, even if they cannot *expect* that everyone should ever grant such consent *de facto*. The critic's claim is that anyone in their right mind (that is, without prejudicial or extrajudicial self-interest), standing where they stand and oriented as they are, *ought* to see the wrongness in what they see. In this manner the difference between the subjective and the objective, the negative and the positive, is retained: the subject is constituted in the motion of objectifying the object; the former's negativity (or opposition) establishes the object in its positivity, as present before. The judgment—insofar as it is correct or righteous—is therefore no more subjective than it is objective. It stems from the place of a universal, or universally shareable, subjectivity, since it is constituted not by positive investment but by a pure opposition to, self-withdrawal from, what is positively there, just as *it* is. If nothing else, this much is clear: there is no ground from which such claims can be categorically denied or refuted. To try and do so would be contradictory, for it would be to assert an objective truth (that the critic is wrong) in the very act of denying the legitimacy of such an assertion.

I will conclude this section by advancing two claims that I would most like my reader to take from it: (a) that it is in bad faith to argue for the mere existence of facts or of the Truth without the operation of an orientation.

This observation does not yet make objectivity into something subjective or willful, let alone illusory. It does, however, mean that objectivity *is* partial in the final count, that it is not absolute, that it does not equal Being without remainder or qualification. No matter how well they are argued for—if on empirical, statistical, logical, even mathematical grounds—one may only demand universal consent to one's judgments to the extent that one may demand the adoption of a similar orientation. And such a demand will *never* be warranted by "the things themselves" nor by any moral law, common sense, or common good. As far as orientation is concerned, you may try to *force* others to think or perceive as you do, even under the conviction (perhaps justified) that once they do, they will indeed think and see as you do. But there is no way that you can *justify* this use of force, either a priori or a posteriori, because what happens in an orientation stays in the orientation and does not extend beyond it. No orientation has any legitimate claim *over* another.

(b) The second point I want to highlight is this: if it is true that what is objective is also objectionable, it must follow that there will *never* be a world, or even a single object, fact, or state of affairs, that is *not* objectionable, reprehensible, deplorable. On the premises of the spectatorial orientation, whatever is present is also potentially unjust; therefore, critique belongs to this orientation inseparably. This is not a consequence of any particular facts but of the very ontology of factuality or, as Kant would have it, the conditions for the possibility of objective knowledge and of experiencing things as facts. The question of what we are to make of this claim—that the attainment of true justice is, in a way, objectively impossible—will have to await a discussion about time and progress in chapter 8.

ACTUALITY, CAUSE, AND ACCUSATION

Objectivity may, however, still be an ontology of the cave—the spectacle in the most literal sense of the term. Sensibilities that have historically gone by the names of "empiricism" and "positivism" are more prone to such an ontology, which implies the conviction that there is an objective world out there and against it our subjective ideas, opinions, interests, and moral judgments. The question then becomes whether, and how, the two sides are correlated. Yet there also are other sensibilities, like the rationalist and ide-

alist, which are more invested in the *metaphysical*, and these sensibilities are no less at home in critique. To accommodate this difference in sensibilities, we can draw a distinction between the ontology of objectivity and an ontology of actuality. The latter, to the exploration of which the present section is dedicated, lays stress on the metaphysical underpinnings of the objective world, specifically, on the order of *causes* or *reasons behind* the occurrence and appearance of things.

The difference between the ontology of objectivity, as discussed in the previous section, and the ontology of actuality, to be discussed in this one, is first a matter of emphasis: "objectivity" belongs to an epistemological vocabulary (how do I know or validate my claims?), whereas "actuality" points to a more properly ontological vocabulary (what is real?). Whereas the former is more theoretical in emphasis, the latter also lends itself more easily to political or practical considerations, as comes to bear in such phrases as "We need to look at what is *actually* happening in the world today" or "The real question is what is *actually* done about it." The practical bent of the ontology of actuality is again inscribed in the words themselves. Whereas objectivity relates to projection, and thus more readily to sight, actuality stems from *actus* (doing). Actuality has been used to translate the Aristotelian term *energeia*, which literally means "being *at work*." In Aristotelian philosophy, *energeia* names the state in which a thing is carrying out its proper activity or function (*ergon*). In the case of an eye, for example, this function is seeing, so the eye is fully *"actual"* when, and to the extent that, it *sees*. A blind eye or a glass eye, in contrast, is an "eye" in name only, something that looks *like* an eye and is perhaps *located* where eyes habitually are but is not an *actual* eye. Actuality is thus a term of action, and whatever is said to be actual is also active.

On the face of it, there may be something counterintuitive in this identification of being with action. "The natural attitude," as the phenomenologists call it, by which I understand the ordinary, precritical manner of inhabiting the spectatorial orientation, tends to equate being with *matter*— with what is palpable, tangible, visible, or, in the least, takes up space. This habitual conception of being as what is present *to the senses* reflects the initial state of being of the spectator. The spectator sees things from "outside," so to speak; she sees the book by its cover, its surface appearance. On this common view, being is by no means equal to action. A giant rock standing in my way, or falling on my foot, is certainly *real*, yet it can hardly be said

to be "active." So the identification of being with matter, or tangibility, appears to render activity secondary at best. Still, the same natural attitude, and popular culture in general, does *value* action above all things. Yet this action it valorizes is, again, associated with *palpability*. The valorization of action can be seen in banalities like dating-site profiles, which, to be successful, need to evidence an "active lifestyle." This lifestyle, in turn, involves such activities as hiking and working out rather than, say, reading articles or ruminating intently on metaphysical problems. Activity is thus equated with *restlessness*, whereas action is equated with *movement*. Conversely, the more immobile one is, and the less palpable changes one effects in the world, the *less* active one is considered, and indeed *appears*, to be. Thinking, for instance, is the least valued activity, or at least the one least likely to count *as* an activity. An NYC subway ad by a company called "Fiverr" expresses this value system:

> Thinking big is still just thinking.
> In doers we trust.

Like the active lifestyle of the attractive dating profile, this kind of message sells. In fact, I am so inspired by these words that if I only knew what products Fiverr sold, I would promptly order them on Amazon. The only people I trust in even more than doers are those who trust in them. (To be honest, I did look up Fiverr after writing this, and it appears to be a platform where freelancers can go to find gigs. I can only assume their ad aims at the sense of inadequacy that people who are nonfully or nonofficially employed may experience in a society that mistrusts anyone who is not sufficiently recognized as "active" and is therefore not fully recognized as *being*. "What is it you do again? . . . Oh, I see.").

I will note in the conclusion to the book, in a discussion on what I call the "activist mystique" that this—in my view abhorrent—tendency to contrast "*real* action," as "actually *moving things* in the world," to "*just* thinking" gains expression even in some of the most sophisticated iterations of critique and critical theory. After all, as the Marxists preached, we've had enough of philosophers merely "interpreting" things; what we need is to *change* them. But before examining these iterations of critique, and the extent to which they are iterations of critique, we should first acknowledge that, and how, this view is certainly not necessary to critique. The philosophical tradition tells a different, and arguably more plausible, story about

the relation between action and thought. When Aristotle recommended the *bios theōretikos*—the contemplative, philosophical life—as the happiest one, he praised it for being "the most continuous activity," noting that "we can contemplate truth more continuously than we can *do* anything." In addition, he claimed, theoretical activity is the most self-sufficient and self-*propelling*, providing its own energy and fuel, for it "aims at no end beyond itself, and has its own proper pleasure, which [only] increases the activity" (*NE* 1104). Yet this activity—this *energeia*—is *not* to be conflated with motion. On the contrary, because it is the most active of activities, thinking is the most *restful* one, and this restfulness (or serenity, if you prefer) is what, for Aristotle, renders it the happiest.

The more active something is, the more it is *at rest*. If this standpoint seems counterintuitive at first, it takes no more than a second thought to come to terms with it. Anyone who has experienced instability or restlessness—in housing, in livelihood, in the family, in one's mental or physical health—can testify to how difficult it is under such conditions to develop a project or a commitment, to follow something through, to work on one's character or "act in character." An exploited factory worker, while she may have little time for hiking or attending the gym, does work *hard* and *constantly*, but nothing of this doing and moving constitutes anything like an "active lifestyle"; it only suppresses her humanity. Why? Because doing is not yet acting, and mobility is something we share not only with other beings in the animal kingdom; we share it with inanimate things as well. The same goes to the equation of being with matter, which fails to distinguish our existence from that of a rock. What is it that makes a work *free*? It certainly is not the simple fact of working, let alone its outer *appearance* (motion, sweat, effort). It is, rather, the intentionality and aims *behind* it: those which can only be produced, or inferred, by *thought*. The truth is that—putting aside the mere implementation of disciplined routines (which can be better achieved by a thoughtless machine than by a thinking being)—what makes a "lifestyle" active or, for that matter, a "style," is not mobility but *purposiveness* (planning, premeditation) and *originality* (that is, something that originates in, and is unique to, the person living it).

For philosophers from Plato and Aristotle to Descartes and Kant to Sartre and Arendt, the most active life is also the most thoughtful one. And the fact that thinking is the least palpable and least mobile of activities is only evidence that it is the most active. Of course, the pressures of corporeal

existence—its pushes and pulls—rarely grant us enough respite to *be there* so intensively or, indeed, freely, as we are when we are immersed in thought. Thinking requires free time and space, a time and space for leisure, which in turn relies on economic security and sociopolitical institutional support. Plato was among the first to try and institutionalize thinking—to establish for it a room of its own. He formed a boarding school in a part of Athens called Academia, from which our "academy" derives its name. The words *school* and *scholar* derive from the Greek *scholastes*, which literally means living at ease or having free time. But, as Arendt clarified, "*Scholē* is not leisure time as we [ordinarily] understand it . . . but the deliberate act of abstaining, of holding oneself back (*schein*) from the ordinary activities determined by our daily wants" (*LMT* 93). This abstinence, she explained, was a matter of *acting out* "leisure (*scholēn agein*), which in turn was the true goal of all other activities, just as peace, for Aristotle, was the true goal of war" (93). Thus, long before it became co-opted for professional and occupational training, the institution of "the school" in Athens was designed to put the surrounding "work-world" in abeyance, a place and a time in which to *stop* and think, a place in which leisure itself, and the thinking that fills it, becomes *work*, actualizing what Socrates, Plato, and Aristotle took to be the distinctive function and essence—the actuality (*energeia*)—of the human being.

I have focused on human freedom and thought because, next to the being of the gods, they traditionally serve as the prime model for, and apotheosis of, the ontology of actuality and its value system. But this ontology neither begins nor ends with the human being, let alone the scholar or the philosopher. *Theoria* is, after all, an active *spectatorship*, entirely geared and oriented toward the actuality and activity of the world itself, of *being*. To truly understand what makes thinking the most active and actual of activities, and the thinker (or consciousness) the most autonomous being, we need to address the *contents* of thought. True thinking, while it may require an autonomous subject with free time and space, is the least "subjective" of all mental states and activities. Thinking is the *common ground* of subject and object; it is a direct access to the intelligibility of things themselves. If *theoria* is the most continuous of activities, as Aristotle claimed, it is because its objects are the most universal and eternal—the kind that are always and everywhere there. These are the objects of *knowledge*, as opposed to the fleeting and conventional items of opinion, belief, or the

senses, which are always conditioned by sociohistorical contingencies. The objects of knowledge can be principles, forms, essences, structures, laws, patterns, underlying conditions (material or ideological). As such, they are the *least* visible and empirical, indeed, the most permanent and least mobile. They are also, and for the same reasons, structurally *hidden*, requiring hard work—of thinkers in their leisure—to *expose* and *explicate*. What is least visible is thus not only the most "objective" but the most *actual* and *active* as well: it is true *being* as opposed to mere appearance, true evidence as opposed to a merely circumstantial one. In all cases, to know something is not merely to witness its happening but to understand *why* it happens there and then, and thus also to be in the position to anticipate and predict its happening if not to *generate* it.

If the order of reasons and causes is least circumstantial, it is because it is the least time-bound. More than anything, the order of causes is what enables the spectatorial orientation to soar above time, as the condition of unfreedom and ignorance. Knowledge sees into the *cause* and therefore into the *necessity* of the occurrence, not just the fact that it occurs. As exhibited in logical deduction and in mathematical reasoning, this necessity is eternal and universal, not transient. As Jacob Klein noted concerning the turn to mathematical thinking in Attic Greece: "the special nature of the object of arithmetic and logistic [is] that which alone of all things is in the strict sense *knowable*, being in fact always to some degree *already* known" (Klein 1992, 50, italics added). In line with this understanding, Plato argued that the experience of knowledge *feels* like recollection. Whenever I come into new knowledge, it is as if I suddenly remembered something I had already known, as if in a past life. A figurative lightbulb turns on above my head, and I utter, "But of course! This must be so! This must always have been so! It cannot be otherwise!" This is also what it feels like to realize that one is part of something greater (if not the greatest of all), to experience things not as a function of one's perspective but, on the contrary, one's perspective as a function of a universal order. This experience has, as Aristotle attested, its own kind of pleasure. And Arendt noted that the immortal and divine part within a human being "does not exist unless it is actualized [by] and focused on the divine outside; in other words, the object of our thoughts bestows immortality on thinking itself. The object is invariably the everlasting, what was and is and will be, and therefore cannot be otherwise than it is, and cannot not be. This everlasting object is primarily the "revolutions

of the universe," which we can follow mentally" (*LMT* 136–37).

For these reasons, the primary philosophical affect has been, for Aristotle as for Descartes, and still for Heidegger, that of *wonder*, being struck by awe. This wonder, like a shock, stops one in one's tracks and makes one still, makes one think intensely. There is another kind of affect, besides wonder, that carries a similar effect: horror. The proximity of the otherwise oppositional affects, wonder and horror, is conveyed in the coincidence of the expressions "awesome" and "awful," which in the Jewish tradition are equally attributes of God and of the encounter with God. Remarking on the affinity between the two affects, though in connection to the human world rather than the heavenly, Arendt wrote: "the speechless horror at what man may do and what the world may become is in many ways related to the speechless wonder of gratitude from which the questions of philosophy spring" (Arendt 2005, 445).

The turn from wonder to horror can be compared to the turn from pure theory—the contemplative life of the thinker invested in divinity, permanence, regularity, law—to critical theory, or critique, a thought anchored in the human world and history and one that is more prone to discord than to harmony with its objects or world. Whereas the former reaches beneath or beyond the subject-object opposition to a common universal ground, the latter maintains its oppositional stance vis-à-vis the world and its objects. Notwithstanding this difference, Aristotelian *theoria* and critique are equally *active*, that is, *thoughtful*, modes of inhabiting the spectatorial orientation.

Experiencing the world, human or otherwise, as horrific goes beyond mere opposition to it. What precisely is the kind of thing that invokes horror (or wonder)? We could refer perhaps to the opposite of reason itself, that which we name "irrational," that which is without cause, without purpose, without meaning. The difficulty faced by the ontology of actuality in the final count is that the one thing that is supposed to be knowable, if knowledge is possible at all, is true being, yet true being is also the *least* knowable of all. Why? Because the truest being, per this ontology, is the most active, and the most active is the most free. It is not by chance that philosophers, especially modern philosophers, tied freedom to the possibility of evil. Why wouldn't a completely free being choose evil or, for that matter, *irrational* over rational behavior? Even Descartes, who would go on to prove not only God's existence but his necessary benevolence, first observed that, precisely

because of God's omnipotence, there seems to be no ground for denying that he might be a deceiver rather than a truth-teller: "How do I know that he has not brought it about that there is no earth, no sky, no extended thing, no shape, no size, no place, while all the time ensuring that all these things appear to me to exist just as they are now?" (*M* 14)—a horrifying thought, revealing an unfathomable abyss, the stuff of nightmares. "It feels as if I have fallen unexpectedly into a deep whirlpool which tumbles me around so that I can neither stand on the bottom nor swim up to the top" (16).

This is the horror of the rational thinker—the thinker who must ask *why?* and is compelled to search for a sufficient cause or reason. What if being, which is action, is not good but evil? What if that which I take to be reason is itself irrational? These are among the questions that Descartes asked himself. Immanuel Kant, another champion of reason, made this general statement: "Human reason has this peculiar fate that in one species of its knowledge it is burdened by questions which, as prescribed by the very nature of reason itself, it is not able to ignore, but which, as transcending all its powers it is also not able to answer. The perplexity into which it thus falls is not due to any fault of its own" (*CPR* 7). Whose fault is it, then? For Kant, it is not a fault at all but the mark of irreducible freedom. If knowledge is limited, it is because freedom, which is the ground for the possibility of knowledge, is not itself something to be "known." Kant therefore relegated the domain of this freedom, together with any consideration of an entity that is *self*-causing and *self*-grounding, like God or reason itself, to faith (*Glaube*) rather than knowledge. And though he considered this faith "necessary," that is, rational, it was still not knowledge and not something that could be proven or forced on someone who does not believe, or believes otherwise, if only because, being free, not all people choose to abide by the laws of reason.

In the end, reason has no way of validating itself or its grasp of the world. It may be that there simply is no clear ground, within an ontology of actuality, for *deciding* between good and evil, or even that, ironically, there simply is no ultimate *ground* at all. It is important for those who live and think by this ontology to seek for a first and absolute cause, and it is equally important to see in it something inherently good, rational, or rationalizable. But to the extent that reason is a spectator, that it is not *at one* with the act but is its judge, the good is necessarily bound up with, shadowed or haunted by, its opposite. So although the order of causes promises to be the most natural

environment for the thinker, this does not mean that the thinker must be content with this environment as it is. Here, too, language bears testimony to the fact: just as the term *objection* is wedded to the term *objective*, so the term *accusation* (from *ad causa*) is wedded to *cause*.

PROBLEM AND POSSIBILITY, THE REAL AND THE IDEAL

In the *Phaedo*, Plato has Socrates explain to his interlocutors the meaning of "form" by asking them to consider the appearance of equality in the visible world. When we look at what we consider "equal" sticks or "equal" stones, he challenges them: is it not the case that the equality between them is at best an approximation? But an approximation of *what*? From where do we obtain the idea of a perfect equality?

> Whenever someone, on seeing something, realizes that that which he now sees *wants to be like* some other reality but falls short and cannot be like that other since it is inferior, do we [not] agree that the one who thinks this must have prior knowledge of that to which he says it is *like*, but deficiently so? . . .
>
> We must then possess knowledge of the Equal before that time when we first saw the equal objects and realized that all these objects *strive to be* like the Equal but are deficient in this. (*Ph* 65, italics added)

Here, the theory of knowledge-as-recollection (as something we already have within us) potentially points to the gloomier aspect of the ontology of actuality to which this theory belongs, for it suggests that the things that populate our world *fall short* of the way they ought to be, or "want to be like" in Plato's words. It is as if everything in the world is at once striving and frustrated, inadequate, flawed. And it is interesting that of all forms, Plato should choose the form of equality to argue this point. Beyond the merely approximate equality of things like sticks and stones, it would not be unfair to argue that human history provides little evidence of anything like true equality among humans. Yet Plato seems to suggest that to the active (critical) observer, such true equality announces itself in empirical realities in the form of a *wanting*—in both senses of the term.

Kant would later modify this claim, extending it to the practical realm, by suggesting that a constitutive disparity between the *real* (as that which appears) and the *ideal* is not so much an inner striving of things as it is an imperative posited by rational thought: "reason unrelentingly commands

actions of which the world has perhaps hitherto never provided an example and whose feasibility might well be doubted by one who bases everything upon experience; for instance, even though there might never yet have been a sincere friend, still pure sincerity in friendship is nonetheless required of every man" (Kant 1993, 20).

The ideal of sincerity in friendship is not based on experience but the other way around: the experience and practice of friendship *ought to be* like the ideal. This claim is designed to guarantee, and explain the possibility of, genuine progress: a progress *toward* an ideal, which is precisely what is captured by Plato's notion of "striving." Even if all my friends betrayed me, or I had never known anything like a "true friend," I still have a concept of this friendship in light of which I say I never experienced it or anything like it. The difference between real and ideal introduces a categorical opposition between what *is* the case and what *ought to be* the case: the real and the perfect. And this opposition guarantees that, notwithstanding progress and approximation, the real always is, was, and will be *im*perfect, subject to a standard that exists separately from it—a standard before which, as per Plato, the real is at best a more or less faithful representation.

The categorical distinction between what-is and what-ought-to-be was for Schopenhauer the necessary premise for theory as such. In a passage cited earlier in the book, he put it plainly: "If the world were not something that, practically expressed, ought not to be, it would also not be theoretically a problem" (Schopenhauer 1966, 579). This statement not only posits the disparity between what is and what ought to be but also names it: *a problem*. Theory, we are led to understand, presupposes the existence of problems. The problem is thus the subject matter of theoretical work and its raison d'être. Where there is no problem, there is no theory.

The postulation of a problem is one of the most outstanding features of critique. Here, as elsewhere, we can see that the notion of "critique" extends far beyond the scope habitually relegated to it. Where do we not find the postulation of a problem as the starting point for theory and practice? Take, for example, medical science and our healthcare system, and consider how each of them hinges on the diagnosis, cure, or prevention of those "problems" we call disease. A disease is something that is not as it ought to be— not health; it is a health-problem and as such calls for intervention, analysis, correction. The same applies to the popular perception of psychotherapy,

according to which one enters therapy only if one experiences problems or what we otherwise call "issues." These widespread approaches to the institution and raison d'être of healthcare are expressive of the orientation of critique or the spectatorial orientation more broadly. Under this orientation, we assume that a healthy or happy person—one who does not experience any special problem—would have nothing to look for at a doctor's or a therapist's office, except for a general checkup, meant to ascertain that, indeed, no problem exists.

Yet another institution in which we detect the same foundational tendency is the justice system. Those who do not work there have nothing to look for in the buildings and hallways of the justice system unless they are somehow involved in wrongdoing. Justice is the correction and arbitration of wrongs—problems. Just imagine a good-seeking person who, out of sheer excitement and motivation, steps up before the court and says: "I seek justice!" *What* justice? Without reference to a specific problem that needs correcting, this statement would be meaningless.

In all these cases we see at work what we can call the *Schopenhauer Principle*: if your health, your life, or your conduct does not involve something that, practically speaking, ought not to be, then it is not medically, psychologically, or legally a problem. It is simply a nonissue, *not a thing*. There is an ontological assumption at play, and it will be useful to point out some alternative ways of thinking to further demonstrate this fact. Jonathan Swift had his Gulliver journey to fictional lands that, among other anomalies, fostered alternative judicial systems. In one of them, Gulliver met people whose goddess of justice was not blindfolded like ours but "formed with six eyes, two before, as many behind, and on each side one, to signify circumspection." And she was not carrying any scales. With "a bag of gold open in her right hand, and a sword sheathed in her left . . . she is more disposed to reward than to punish" (Swift 1996, 34). Montaigne found similar alternatives even closer to home, in the lands of the real rather than the outreaches of fiction. "In China," he wrote, "the officials delegated by the prince to examine the state of his provinces . . . punish those guilty of corruption in office [but] also reward quite generously those who have behaved well, above and beyond the call of duty." Therefore, the people there appear before the court "not only to escape punishment but to gain thereby, and not simply to be paid but to be rewarded as well" (Montainge 2012, 235). The analogue of such alternative practices of justice in the field of

healthcare (physical or mental) may involve a conception of health that is not premised on the negation of (opposition to) the problem disease but as answering the question of what would make life better and, in general, fostering an atmosphere of self-care as a matter of enhancement and reward rather than a cure.

The problem-grounded, and the detection-, solution-, cure-, or prevention-driven constitution of systems and theories, is thus a matter of orientation to and within the fields of health and justice, morality and politics; it is a manner by which these fields are constituted. This is not simply a matter of convention or disposition but an ontology. Let us look more closely at what it means to *be* "a problem," what the conditions for the possibility of a "problem" are.

In the above cited statement by Schopenhauer, it appears that the term *problem* goes hand in hand with the term *theory*, but this was not always the case. Ancient Greek geometry distinguished between a "theoretical" and a "problematical" method. Whereas theoretical geometry advanced through positive assertions (theorems), problematical geometry advanced through suppositions or hypotheses (terms that literally mean *standing under*). To this distinction corresponds another: that between *categorical* claims, which state unconditional necessities ("this *must* be so") and *hypotheticals*, which state conditional necessities ("*if* this is so, *then* that must be so").

"Problematical" is thus related to the hypothetical or conditional. This connotation of the term *problem* acquired its full ontological significance in Kant's philosophy, where it came to occupy the very ground of human experience and knowledge. Human experience and knowledge, for Kant, are problematical from the ground up. How so? In that we can only *directly* experience effects (appearances) but not causes. We know *that* things are and *how* they are, but we cannot *know why* they are or why they are this way. For that reason, nothing exists for us with any necessity. Now, one thing *is* certain: if something exists, then it is necessarily *possible*. But the converse does not hold; if something is possible, it does not mean that it *must* exist, that it could not be or have been otherwise. On the contrary: in the ontology espoused by Kant, anything that exists, at least as far as we can experience it, is *only* ever possible. This is, for example, the reason for which the existence of God is necessarily a moot point for us. Since God is an *unconditional* being, a being that, if it exists, exists necessarily and for all time, we

could never, according to Kant, have any direct experience or knowledge of that existence simply because *we* are finite and conditioned beings.

Thus, to say that our experience is "problematical" is to say that our experience and everything we encounter through it is conditional, contingent. This fact is captured in Descartes's famous proclamation of the certitude of his existence: "I must . . . conclude that this proposition, *I am, I exist*, is necessarily true *whenever* it is put forward by me or conceived in my mind" (*M* 80, italics added). The little word *whenever* (*quoties*) marks the hypothetical structure of this statement. I cannot say that I am due to some necessity, only that, *now* that I am thinking, and *as long as* I think, I must also be. If Descartes's statement expresses necessity (and it does), it is only with respect to the necessary truth of his *judgment* regarding his existence ("*this proposition*," he says, "is necessarily true whenever . . ."). Later, he makes the point more explicitly: "I am, I exist—that is certain. But for how long? For as long as I am thinking. For it *could* be that were I totally to cease from thinking, I should totally cease to exist. At present I am not admitting anything except what is necessarily true" (82, italics added). The structure of the statement is thus hypothetical: *if* I think, I necessarily must be, and so from the fact that I am now thinking, it follows that I am, or in short form: *if* I think, *therefore* I am.

Existentially speaking, what Descartes implies is what we all know to be true: our existence is not guaranteed; independent though we may be in thought, our existence is structurally dependent. We are not the kind of beings that can ground and sustain themselves. I am, I exist, this much I know for a fact, but for how long? This I have no way of knowing; it is a question that pertains precisely to *the limit* of my power of thinking and therefore to the limit of my capacity to know. We can also see from Descartes's formulation the manner in which, as conscious beings, we are, so to speak, "locked" into the present: all I know for certain is what *is* the case and what must be the case *given* that this is the case, but I cannot know anything beyond that. Human existence is "problematical" because it is dependent on things that fall outside of its powers of knowledge and control. These "things" are nothing but being itself. Humanity can experience being and know being, but it cannot *create* being in any substantive sense. Here, once again, we recognize the essential condition of the spectator in its opposition to the maker.

For Kant, as for Descartes, the constitutive limitation of the human condition was far from tragic or lamentable. For Kant, it was more like a superpower than a weakness. For the fact that everything that exists is problematical also means that everything could also be otherwise. We may not be creators, but we are certainly *problematizers*; we do not accept anything at "face value." Beyond our limited experience and knowledge (and even *thanks* to that limitation), an entire new field, proper to the mind, opens up: the subjunctive field, we might call it, the realms of what *could* be and what *could* have been. As I noted in chapter 2, this field makes us *dreamers* in the active sense of the word.

This, then, is the *true* meaning of "the problem": so long as nothing *has* to be the way it is, everything is *contentious*, problematic, and problematiz-able. This is also the significance of the opposition between what *is* the case and what *ought* to be the case, which is the condition for the possibility of critique and, per Schopenhauer, of theory in general. The subject is freed from the arbitrary authority of the real with the very same gesture in which she submits and defers to this authority. This may sound ironic, but under the auspices of critique it makes perfect sense: since nothing is necessary, my own existence least of all, I am sovereign and free. Nothing compels my judgment, not even knowledge itself. And maybe there is a God who created me, and could annihilate me, yet there is no God who could command me to accept my existence and the world he created based on anything but my own terms and judgment.

By the same token, every knowledge I have about the world is at the same time a doubt: This is the case, so much I know for certain, but for how long? Does it *have* to be so? Is it *right*? Perfection is banished from the visible world together with unconditional necessity. If something exists, it is at least potentially flawed, and if the critic *wills* it, then flawed it will be shown to be. For while the critic's gaze has no hand in the land of the real, it has perfect reign over the land of the flaw and the flawed. *Here*, no limitation exists. If *perfectionism*, as many of us know from experience, knows no bounds, it is precisely because *im*perfection is boundless. "My dear fellow," says Socrates to the one who naively prizes things he considers "beautiful" and "just," "of all the many beautiful things, is there one that will not also appear ugly? Or is there one of those just things that will not also appear unjust? Or one of those pious things that will not also appear impious?

There isn't one, for it is *necessary* that they appear to be beautiful in a way and also to be ugly in a way" (*R* 1106, italics added). This is also the rule of all procrastination, which, together with perfectionism, can be deemed "the critic's disease," the condition that most distinguishes the critic from the artist. As critics, we are all plagued with the knowledge that whatever *is* is never and could never be as it *ought* to be.

THE DEBATABLE NATURE OF TRUTH

Another important aspect of the problematicity of our existence can be un-veiled by looking at the etymology of the word *problem* itself. In remarkable affinity to the word *object*, *problem* means being "thrown-before" (from *pro-ballein*). Gadamer noted that the term originates in the context of an-cient sports, where "competitors who line up against each other . . . attempt to throw obstacles in each other's way." From there, he said, "the expression is transferred figuratively to debate: an argument posed against the per-spective of the other participants in a conversation is like an obstacle" (Ga-damer 2016, 16). The problem-posing orientation is thus intrinsically linked to a culture of debate. Since, as Mallarmé put it, a critic is someone who meddles in *other* people's work (Gauguin 2002, 20), it should not surprise us that the relation *between* critics, as the one between lawyers, is charac-teristically disputative, where each one exerts their intellectual efforts, and flaunts their intellectual expertise, by finding flaws in the other's reasoning, throwing obstacles their way.

Kant portrayed the entire history of metaphysics as a kind of philosoph-ical Olympics, a "dialectical battlefield," he called it, where "vigorous fight-ers, no matter whether they support a good or bad cause, if only they . . . make the last attack . . . [may] count on carrying off the laurels" (*CPR* 394–95). The "last attack" is of course a matter of arbitrary finality; there can only be a last attack insofar as there is some arbitrary time limit on the debate. In writing this, Kant might have had Aristophanes's caricature of Socratic dialogue in mind. In his comedy *The Clouds*, Aristophanes had a character named "Mr. Bad Reason" enter a debate with "Mr. Good Reason." The former acts "generous": Let him go first, he says, because

... no matter what he speaks
I'll shoot him down with new ideas
And modern idioms till he freaks
Out ...

The Chorus follows:

Now we shall see who is superior
In debate and common sense;
Yes, and also word defense.
Which of the two will appear
The better in his speech?
The very moment is here
When the wisdom of each
Depends on a toss of a die. (Aristophanes 2005, 174–75)

Because the formal "rules of the game" (who gets to go first, who has the last word) seem to override philosophical content (good or bad reason), Kant, for his part, preferred to steer clear of this kind of polemics altogether. "As impartial umpires," he wrote, "we must leave aside the question whether it is for the good or bad cause that the contestants are fighting. They must be left to decide the issue for themselves. After they have rather exhausted than injured one another, they will perhaps themselves perceive the futility of their quarrel" (CPR 394–95). Heidegger, expressing similar discontent with the philosophical culture of debate, framed the issue in commercial rather than athletic terms. Professional philosophy, he said, is but an "industry of problems" (Heidegger 2008b, 4). The mind-body problem, the problem of solipsism, the problem of the source of knowledge (empirical or rational), the problem of the origin and destiny of humanity (individual or communal), metaphysical, epistemological, political, and moral problems—all are subject to debate, yielding so many solutions, and with them, so many "positions" (characteristically marked by "-isms"), so many "schools of thought."

All this does not, however, *have* to be futile as Kant and Heidegger considered it to be. Karl Popper, for one, considered the "emergence of a problem [as] the first step along the road of progress" (cited in Gadamer 2016, 17). Hegel, and indeed Marx, took it even further than that. To them, the whole progress of *history* was premised on the dialectical clash of oppositions,

whether on ideological or socioeconomical grounds. Of course, this view (or again, orientation), while it accounts for the possibility of progress, also makes it a rather fraught and agonistic affair. In general, the notion of progress is contingent on the obstacle-throwing that is "the problem." Like the advent of crises and breakdowns, problems are conducive to critique simply because they force us to stop and think, providing the ground and need for the turnaround of reflection. The entire ethos and practice of the Socratic dialogue, which consists of disputation (*elenchus*), is built on this premise. Socrates's art, beyond its mocking depiction by Aristophanes, is the art of problematization, casting obstacles in his interlocutors' way or poking holes in their reasoning. The original aim of this process for Socrates, at least in Plato's "early dialogues" (an appellation that is—how else—subject to debate), was less a matter of progress than of bringing his interlocutors to a *halt*, or *aporia*. One of his interlocutors testified to this experience:

> Socrates, before I even met you, I used to hear that you are always in a state of perplexity and that you bring others to the same state, and now I think you are bewitching and beguiling me, simply putting me under a spell, so that I am quite perplexed. Indeed, if a joke is in order, you seem, in appearance and in every other way, to be like the broad torpedo fish [electric ray], for it too makes anyone who comes close and touches it feel numb, and you now seem to have had that kind of effect on me, for both my mind and my tongue are numb, and I have no answer to give you. (*Meno* 879).

The primacy of the problem is the primacy of the question over the answer, the debate over the resolution; and it guarantees that no one, not even Socrates (or Hegel, or Marx), may have the last word.

SIX

Political Ontologies
of Critique

This chapter proposes something like a deduction of political categories
and values from the ontological and logical framework of critique: these
categories include the notions of class, gender, and race, as well as class
consciousness, authenticity, property, rights, and finally universality. I use
the Kantian term *Deduction* (*Deduktion*) deliberately to invoke the analogy
to Kant but also ironically to underscore the difference in approach. Kant
used *deduction* in a juridical sense, as the act of *justifying* and proving the
necessity of "pure concepts" and principles and their hold on our thought
and experience. But just as I do not take the spectatorial orientation to be
coextensive with human "experience" (there are other possible orientations,
and therefore other modes of experience), I also do not take the list of cat-
egories deduced from this orientation to be necessary or complete. What I
do want to suggest in this chapter, however, is that the categories I discuss,
which function as keywords in our political vocabulary and debates and in
much of the philosophical tradition, have their home in the ontology of the
spectacle. This implies that, if we are oriented differently and think under
the premises of a different fundamental ontology, these categories may not
impose themselves on our thinking quite as much.

So what does it mean, to categorize? It is to sort out, to place things in certain drawers, under certain labels. By now, it should come as no surprise to find out that the Greek term *kategória*, the origin of our *category*, also means "accusation." *Kategória* was originally a matter of bringing someone before the *agora*—the public assembly. In modern Hebrew, the Greek *kategória* is still employed to mean both a category of things and the prosecution in a trial. And while in English this etymological connection is largely lost, we can still observe its intelligibility in practice, as when someone gets "called out" in the agora of social media by being *labeled* such and such (for instance, a harasser). There is a sense in which every labeling, as the act of making something publicly recognizable within a nominal system of categorization, is implicitly a sentencing. Yet the manner in which modern science managed to set itself categorically apart from morality and politics (as an activity that is concerned solely with facts and not with values) contributed to our losing sight of this essential link. It is not immediately clear in what way the classification of the animal kingdom according to intricate taxonomies expresses any moral attitude, though I would suggest that it does. Just as values can be studied as (social) facts, so facts, even concerning "nature," can be studied as values. We might even say that the very oppositions between facts and values, and between science and morality, bespeak a certain value system, wherein the natural world is set in opposition (and moral inferiority or subordination) to the properly *human* world, which alone is attributed moral significance. It bears repeating that the world that is objectively knowable is also morally reprehensible, and in both cases (knowledge and morality), it is subject to *judgment* as implied in the activity of categorization, classification, predication. This is why Kant, as cited in a previous chapter, suggested that the properly critical theoretical attitude toward nature is to approach it not as a mere observer or pupil but as a *court judge* "constraining nature to answer to questions of [his] own determining" (*CPR* 20). And Francis Bacon, among the chief architects of early modern science, went so far as to suggest that the scientist should "vex" (in other editions, *torture*) nature, almost as if to force out of it a confession. The new science, he wrote, was to show nature not only as it is "free and at large (when she is left to her own course and does her work her own way) . . . but much more [as she is] under constraint and vexed; that is to say, when by . . . the hand of man she is forced out of her natural state, and squeezed and molded . . . seeing that the nature of things betrays itself more readily

under the vexations of art than in its natural freedom" (Bacon 1999, 82). In general, we say that the scientist "investigates," like the detective does, and everything in our attitudes and vocabulary discloses some note of suspicion if not outright accusation. Whether scientifically or morally, the activity of categorization and classification conveys a judgmental relation to the world and human society, and this relationship is fraught.

CLASS, GENDER, RACE

The activity of categorization is recognizable in Marxist thought, specifically in the historiological claim that all social organizations have involved stratification into economical classes. The common tripartite structure of this classification—lower class, middle class, ruling class—evidences a conceptual formalism and dialectical logic, just like the classification of the history of civilization into ancient, middle, and modern. In more recent iterations of critique, the socioeconomical classification of society, or the idea that it is the most significant one politically, has come under scrutiny. Intersectional theory, for instance, reminds us that people are often situated at the intersection/s of more than one form of oppression and discrimination. Besides economical classes, there are racial, gendered, and other cultural classifications. But this fact does not yet challenge the core of the Marxist mode of analysis, which never took class consciousness as a *given* but as something to establish. Class consciousness is the *identification* with one's economical place in society and with others who share it. Such identification provides the conditions (unity, solidarity) for the possibility of revolutionary action, as well as the impetus for it (anger, having a common enemy and goal). Conversely, what stands in the way of acquiring class consciousness is precisely the fact that there *are* competing lines of identification. Conflicting *affiliations* along national, religious, and cultural lines were ideologically erected and deployed in the interest of the ruling classes to keep workers divided and thus easier to control.

Economical classification is therefore at least in part strategic, necessary for revolutionary purposes. This understanding, furthermore, is not limited to a Marxist or socioeconomical perspective. Imagine, for instance, that all voting women in the United States would vote *as* women, devoting their electoral power not simply to a candidate who happens to be a woman but to the woman who is most committed to women's empowerment. Such

political solidarity should, in principle, produce palpable, and indeed revolutionary, results. As things stand, however, a woman has yet to be elected president in the United States, and we can assume that when the first woman is elected, her victory will probably come at the price of her toning down rather than amplifying any feminist sentiments. Why? Because a political "gender consciousness" does not seem to exist on a national level. Many women do not vote *as* women. Many women are, in fact, advocates of sexist views and practices, just as many members of the working class in the US appear to cherish economical views and practices that disfavor them. Already Adorno and Horkheimer noted that "the defrauded masses . . . cling to the myth of success still more ardently than the successful. . . . They insist unwaveringly on the ideology by which they are enslaved" (*DE* 106). Providing an explanation for *why* this is the case is perhaps less important than observing that it does not, for all appearances, *have* to be the case, let alone *ought* to be.

But by noting this problematic, and being frustrated by it, we're evading something more fundamental. Even if we regard class consciousness as a political imperative rather than a factual given, and even if we shift and complexify the rubrics of affiliation and oppression, the fact remains that we take *classification* as a premise. By saying, for instance, that many *women* do not vote as women, or that many of the *proletariat* do not vote as proletariat, we still assume these groups of people—women or proletariat—as a theoretical given. We then observe a gap between what these groups of people *are* ("in fact") and how they identify and mobilize politically. In addition, we claim a logical connection between what they are and how they *should* mobilize politically. And since this logical connection does not seem to translate into actual causation, we are moved to forge theories that explain why the facts are not as they could or ought to be (for example, ideology, false consciousness) and to point out ways in which this can be corrected (for example, critique, education, enlightenment).

These theoretical and practical-political efforts would not be possible without the ontological assumption that society is *in fact* split up and classified along economical, gendered, racial lines (intersecting or otherwise). This assumption is common and evident enough. As Simone de Beauvoir noted, all one needs to do to arrive at the conclusion that human societies divide themselves along binary gendered lines, where "clothes, faces, bodies, smiles, gaits, interests, and occupations [add salaries] are manifestly

different" is to "go for a walk with one's eyes open. . . . Perhaps these differences are superficial, perhaps they are destined to disappear. What is certain is that they *do most obviously exist*" (Beauvoir 2011, 14, italics added). Yet, even if we grant the truth of this statement, it does not refute that this truth is ontologically grounded. Judith Butler, for example, while not disputing Beauvoir's factual observation, underscored its reductiveness: "[In their] effort to combat the invisibility of women as a category, feminists run the risk of rendering visible a category which may or may not be representative of the concrete lives of women. As feminists, we have been less eager, I think, to consider the status of the category itself and, indeed, to discern the conditions of oppression which issue from an unexamined reproduction of gender identities which sustain discrete and binary categories of man and woman" (Butler 1988, 523).

Ontological assumptions are not gratuitous. Ontology is not something floating in the sky apart from reality, facts, or values. Ontology determines not only how facts are theoretically analyzed (and what counts as "facts") but also the fundamental features of our experience—what becomes obvious to us as soon as we "go for a walk" or simply "open our eyes." The idea that society is divided into classes and categories, whatever they may be, and that identities or identifications are how individuals and groups recognize or ought to recognize themselves, is not beyond question. Even such obvious things as the similarity of (and differences between) "clothes, faces, bodies, smiles, gaits, interests, and occupations" depends on a certain orientation that highlights some features over others. It is also not beyond question that all proletarians share "the same" working conditions. It is true that for Marx the ultimately positive import of industrialization was precisely in *homogenizing* and depersonalizing, as well as increasingly globalizing, working conditions. This, together with the commodification of labor, would obviate qualitative differences among workers and facilitate their uniting. Yet—aside from the fact that capitalism, through subsequent technological developments, proved itself much more insidious—from the beginning, "zooming in" on working environments would show that local hierarchies and power dynamics among "workers" complicate the picture and challenge not only the reality but also the ideal of a "working class." Monique Wittig , for example, argued that the Marxist picture is oblivious to intraclass gender hierarchies: Marxism, she said, left "the relation 'women/men' outside of the social order, by turning it into a natural rela-

tion . . . along with the relation of mothers to children . . . and by hiding the class conflict between men and women behind a natural division of labor" (Wittig 1992, 17).

All "pictures" of reality and history are ontologically framed and organized. As Kant suggested, they are always there to answer questions that *we*, the spectators or theorists, ask. Let us take a step back, then, and point out a few things about classificatory logic and the ontology informed by it. Although the word *class* seems to originate in the Roman practice of dividing people for taxation purposes, the logic of *classification* is by no means exclusive to political economy or political organization. If anything, it is more prevalent, and "evident," in logic and science. In logic, for example, we speak of "the class of red things," referring to all things that share the property of "redness." A "class" in that sense is any kind of grouping under a common predicate. In biology, classification manifests in a species-genus organization of living forms, whose ontological roots can be traced back (at least) as far as Plato and his so-called theory of forms. The definition of a form for Plato always involved determining its relationship to other forms. For example, in probing the form of "piousness," Socrates asks his interlocutor Euthyphro to consider its relation to the form of "justness": "[Do] you think all that is pious is of necessity just?" And, if so, do you think that "all that is just [is also] pious? Or is all that is pious just, but not all that is just pious?" To this, a bewildered Euthyphro responds, "I do not follow what you are saying, Socrates" (*Eu* 11).

This is what he is saying: do you think that being pious is the *same* as being just, or is it only a *species* (a specific modality) *of* it? Forms can relate to each other in different ways—some intersect; some are mutually exclusive; and some are subordinate, related to each other as a genus (the more general) to a species (the more specific). We can depict these possible relations in four diagrams: either (a) we draw one circle of which piousness and justness are two different names, or (b) we draw two completely separate circles, one for piety and one for justice, or (c) we have one circle nested inside the other, or (d) we have the two circles intersect. Under a similar ontological framework, Aristotle produced his definition of the human being as an animal with *logos* (language, reason). Here, the class of animals is the genus of which the class of humans is the species (so that, in a diagram, the circle representing humans would be nested within the circle representing animals). Humans belong completely to the class of animals

but are *distinguished* from all other animals by a specific property—which in Aristotle always means a specific *activity* or "function"—namely, *logos*. In the form of a judgment: "all humans are animals, but only some animals are humans."

It should be obvious from this account that "species-genus" coordinates, and the whole business of classification and specialization, are inherently *relative*. Each thing is a species with respect to one thing and a genus with respect to another. The "nesting" of forms can therefore be stretched out in either direction—the telescopic or the microscopic—zooming out or zooming in. If it is true, for example, that humans are a species of the genus animals, it is also true that humans are the genus for the species Greeks ("all Greeks are human") and that Greeks are the genus for the species Greek women ("some Greeks are women"), or, should you prefer it, Greek women are a species of the genus women ("some women are Greek"). Similarly, while humans are a species of the genus animal, animals themselves are a species of the genus living things, which includes vegetative life as well as animal life. Accordingly, no class or "form" is *inherently* a "genus" or a "species" but rather, they are all given *within a system of relations*—the product of judgment and categorization—in which they stand to each other either in a relation of identity, or in a species-genus (nesting/hierarchical) relation, or in a mutually exclusive (interior/exterior) relation, or in some form of intersection (as in a Venn diagram).

The rubrics of "gender" and "race" are just as generic, and indeed formal, as "form" and "class" and are therefore just as relative as genus and species. The word *race* was apparently used to classify wine flavors long before instilling itself in biological and genealogical practices of species classification, which opened the way for the racist practice of classifying "species" (or subspecies) of humans. It quickly becomes an ugly business, from which it is difficult to emerge with clean hands, no matter how good the intentions. "Humanism," for example, which is often pitted as an antidote to racism, itself specifies a race—the "human race"—to the exclusion of, and as standing over, others. An ontological-logical perspective helps us see this connection and relativize the semblance of opposition between the human and the inhuman. Is humanism a species of racism or is it the other way around? Be it as it may, if humanity is in fact a race, then humanism is "racist." Perhaps there is nothing more to our "species-being," as Marx called it, than calling ourselves a species: "Conscious life-activity directly distinguishes man

from animal life-activity. It is just because of this that he is a species being. Or it is only because he is a species being that he is a Conscious Being, i.e., that his own life is an object for him" (EPM 76). The human being is, first, a species of animals that has consciousness and, second (which is inherent in the first), the species of animals that represents reality to itself through genus-species classification, within which it locates and understands itself (a bit below an angel, far above the beast).

The classificatory-formalism inherent in the notion of gender is an even clearer case in point than race: "gender" is but a modification of "genus." So when we ask what *kind* of genus is "gender" (one that pertains to "sex" perhaps?) or what *kind* of species is "race" (one that pertains to what—skin color? body type? ancestry?), we may be embarrassed to realize that the generic, if not empty, nature of the terms corresponds to an equally generic nature of specifications. We may also come to see them as intrinsically bound up with the messy business of hierarchical ordering of living forms, which somehow has the odd tendency to support the practices of asserting superiority and inferiority. As to "class," albeit lacking the biologistic connotation that has stuck to species-genus, it is just as generic and empty, a figure and function of hierarchical division and ordering of being. It is no wonder, perhaps, that those who affirm the existence of classes for the sake of combatting classification always resort to the purest designator of a "class"—namely, the *degree* of oppression and inferiority. In the end, nothing defines this or that "class," "gender," or "race" but their place on a hierarchical ladder, a place defined by the ladder or the ordering itself.

Classification carries several functions: it labels, and by labeling it marks what is common to a group and what distinguishes it from others. This distinction, as other uses of the word suggest, is always implicitly a question of superiority and inferiority—of which category includes which, and what class stands over what. This is the reason for which the notion of class is so closely associated with prestige that we can make statements like "You have class." It is important to acknowledge this, for the aspiration that a theory grounded in hierarchical logic would support the dissolution of all hierarchy rather than the formation of new ones may be self-defeating. It is also understandable that in contemporary culture, the ancient competition over who belongs to the higher class has been replaced by a competition over who belongs to the lower one. Such reversal exemplifies the way that form, when rigidly applied, becomes indifferent to content. Hierarchy is

hierarchy, and the high/low, privileged/underprivileged coordinates are as relative, and reversible, as those of genus and species. There is no *absolute* "high" or "low" because they are inherently comparative terms, and the coordinates, as we repeatedly see, are in principle subject to metastrophic overturning, in one way or the other. What survives such turnarounds is the hierarchy itself and the conception, as well as practice and experience, of power that is adjacent to it: power-over, the power of the "scales."

If classes exist along a hierarchical scale, the scale itself is defined by its polar extremities, which are ideal rather than real. On one end of the scale, we have the ideal notion of *universality*; for example, a universal class or a classless society. On the other end, we have the equally ideal notion of *singularity*, that which is so specific and special that it transcends all classification and generalization. It would thus be *sui generis*, a genus unto itself. Conversely, singularity could also refer to that which is so *other* it *escapes* all categorization and representation, is ineffable, invisible, or only present to itself. On the one end, then, we have the class of all classes, in which all classification is dissolved. On the other end, we have pure being (or non-being) as unclassifiable. On the one end, complete inclusion; on the other, complete exclusion. At the limits of the hierarchical ladder, there is no more ladder or hierarchy, not even comparison. The necessity of both these oppositional poles guarantees the instability of the force field generated between them. This force field is reality itself, the field of knowledge and analysis (judgment)—all that lends itself to classification. If genuine political commitment to universalism means respect to the singularity of each being, then the industrious efforts at specification and inclusion are structurally endless—its ends are unrealizable ideals. These efforts are also, in a way, structurally wrong.

The ideal limits of complete specification (microscopic) and maximal inclusion (telescopic) are above all fictitious, mere functions of the movements in between. Mistaken is the one who thinks there is an absolute or universal class: a genus so general that it is not a species of anything else, or that there is a species so special it is not itself a genus. This is not how classificatory logic works. It is not only the case that we can always introduce new classes (complexification); it is also the case that we can always introduce new *levels* of classification (replexification). There always exists the mathematical and logical possibility of generating *meta*level classifications; for example, we can introduce a class that consists of certain classes, like the

class of large classes, and we can also group different types of classification into classes. Classificatory logic cannot be "closed off" because every apparent totality or *maximum* can always be subsumed under a metaorder, which becomes a class unto itself (we can, for example, have a theory of theories, and then a theory of theories of theories). The advent of a metastrophic turn—a revolution or a critical/dialectical turn—belongs here, in the generation of entirely different orders that render what before was considered fundamental as in fact secondary or derivative.

Thus, to the infinite "horizontal" expandability in both directions of the genus-species classification we can add an infinite "vertical" expandability where whole *systems* of classification are continuously overturned as their limits are exposed. Time and again we see such overturning at work, together with the relativity of each system of classification: what a previous generation of Marxists call "class," for a future generation appears as at once overly inclusive (for by "including" women in this class, it collapses the disparity between the conditions of women and men) and overly exclusive (for the implicit paradigm of this allegedly monolithic working class is the working *man*). And similarly, what a generation of feminists counts as a "gender," for a future generation appears as at once too general (for it collapses the disparity in the experiences of queer and straight women, white and black women, cis and trans women), and too specific (since the implicit paradigm is a straight white cis woman). The undeniable truth of each of these critiques should not obscure the more general truth they disclose about categorization: as per its etymological meaning, categorization is a matter of *doing justice*, yet its abstractions and generalizations are always, categorically, unjust.

BEING AND HAVING: AUTHENTICITY AND RIGHTS

Classification seems to always fall short of, disappoint or betray, the individual, singular being, reducing it to some property it shares with others or that distinguishes it from others, but does not adequately single out what it truly *is*. This is perhaps because categorization, as I have said, always faces the public, the agora, always externalizes. For Aristotle, one "category" stood above and apart from all others, a mysterious category, that of *being-ness*. As Heidegger explained, this category is especially mysterious because it seems to apply to *all* things that are, indiscriminately. Yet, Heidegger in-

sisted, it does not truly apply to *all*, like the "class" of all things, but to *each*. Whereas all classes pertain to *what* a thing is, beingness pertains to the fact *that* it is, which is at once ungeneralizable *and* unspecifiable. The category of beingness thus describes a thing's irreducible uniqueness. We can trace this idea back to the substance-property ontology briefly alluded to in the previous chapter, in which *substance*, which literally means "standing under," is the *bearer* of properties but is not itself a property. "Properties" can be understood grammatically as predicates. To say, for example, that "a whale is a mammal" is to attribute certain properties (mammalian properties) to the whale. Similarly, to say "*this* is a whale" is to attribute whalean properties to this *thing* or *substance*. The idea is that underlying all these attributions is the thing *itself. This* mammal differs from all other mammals, not because of something special it *has* (this or that property) but because it *is*. When this whale dies, none of the essential properties of whaleness would die along with it; only its *existence* would end, its substance, or unity, dissipate.

In Kant's philosophy, the claim that being is not a property or a category of things becomes explicit. "'*Being*,'" he writes, "is obviously not a real predicate; that is, it is not a concept of something which could be added to the concept of a thing" (*CPR* 504). It is true that some properties are essential to a thing, that is, are contained in its concept or definition. The inessential properties, by contrast, are *additive* and can be removed without annihilating the thing altogether. A classic example of the distinction between essential and inessential properties is seen in Descartes, who defines himself (and by extension, the human being) as a "thinking thing" (*res cogitans*). Thinking is indeed a *property* of the human being and, as such, is distinct from its existence. You can note this distinction in the famous sentence: "I am thinking; *therefore*, I exist" (Descartes 1985, 195), where Descartes takes care to keep the two verbs separated with an *ergo* ("therefore"), as if with a hyphen. The claim is divided in two: "I am a thing which is real and which truly exists. But what *kind* of a thing? As I have just said—a *thinking* thing" (*M* 18). Thus, even an essential property is still only a property, a *kind*, but not the thing itself, not the "I," which exists and *does* the thinking or *has* the faculty of thinking (reason). Notwithstanding this distinction between essential property and substance, an essential property of a thing is one *without* which it cannot exist. "For it could be that were I totally to

cease from thinking, I should totally cease to exist" (*M* 18). So, to clarify the essential-inessential property distinction, we could say, for instance, that the author of Descartes's *Meditations* is a "*thinking* thing" by essence but a *wealthy* thing by circumstance. He can stop being wealthy, but he cannot stop thinking, and in either case, his *existence* stands apart from anything that can be said about him, essential or otherwise.

The existentialists, whose thinking in this respect exhibits the orientation of critique, radicalized this line of thought by arguing for a distinction between "existence" and "essence." Notably, both Latin terms designate the same thing: *being*, but whereas *essence* (from the Latin *esse*, "to be") simply means being, *existence* means "set-apart." To emphasize this point, Heidegger mobilized the German word for existence, *Dasein*, which suggests something similar, as it adds to the word being (*Sein*) the prefix "there" (*da*)—as in, being-*there*, *over* there, *out* there, ahead, or before, as if being pointed to. But pointed to by whom, or by what? Set apart from or beyond what? The answer is beyond *essence*. A thing's essence only pertains to *what* it is, to its definition, but being itself is beyond essence, so much so that the existentialists were moved to argue that being itself is *nothing*, yet a nothing that is nonetheless the *truest* being. More specifically, existence pertains to a thing's being insofar as we can strip it of all specific contents and facts, all assignable properties.

The enigma of being—the "thingness" or reality of the thing—which is nothing separate from the thing yet is separate from everything and anything specific that can be said about it or perceived in it—can be thought of in two ways: on the side of the object and on the side of the subject. On the side of the object, the enigma is expressed in the questions "Is X *real*, or is it just an apparition?" That is to say, "Does it exist apart from or beyond my perception of it? And if so, does it exist *as* it appears to me?" This is the eternal riddle plaguing the spectacle and everything in and about our world insofar as it is a spectacle. All objects are *doubtful*, as the skeptics take care to remind us. Or, as Descartes famously phrased it: I know for certain that I exist, and that I am thinking, but one thing I could never *know* for certain is whether I am dreaming or awake, whether the world, including my bodily self as I perceive it, is not only a fantasy. Anything that would serve to "prove" it could, after all, be part of the dream or some other kind of deception.

On the side of the subject, the riddle of existence is more complex. Regardless of whether my thoughts and perceptions are true, I cannot doubt the truth of my existence, for whatever I am and whatever could be said about me, it is certainly true that I am the one *doubting*. I am a spectator on a world, and the world is a spectacle, and whether this spectacle is "real" or not does not change the reality of the experience. Yet the enigma remains, because the spectator can only grasp its own being via the spectacle and so remains a stranger to itself—always *there*, outside itself or its own grasp. Husserl provided what is perhaps the most decisive characterization of the spectatorial position, saying that subjectivity, as consciousness, is pure *intentionality*. No one explained this idea more vividly than a young Sartre, who wrote, with palpable excitement, about the difference between being conscious of a tree and *eating* it:

> To know [i.e., to be conscious of something] is to "burst towards," to tear oneself out of the gastric intimacy, veering out there beyond oneself, out there near the tree and yet beyond it, for the tree escapes me and repulses me, and I can no more lose myself in the tree than it can dissolve itself in me. I'm beyond it; it's beyond me. Do you recognize in this description your own circumstances and your own impressions? You certainly knew that the tree was not you, that you could not make it enter your dark stomach and that *knowledge [consciousness] could not, without dishonesty, be compared to possession*. All at once consciousness is purified, it is clear as a strong wind. *There is nothing in it* but a movement of fleeing itself, a sliding beyond itself. If, impossible though it be, you could enter "into" a consciousness you would be seized by a whirlwind and thrown back outside, in the thick of the dust, near the tree, for consciousness has no "inside." *It is just this being beyond itself, this refusal to be a substance* which makes it a consciousness. (Sartre 1970, 4–5, italics added)

The spectator, then, has no "interiority," or substantiality for that matter, either soulful or bodily. The spectator has no *properties* or contents of its *own*. It is pure *intention* (also pure *will*). This intentional essence—being *of*, or *about* something else—is revealed *through* the object, in endowing it with special meaning. Without an object, consciousness is about as visible as "a strong wind."

Sartre's insistence that intentionality cannot, "without dishonesty," be conflated with "possession" (here metaphorized as food, something I could

grab and ingest) echoes Kant's claim that being is not a property. Insofar as it is without properties, existence turns out to be empty and void, like a room without ceiling or walls. Perhaps the obsessive need some of us have to accumulate possessions and surround ourselves with thick walls and tall fences derives from that constitutive sense of emptiness and outsidedness, from the inadequacy of any and all properties, nominal or physical, to satisfy the desire for self-substantiation (or the refusal to be substantiated, as the case may be). Gustave Thibon gave a theological account of this phenomenon: "The etymology of the word 'exist' (to be placed outside) is very illuminating," he wrote apropos of Simone Weil. "We can say we exist; we cannot say we are. God [alone] is Being. . . . Psychologically [the predicament of being existentially 'placed outside'] is shown by all those motives which are directed toward asserting or reinstating the self, by all those secret subterfuges . . . which we make use of to bolster up from inside our tottering existence" (Thibon 1997, 20). Here we perceive the link between the ontological or logical and the political concept of "property." It is no wonder that sometimes, the more property and wealth one accumulates, the emptier one feels. This is the structure of obsessional desire, like a fire that fuels itself. The truth is that, unlike intentionality, property can always, in principle, be stolen or taken away. No one ever truly *owns* anything in the sense that it is secure and inseparable from the self. Then again, existence itself, which is not a property, can be gone at any moment, along with all properties. As suggested in a myth told by Plato and recounted in chapter 2, wealth has no purchase in the afterlife, and souls arrive naked at the crossroads between life and death to be judged not for *what they had* but for *who they were.*

Something of the Marxist or communist ethos is implicit in this thought, for it suggests that all property is *essentially* common, even if it is not so in fact. As in the case of Sartre's tree, to "own" the tree or devour it is in some way to steal it, or hold it hostage, because the tree *exists* beyond the grasp of any consciousness. No one (truly) owns a thing, and no thing is (truly) owned. Heidegger developed this claim by problematizing the notion, or meaning, of "owning." He coined the word "mine-ness" (*Jemeinigkeit*) to name a characteristic of *all* things that exist in the human world. Mineness in this sense is not a factual possession but a certain coloring of, and indeed orientation to, being in general. Thus, life is always *my* life, the times are *my* times, being is *my* being, the world is *my* world. But even this existential

relationship to being, just like the factual relationship to property, can be disavowed. This fact is expressed in the difference between *authentic* and *inauthentic* existence. *Eigentlich*, the term Heidegger used for "authentic," literally means "own-ly" (having the character of being one's own, *eigen*). The Latin equivalent of authentic and *eigentlich* is "proper" or "appropriate," which again derives from *proprius* or *pro-privus*—the root of the English *privacy*, and of course, *property*. An authentic existence is an existence that is *properly* one's own, lived in full cognizance of its being *one's own*. Using the term *Dasein* (being-there), as I mentioned earlier, to describe the specifically human mode of existence, Heidegger writes:

> In each case Dasein is mine to be in one way or another. . . . In each case Dasein is its possibility, and it "has" this possibility, but not just as a property [*Eigenschaftlich*]. And because Dasein is in each case essentially its own possibility, it can, in its very Being, "choose" itself and win itself; it can also lose itself and never win itself. . . . But only in so far as it is essentially something which can be authentic [*eigentliches*]—that is, something of its own— can it have lost itself and not yet won itself. As modes of Being, authenticity and inauthenticity . . . are both grounded in the fact that any Dasein whatsoever is characterized by mineness. (Heidegger 2008a, 68)

Authentic existence, per Heidegger, does not consist of any specific contents or deeds. Authenticity is existence itself, not only insofar as it is "my" property (proper and unique to me), which is always the case, but insofar as it is lived in *a way* that is proper to me, as "chosen" by me (Heidegger uses the scare quotes around this word to mark his discomfort with it, yet he uses it nonetheless). But even when authentic, and "won" over by Dasein, existence is not a *real* property. The reason is simply that there is no real duality here between the "owner" (Dasein) and what is owned or owned-up-to (existence). The best mark of this is the idea that when Dasein "loses" itself, it is still that self that has lost (and that keeps losing) itself.

It is telling that, in the end, what truly makes a life authentic for Heidegger is nothing in or about life itself but rather *death*. Death, or life insofar as it is always also a dying (a being *toward* death), is the *ultimate* property— one's "ownmost" (*eigenst*) as Heidegger calls it—although it is of course not a real "property" but a possibility, or "choice." To be authentic, for Heidegger, is to own up to one's death, and the irony is that, in order to win oneself, one needs to come to terms with the possibility of being, literally, *lost*.

Death is the choice to own up to what is not chosen and yet is *only mine*, one's "ownmost impossibility." This claim is easier to grasp in the negative: *"No one can take the Other's dying away from him"* (Heidegger 2008a, 284). Someone can take over my job and all my possessions, but no one can die in my place; hence, death is my essential property.

If you find it difficult to perceive the nature of the distinctions suggested here between authentic and inauthentic existence, it is at least in part because they are, well, barely perceptible. This duality in my relation to my existence—finding or losing oneself, choosing or giving up on oneself—is yet another expression of the duality within existence itself, being at once the owner and what is owned. We meet with a similar tension in the liberal concept of "autonomy," which, likewise, implies a coexistence of the ruler and what is being ruled. Like the existentialist concept of "authenticity," autonomy is a certain mode of self-possession, self-ownership, self-choice. The root of both terms is *auto*, which means *same* or *self*, except that this sameness, and even selfhood, can, like all other property, be disavowed, abandoned, lost. Even while existing, existence itself can somehow slip out of one's control, taken hold of by external forces.

In the end, what plagues being under the spectatorial orientation is that *it is never a having*. The English grammar, as that of other languages, captures this distinction between being and having by utilizing the latter as an auxiliary in the construction of past or future tenses: "I have been out of it lately, but I will have come to." This may suggest that "having" only pertains to my being in the past or in the future but not at present. If being can never be properly had at present, it is because to "properly have" something would mean being *inseparable* from it and therefore, again, not really "having" it. Having implies distance, separation. The tenuous relation of being and having, which expresses the tenuous relation between being and itself, is probably the grounds for the development of the concept of *right* in liberalism as well. We should bear in mind that, to begin with, rights were devised as a matter of regulating *property*. A *right* to property, and ultimately, to life, needed to be established to solidify and naturalize, certainly legalize, the otherwise volatile link between the subject and her properties (the same endeavor that the communist tradition would later struggle to reverse). Ontologically speaking, there is no fundamental difference between property rights and human rights. *All* things that the subject can be said to "own," including life, body, and liberty, are, from an ontological stand-

point, *properties* of the subject. The concept of right was devised to link and bind things that are of a fundamentally different order: being and having, substance and property. More specifically, it was devised to *bridge* the gap between being and having, while at the same time entrenching the gap that is being bridged. Let me explain this thought.

One has the duty, but also the *right*, to oneself—to one's purse, of course, but also one's person. Right stands between me and myself like a ridge, which doubles as a bond. Right is the most fundamental possession since it is the possession that entitles me to all other possessions. In an even broader sense, the notion of right hinges on the separation between what *is* the case and what *ought* to be the case—between what is and what is *right*. There is a difference between what belongs to me *de facto* (as a matter of fact) and what belongs to me *de jure* (by right). This is what allows us to say something seemingly as absurd as "a human being is always free but always in chains." Or, "in America, all people are equal." They are free or equal *de jure*, and in substance, but they are unfree and unequal *de facto*, in what they actually *have*. Thus, right, as an ideal, yet substantive, possession, is also the most enduring one, surviving all deprivations. Paraphrasing Heidegger, we could say, "*No one can take the Other's rights away from him.*" Or, to be more precise: "No one *has the right* to take the Other's rights away from him." Or again: "It is not right when people—as they so often do—take the Other's rights away from him."

Right is the right to have what I have and also the right to have what I *don't* have. And the *ultimate* right—the one that all humans are said to share (or *ought* to share in principle)—is the right to *have* rights. But even this right-to-rights is not inalienable. As Hannah Arendt noted, this right is entirely contingent on being a citizen of a sovereign state, a condition that, as seen in the plight of millions of stateless refugees, is no more attached to my person than a passport or an identity card (Arendt 2008, 34). The language of rights is thus highly elusive and has a tendency to proliferate and duplicate itself: "I—have—x;" "I—have [the right to have]—x;" "I—have [the right to have (the right to have)]—x." With each right, the "I" moves farther from the x—its actual (or ideal) possessions—and this, in a seeming attempt to bring it *closer* to itself, to *bind* itself to itself. This proliferation, like the proliferation of class and categorization, has no terminus, for right will never meet the *is*, or will never be truly possessed, for the simple reason that it is split between two orders that are ontologically and categorically

opposed: being and having. It may have a leg on both sides, but it can never *be* both. That rights have a leg on both sides can provide insight into some of the more perplexing phenomena in liberal politics, such as the easy slippage from regarding human rights as a means-to-an-end to regarding them as the end in itself, as the true *substance* of politics. For instance, while the original invocation of human rights was arguably meant to protect humans, liberal democracies often come to take these rights as sacred entities to be protected *from* humans, even at the cost of their lives and well-being. Thus, the line between the right to defend oneself or the community and the right to endanger and kill others is never clearly demarcated.

To conclude, we have seen that the essential disparity between being and having produces, and haunts, an entire family of related concepts—possession, property, privacy, autonomy, authenticity, rights. I would argue that this disparity mirrors the one between the seer and the seen—the doubling and splitting that I described in chapter 2 as characterizing consciousness itself. The same mode of being that is ontologically alienated is politically and morally bound to seek and enforce unification, ownership, and control. These concepts and the values they entail have a real history and real practical implications and manifestations. It is tempting to trace this alienated condition to the historical rise of a given sociopolitical system, if only because doing so seems to open the possibility of ending the alienation. The question this invokes is what comes before what, what is the *cause* of what—the political reality or the spectatorial orientation? I do not think this question is answerable for the simple reason that it can only be asked on the grounds of the spectatorial orientation itself. It is the only orientation that could yield the suspicion that ontology and real politics are separable, such that the one could ever be caused (or overthrown) by the other.

UNIVERSALITY AND THE SPECTATORIAL POSITION

The association of critique with the spectatorial position or consciousness may be taken to suggest that critique, and perhaps orientations of thinking and being in general, are matters of *individual* comportment if not choice. What may cause this impression is that, on a cultural level, we have come to associate consciousness with subjectivity and subjectivity with the Cartesian "I." This association is reductive even within the conceptual framework

of critique. The notion of "consciousness" makes up a part of a constellation of ontological, epistemological, logical, ethical, and political premises. The politics that sanctions an ideal of communal property is inscribed in the same ontology as the one that sanctions property and privacy rights. Both hinge on the essential conception of being as apart from its properties, and as split or doubled within itself. There is, of course, a *significant* difference between a value system (as communism) that lays the authentic on the side of the common and one (as liberalism) that lays it on the side of the private, but this difference pales before the split within being itself, which is what makes ownership and property into a fundamental problem in the first place.

Among the philosophical systems that exhibit the orientation of critique, the ones that most emphatically challenge the identification of consciousness with the individual thinker are Hegel's and those that follow it. Hegel acknowledged the particular importance of the individual thinker as a site for actualizing and explicating the sovereign essence of consciousness. The Cartesian (and later the phenomenological) thinker—having set up an isolated, laboratory-like retreat for meditative introspection—is in a position to *experiment* with consciousness, analyze its structures, "direct" it at will, turn it from side to side and turn it around itself, examine and modify its every procedure. The Freudian psychoanalyst can do something similar in the equally secluded but *inter*subjective context of the clinic, permitting to extend the analysis to *un*conscious intentionality, which is still lodged in the individual psyche. Such meticulous procedures of introspection and interspection are not something a collective can achieve. However, as Hegel reminded us in his *Phenomenology of Spirit*, certain sociopolitical conditions must already be in place for such individualist procedures to be possible. Modern philosophy does not occur in a bubble but in a particular sociohistorical and political context. Hegel also reminded us that there is something extremely limited in a consciousness that is isolated and detached from the lifeworld, work-world, and the political arena.

The "I," Hegel said, always *presupposes* a tacit (political) "We," even if the capacity to *utter* a "We" (and to say anything meaningful following it, for example, "We want that . . . ," "We believe that . . . ," "We have decided that . . .") requires very elaborate institutional apparatuses. The meditation of the solitary thinker can at most be a stage in the formation of these apparatuses, as indeed historically it has been (just consider the importance of

a manifestly introspective thinker like Jean-Jacques Rousseau, immensely influenced by Descartes, for the advent of the French Revolution). Whether explicitly or implicitly, the possibility of attaining, safeguarding, optimizing the spectatorial position and the orientation of critique is *always* sociopolitically grounded. We should also recall that there is nothing individual about the spectacle. The spectacles of the ancient Greek and Roman cultures, for example, were public affairs through and through. The vision of an individual spectator munching popcorn on her living room sofa in front of a TV production of Sophocles's *Antigone* was not something Sophocles could fathom, nor is such an eventuality essential to the spectatorial culture fostered by the ancient Greeks. To the contrary, their public spectacles were a means for the making of a *collective* identity and ideology, as spectacles in one way or another essentially are.

If there is one thing that makes the rise of the solitary spectator as a paradigm inevitable, it is the essentially monocular and hegemonizing function of the spectacle. The transcendental individual consciousness crystalizes the transcendental unity of the community and of what Rousseau and others called the "General (or Common) Will." Whether it refers to itself as "I" or as "We," or does not refer to itself at all, the *essential* markers of consciousness are its *transcendental* position with respect to its object and itself and its *individuating* character, which does not have to be reduced to the liberal conception of an "individual." "The transcendence of Dasein's Being . . . implies the necessity and the possibility of the most radical *individuation*," said Heidegger (2008a, 62), who likewise considered that Dasein does not have to refer to a single person. As long as it is *individualizable*, Dasein can also, for example, be a *Volk* (a people). Heidegger would sternly reject the association of his *Dasein* with the spectatorial position or consciousness, for a number of significant reasons; yet these two key features of the spectatorial position—transcendence and individuation—do survive his effort to move away from the "traditional" (that is, spectatorial) conceptions of subjectivity and consciousness.

The spectatorial position individualizes in that it is monocular and univocal, and it becomes more so the more it becomes *self*-conscious. Its unifying structure is the one that Kant named "the unity of apperception," where *ap*-perception means no more than the hither side of perception—namely, the fact that every perception has a perceiver "behind" it and some degree of intellectual proprioception (self-awareness) to go with it. Owing to this

apperception, the spectacle is always a unified whole, itself situated within a greater unified whole, up to the maximum we may name "the universe" or "world history." There is, however, no unified spectator, private *or* public, *outside* this universality; the two sides of the equation (spectator and spectacle) are coinstituted.

With these preliminary considerations, we return to the Marxist notion of "class consciousness." Without such consciousness, Marx argued, the working class would, at most, be a theoretical object for the critical theorist but not a subject and certainly not an agent. There are, of course, workers, and there are factories and working conditions, but the working *class* names a unity of *experience*, and more important, a unity of perspective, history, voice, and ultimately, will. For "the workers of the world" to unite, they must first come to perceive themselves, and their world, in a collective way. They must be able not only to utter "we" but to genuinely recognize and organize themselves in and through this pronoun. This is one of the reasons for which the critical work of the theorist, as well as the party and union organizers, is important. The theorist establishes a unified view of the world and of history, as well as a shareable and recognizable characterization of the proletariat; the party administrators express the proletarians' voice and coordinate their movement (Marx himself played in both roles). The critical theorist, or group of theorists, thus aids in forming a collective self-identification and program. This is the case not only for the proletariat but for any group or class—the class of women, of African Americans, of Jews. And if theory can achieve such identification intellectually or explicitly, the theater—which could serve ideological purposes as well as revolutionary ones—is conducive to *emotional* bonding, equally crucial for mobilization.

The use of the term *consciousness* is not the first or last thing that makes the spectatorial position, or rather the orientation of critique, recognizable in the Marxist vocabulary. More significant still is the way the Marxist *characterizes* the working class. Here, we return to the same ontological theme surveyed in the previous section about the propertyless nature of being. The proletarian class is the one that is tasked, in its revolutionary act, with *ending* class and class struggles. For freedom to be possible, Marx said:

> A class must be formed which has *radical chains*, a class in civil society which is not a class of civil society, a class which is the dissolution of all

classes, a sphere of society which has a universal character because its suffer-ings are universal, and which does not claim a *particular redress* because the wrong which is done to it is not a *particular wrong* but *wrong in general* . . . a sphere, finally, which cannot emancipate itself without emancipating itself from all the other spheres of society, without, therefore, emancipating all these other spheres, which is, in short, a *total loss* of humanity and which can only redeem itself by a *total redemption of humanity*. This dissolution of society, as a particular class, is the proletariat. (CH 64)

The proletarian class is thus in fact *not* a class at all. Owing to the universal-ity, and totality, of its suffering and deprivation, its experience transcends the boundaries of classification, as well as all bias and special interest. The proletariat represents humanity *as such* and *as a whole*. The working class is the "the true universal" as Adorno and Horkheimer confirmed (*DE* 107), and its class consciousness is ultimately a *species* consciousness (and no less so, a species *conscience*). Recognizable here, in this logic, is the substance-property opposition discussed above, and in this case, a substance-class opposition, which is essentially the same since "class" names a distinguish-ing (both common and exclusive) property. Since true being undergirds all properties that may be predicated upon it, and since all classification and specialization are predicates, the *dis-possession* of the working class is pre-cisely what renders it most *substantive* of all, and the most universalizable and universalizing. Its suffering stands for the pure being—the being that carries the superstructure on its bare back.

Thus, the class consciousness of the proletariat, and the Communist Party, which gives it a voice and a program, is the consciousness of world history, what Hegel (neglecting to adequately factor the *material* conditions according to the Marxists) called *Geist*, or Spirit. The "We" of the work-ing class, as we saw in chapter 3, refers to the agent of history itself, as it finally arrives at self-consciousness, ready to set its affairs in order, sublate its inner antagonisms, and recognize the equal belonging of all its members and "moments" to the unified, if turbulent, course of progress. At that, the interest of the proletariat is the interest of the bourgeoisie as well, who, as soon as they recognize as much, would join the revolution. On the positive side, the interest of humanity and its self-actualization is not only to end needless suffering (which is pure and propertyless) but to convert it into *freedom* (which is equally pure and propertyless).

Also indicative of the orientation of critique in this Marxist narrative is the *metastrophic* trope, visible in the idea of "a sphere of society . . . which is, in short, a *total loss* of humanity and which can only redeem itself by a *total redemption of humanity*" (CH 64). Substance thus turns-around from suffering to its opposite, freedom, around the axis of dispossession, since substance is propertyless. One need not be a Marxist or subscribe to a Marxist worldview to uphold some version of this oppositional-metastrophic logic. We see it in Agamben's *Remnants of Auschwitz*, for example, where we learn that the most dehumanized and depoliticized of all conditions—that of the *Muselmann* in Auschwitz—is the one that would redeem humanity, setting the ground for all "coming politics." The camp, Agamben says, "radically calls into question the fundamental categories of the nation-state . . . and thereby makes it possible to clear the way for a long overdue renewal of categories in the service of a politics in which bare life is no longer separated and excepted" (Agamben 1998, 134). Thus, the complete *collapse* of the existing order (upon itself) enables and impels its complete *overturning*, just as capitalism, by producing the antagonism between the bourgeoisie and the proletariat, also generates the necessary conditions for a communist revolution—for *sublating* this antagonism (*CCPE* 5).

We see this metastrophic logic also in *Afropessimism* (2020), the influential work of Frank B. Wilderson III, who similarly attributes an ontologically privileged status to Blacks insofar as they are (as Wilderson claims), *categorically and structurally* nonhuman and thus paradigmatic of the true (shameful) essence of "humanity" itself, a hole in its alleged universality: "Blacks are the sentient beings *against which Humanity is defined*" (Wilderson, 167), and "There is no world without Blacks, yet there are no Blacks who are in the world" (229). The difference is that in Afropessimism, as the name suggests, no revolution or redemption is promised, no coming community. The dialectic between the human and the inhuman remains at a standstill—a metastrophe unable to happen (Wilderson uses the term "meta-aporia" [13]), an antagonism or contradiction that cannot be sublated or reconciled. In all these cases—the proletariat, the *Muselmänner*, Blacks—we see a vision of pure being, so pure it is almost indistinguishable from nonbeing, a being without power and possession, without qualities or properties of its own, much like consciousness itself.

To conclude this chapter, I propose that the question of whether one is oriented as a critic is not decided by whether one adheres to an individual and individualist politics or to a socialist and sociological one, or whether one prioritizes the intellectual and ideal or the economical and material, or whether one prioritizes the transcendental or the historical, and whether one is a utopian revolutionary or an angry pessimist. The fact is that these very antagonisms within the camp of critique are themselves marks of the orientation with its oppositional logic, its antagonistic conception of power, and its doubled/split conception of being. Where critics oppose each other in terms of content, they express an agreement in form. Ironically, by generating oppositions, the universalizing logic of critique diminishes the tolerance for and capacity to recognize a community of purpose and thus undercuts the capacity to attain *actual* universality and solidarity, at least among the critics themselves. We return to consider this problematic in the conclusion.

SEVEN

Topologies of Critique

Jean-Louis Baudry, the New Wave film critic, claimed that the mise-en-scène of Plato's cave is the "the topological model of [all] idealism" (Baudry 1974, 45). In the cave, as in the cinema, subjectivities are formed through an elaborate process of identification, not only with the protagonist but also with the apparatus itself—with the creation of meaning. This apparatus is such as to render the spectators complicit—not only subject *to* but subjects *of* ideology. The topology of the cave or the cinema hall captures this dynamic perfectly. This typology points to the existence of activities "behind our backs" that are in charge of projecting what we can see and envision in front of us, except that these "back-side" activities are just as internal to the subjects—enacted by their own cognition, perception, desire, if only unconsciously—as they are external. In saying that the mise-en-scène of the cave is the topological model of all idealism, Baudry has in mind only the cave itself—its *interior*. I argue here that, while the interior may be the topological setup for ideological subjectivation, the topography of the allegory *as a whole* is the model for *any* form of thinking that is rooted in the spectatorial orientation of critique, be it idealistic or materialistic, theological or atheistic, transcendental or dialectical, revolutionary or reactionary.

This topography, in other words, is not simply the model for ideological indoctrination; it is also the model for the critique *of* this ideology, within which ideological indoctrination plays an indispensable role as the object of critique. Topology is the *constitution* of space, or, in a word, *spatialization*: it is the logic (*logos*) that governs both our conception and our experience of spatiality (*topos*). To be positioned as a spectator—and subsequently as a judge, a critic, an autonomous agent, or a revolutionary activist fighting injustice—does not simply mean seeing or doing something; it means existing in an intellectual and existential *environment* within which all seeing, doing, and undergoing occur. This environment is constituted by and at the same time constitutes a transcendental subject (be it the naive spectator or the critic, an individual thinker or an instituted collective), and its coordinates are oppositional.

INSIDE VERSUS OUTSIDE

I have already spoken quite a bit about the most obvious feature of critique's topology—namely, the distantiation and withdrawal, the subject-object opposition, the standing-before and standing-against. It is time now to acknowledge more explicitly a second feature: the opposition between interior and exterior, inclusion and exclusion. The very figure of a cave underscores a "container" topology. It is a bounded openness *within which* things exist and events transpire. Clearly, this topology presupposes two things: a limit (the "walls" of the cave) *and* an outside or unbounded beyond. This outside, in turn, is that *within* which the enclosure is contained. In the allegory, for example, the "outside" simply symbolizes nature, or true being, of which the cave must be part if it is anything at all. The enclosure of the cave *represents* this greater enclosure and is nested within it.

To perceive how intuitive and far-reaching this sense of space is to us, consider our ordinary scientific view of the universe. The Hubble Space Telescope, which was launched into outer space in 1990, has led scientists to suppose that the observable universe contains about two hundred billion galaxies. What is astonishing about this bit of information is not that there are so many galaxies but that there are so few. The idea that there must exist a *finite number* of entities "in" the universe has perhaps less to do with the empirical data than it does with the structure of visibility and observation. It is the *topology* of the scientific-theoretical orientation that determines the

essential *limitation* and, with it, the essential quantifiability and measurability, of space. The spectatorial orientation *encloses* a "field of vision" and inspects, counts, classifies, organizes, takes stock of what is "in there." To comprehend any spectatorial space, even the one we suggestively call "outer space," we must tacitly envision it as a container, which is why we use such expressions as *in* space and *in* the universe. It is also this tacitly bounded conception of space that compels reflection on what lies beyond it—some vision of transcendence or invisibility, some vision of "expansion."

Conceptually—and when we are talking of critique, we are always thinking within the framework of conceptual logic—there cannot be an "inside" without a limit. In turn, there cannot be a limit without some notion of an outside or beyond. These three elements—inside, outside, and limit—are mutually constitutive. It is true that, depending on how these specific coordinates are determined, it is possible to deny the *concrete* existence of an "outside." The "limit," then, is deemed "absolute," as the very limit of the world or of possibility. Even in such a case, however, the denial implies a response to a question: "*Is there* an outside?" or "*What* is there outside?" just as atheism implies the question: "Is there a God?" As long as the question is out there, as long as it makes sense, as long as it requires an answer, the logical possibility of an "outside" asserts itself. The thought of an outside must haunt any person who experiences her surroundings, and existence, as an interiority. If the world or the universe is tacitly experienced as a container, the question of transcendence presides over it as a whole, animating not only theological reflections and debates but also scientific, philosophic, and literary ones. The world *itself* must be experienced as an "exteriority"—as the world "out there"—and this is part of the reason for which, as discussed in chapter 5, it is experienced as a "problem" (for example, how do I know that the world exists, or how do I know that what I see or think about the world is the truth about the world?).

As we can see in the cave allegory, the interior-exterior opposition serves to shore up the epistemological opposition between deception, or artificially restricted vision, represented by the relative darkness inside, and knowledge or independent thinking, represented by the natural light of the sun outside. In turn, the inside-outside opposition also supports the ethical opposition between captivity, the enclosure of the inside, and freedom, the alleged boundlessness of the outside. But things are more complicated than that. The irony built into Plato's image lies in the fact that it is just that: an

image. Both the "inside" and the "outside" of the cave, including the sun itself, are *in* the visible world, the world of the senses, the realm of images, imagination, and representation because both cave and sun are physical, visible entities. But the visible world to which the entire allegory belongs is represented only by the *inside* of the cave. This fact impels the question: what does the outside represent, and how, in what sense, does it "represent" it? What does the notion of "exiting the cave" symbolize given that such a movement entails exiting the realm of visibility and representation? *Where* are we to exit from, exit where, and in what sense "exit"? For Socrates's interlocutors, and for Plato's readers, to exit the figural cave means thinking past the allegory and the images that furnish it; in fact, it means thinking past space itself (and also past time).

Consider the conundrum this way: insofar as space is something present, something visual, "inside" and "outside" are visual coordinates. We experience such coordinates all the time, as we enter and exit various spaces on our way to and from work, to and from school, to and from the bathroom, the bedroom, or the kitchen. But philosophically speaking, all these "outsides" (say, going out of the office or out of the house) are still inside (inside the university, the town, the city, the country, the world). The Platonic "outside" alludes to something else, to what transcends, or is transcendental to, the entire sphere of ordinary and possible *experience*. It is crucial for critique to set the realm of possible experience within bounds, to *delimit* it, since doing so allows it, on the one hand, to withdraw from immersion in it and, on the other hand, to reflect on the structures and conditions that govern it. The possibility of critique is therefore secured by the same logic that secures the possibility of governance and structuration of the whole. Both ideology and ideology-critique can only operate in relation to a world, and a society, that is configured as a limited and relatively homogeneous whole, with its inclusions and its exclusions, its knowledge and its ignorance.

One of the wonderful things about the critical appropriation or "modernization" of Platonism by Descartes is that he appears to turn the coordinates of the cave, and the Platonic topography in general, *outside-in*. For Descartes, to move "outside" of the visible world or the sensory, empirical framework that governs it is to turn *inward* in introspective meditation. The *inner* cave of the thinker's mind thus takes the place of the Platonic *outside*. In his *Meditations*, Descartes depicts himself as having retreated from the

"outside" world into a period of solitude within a fire-heated room for the purpose of subjecting his knowledge, and the possibility of knowledge in general, to methodic critique. The figure of the fireplace (or stove, *poêle*), which appears in several of his writings as a necessary companion in meditation, may be a symbolic nod to the fire of Plato's cave. In both cases the fire signifies enclosure, but whereas in Plato the fire, along with the interiority, marks a public, oppressive, deceptive, and restrictive environment, in Descartes it marks the exact opposite: solitude, safety, warmth—all necessary conditions for self-examination and for a sustained, independent critique.

Descartes consolidated his metastrophic turnaround of the Platonic topography by substituting for the figure of the sun—the emblem of exteriority and openness in Plato—the notion of a *lumen naturale* or "natural light." The latter not only emanates from *within* each person's mind but from the very "*bottom*" (or center) of that mind, its innermost core. Exclusive access to and ownership of this light are given to the individual thinker—the "I." In this way, the natural light of reason—the "sun" at the center of my soul—illuminates the mind like a candle illuminates a room in the night. The mind is thus prefigured as a room, a container for ideas and representations, which is why Descartes could describe it, for example, as "*stuffed full* of opinions" or "*taken up* with any number of preconceptions" (Descartes 2005b, 416, italics added). This clutter (we are all hoarders when it comes to opinions) has the effect of blocking the natural light and generally darkening the room, while also making it difficult to "move" about, to find anything, or to distinguish between what sparks joy, or can be known for certain, and what only takes up space and has nothing in particular to do with *me*.

It is impressive how deeply the practice of introspection instilled itself in our psychological and epistemological imaginary and vocabulary. It is difficult to overestimate how accustomed we have grown to thinking of our mental life in these Cartesian terms of interiority, even though, for all appearances, the only things "inside" us, if there are such things at all, are cells and tissues and so on, but there is nothing "inside" of us that looks anything like opinions, sensations, images, and ideas. For Descartes, the mind, although it "contained" images, was itself invisible. Still, as in the case with Plato's allegory, the tropes and metaphors we use to think up this invisibility are telling of the structures—the topology—of our thought and, through it, the topology of the world in which we live.

The Cartesian or modern turnaround of Plato is responsible to the manifestly anti-Platonic idea that rationality and even mind or consciousness are properties of *individuals*, as well as to the notion of a "will" as the gatekeeper, housekeeper, and landlord of this privacy of thought. Yet the radicalism of this turn only accentuates the commonality between the before and the after: the topology itself. Arendt said it best: "putting things upside down or downside up, still keeps intact the categorical framework in which such reversals can operate" (*LMW* 176); indeed, it keeps intact the categorical framework that beckons the use of the terms *upside down, downside up*, and *reversals*. As we may suspect, the Cartesian reversal of Plato was not the last of its kind (Arendt's statement alludes to one performed much later, by Nietzsche, who explicitly claimed to turn Plato on his head). The philosophical tradition continued turning things on their heads, from interiority to exteriority and back again: Kant denied the Cartesian interior by rendering subjectivity *transcendental*; later, Heidegger and the existentialists threw the subject back *into* the world, denying it both a Cartesian interiority *and* transcendental status. With each turn or conversion, the same essential coordinates—inside, outside, and limit—get rearranged and reinterpreted. More important, in each theoretical construct we are once again symbolically exiting a cave of illusion or error and entering the realm of deeper or more fundamental truth.

It is not only in the ontology and epistemology of critique that the inside/outside coordinates play a central role; they are no less consequential in political reflection, where the *demos*, the people, is conceived and negotiated in terms of inclusion and exclusion, suggesting that we tacitly imagine and experience our *political* spaces as containers as well. In addition to inclusion and exclusion we employ other sets of oppositional coordinates: center and margin, "right" and "left." Margin and center are relatively stable coordinates, premised on common reference points and measurements, but they can exist only in a space that is relatively homogeneous and unified and yet in its *inner* organization admits of hierarchy, discrimination, marginalization. This space is *infinitely divisible*, meaning that there is never any maximal or minimal space. For the same reason, there can never be an absolute interiority, one that is exclusive of any exteriority, because the very meaning of interiority is given by its conceptual opposition to exteriority. The class-member and genus-species relationships discussed in the previous chapter bespeak this topology, since, as we

saw, they imply a "nesting" relationship between container and contained, the drama of inclusion and exclusion, and of course, the limits between. The political *vocabulary* of right/left, inclusion/exclusion, center/margin is expressive of what we may call a political *imaginary*. The latter, in turn, structures a political *experience* and sense of political identity and belonging. Topology matters.

To be sure, nothing about this constitutive imaginary is "unreal." The specific coordinates of inside/outside and center/margin are empirically determinable in each case. But such measurements, as Kant taught us, are but *answers* to questions we ask. Scientists used to think of the universe as centered, in which case the question of what occupies the center of the universe made sense. We no longer think this way, and while we may go on counting galaxies and solar systems, no one is searching for the universe's center. Topology is not simply an empirical given. The conceptual coordinates that underlie our empirical observations—physical, political, psychological, sociological—are no more factual than they are metaphoric, figurative, symbolic. Kant's general name for the threshold between the intellectual and the empirical was *schematism*. Topology is the *schematization* of space, and as such, it is neither inside this space nor outside it, no more at its center than in its margins. One way to get to know a schema is to observe its manifold representations. Another is to set it alongside a different schema. Each orientation of thought spatializes differently. Ask yourself: Have you ever experienced a space that has no inside or outside? Have you experienced a space without center or margins? What politics would preside in such a space? What would *its* coordinates be? What kind of aspirations, what kind of movements, what kind of protests? And where, in such a space, would a critical thinker be located? (Certainly not in the margin but also not at the center.) What would the critical task be if there were no cave and no captives, no darkness to enlighten or illuminate, no categorical limit around which to enact a metastrophic revolution?

This is a good moment to note that Plato introduced his allegory of the cave in the context of developing a theory of education. Although classrooms as we know them did not yet exist in Plato's time, it is fair to say that the cave is, first and foremost, a classroom. These "prisoners" are there *to learn*, as all children do in the process of socialization and inauguration into a culture. Especially in cultural situations we find ourselves, like those prisoners, in the literal position of spectators: in school, at the museum,

when watching plays or movies. And since these spectatorial situations are the ones in which we habitually *think* and learn *how* to think, it is not very surprising that the spectatorial topology has a deep hold on our thinking. Aristotle's school was named "peripatetic," apparently because the studies were conducted not in halls but in walkways (*peripatoi*); perhaps the idea was that the mind is most alert when walking. Nietzsche certainly thought so. In a section of his autobiography titled "Why I Am So Clever," he offered this advice: "*Sit* as little as possible; give no credence to any thought that was not born outdoors while one moved about freely—in which the muscles are not celebrating a feast, too. . . . The sedentary life . . . is the real *sin* against the holy spirit" (Nietzsche 1989, 239–40). If we habitually thought and learned in motion, would it become more intuitive to us to think and imagine space differently?

OVER VERSUS UNDER

Schematism is lodged between the transcendental and the empirical. Climbing out of "the cave" or withdrawing into "the meditation room" are allegorical expressions of "turning souls around," as Plato described it (*R* 1136)—recalibrating the intellectual position with respect to the empirical sensorial realm in its entirety. In the end, there is only one space, one visible world, one reality, not two. What changes dramatically in a "critical turn" is the grasp of the conditions *underlying* ordinary experience. In this notion of underlying conditions, a second axis of critique's topology announces itself—*depth*. Plato's "outside" and Descartes's "inside" are essentially *under*, concealed by what lies *over*. If the inside/outside opposition is horizontal, the over/under opposition is vertical. Yet this vertical axis is but a more "adequate" expression of the horizontal. I put "adequate" in scare quotes because with this shift from horizontal to vertical, we are not yet past the allegorical realm. The truth is, once again, that *any* spatial illustration of topology is just that, an illustration, an exemplification of schemata. Like the triangle on the pages of a geometry book, it is only a representation of something that in itself (however paradoxically) is *not in space*: a "true" triangle does not exist visibly; only particular specimens of triangle do, and they are never fully true to the definition of a triangle. Spatiality or spatialization, to quip on a famous statement Heidegger once made about technology, is itself nothing spatial.

The vertical axis underscores the *architectonic* nature of critique's topology. *Archē* is Greek for "rule" or "principle" but also for "foundation." Architectonic structures require a foundation to support them, and as is the case in physical structures, the foundation lies deep underground, hidden from ordinary sight; moreover, it is hidden *by* the architectonic structure that is erected on it. As we also learn from the example of physical buildings, a true foundation—or what the foundation rests on—cannot be artificial. Like bedrock, it must have natural stability and cannot itself be founded on something else. A mathematical axiom is another example of foundation in that sense, for it must be self-evident and self-supporting, requiring no other presupposition to validate *it*. This is also a traditional understanding of the function of reason, as conveyed in the fact that one of its synonyms is *ground*. A "well-founded" argument is a grounded one.

Ground signifies support, solidity, and "bottom." Yet space itself appears to admit of no essential bottom: even planets, however rocky and condensed around their core, eventually hang "midair." How can there be a ground to space itself if all ground, if taken literally, is *in* space? The first philosopher, Thales, argued that the entire universe rests on water (which makes sense, given that the "universe" back then was about the size of the European continent), but a couple of centuries later, Aristotle joked that it was left unclear from Thales what *water rests* on (Curd 2011, 15). True foundations, as Aristotle came to realize, must be *meta*physical (though the word itself was only coined posthumously), where *meta-* means "beyond" but also suggests the possibility of being "under." Yet the same problem haunts metaphysicians, seeing as their principles, which they are convinced are self-supporting, are always regarded by later philosophers as lacking ground. Topology gives us an important clue when addressing this conundrum, since it shows us that ground is ever at the same time *a limit*, just like the one that exists between the inside and the outside. The ground is more like *a stage*, on which things surface, appear, or perform (the Greek word for nature, *physis*, suggests as much, as it means growth or emergence, like the way a flower stems out of the dense, dark soil and into light and open air). But when seen as a stage, or as the soil, it becomes clear that for every ground there is an *underground*. A ground is thus never only a foundation but also a concealment; anything that surfaces upon it is only half the truth.

With its postulation of "ground," the topology of critique thus shores up the ontological and epistemological oppositions between (mere) ap-

pearance and (true) being, and between mere opinion or belief and true knowledge. If the world is like a spectacle, a show, it is also tacitly, or at least possibly, a facade. We already see this at work in these very remarks: topology cannot be spatial since it *grounds* space, yet the very term *ground* is a spatial trope; so this explication of topology presupposes the topology it explicates. We are trapped in metaphor. Language in its entirety, or at least philosophical language, is metaphorical of the ineffable, the unspoken, that which *is* named, labeled, classified, and thereby allowed to appear (always partially, inadequately, selectively, indirectly, or in disguise). As Hannah Arendt noted apropos of Kant concerning the centrality of the use of analogies and allegories in philosophy, "this speaking in analogies, in metaphorical language . . . is the only way through which speculative reason, which we here call thinking, can manifest itself," adding that "there are not two worlds"—internal and external, essential and apparent—"because metaphor unites them" (*LMT* 103, 110). This "uniting" function is the limit, because the limit is by definition on both sides.

The topology of critique shores up the conception of knowledge as *discovery*, in the scientific context, and as *ex-pository* in the moral/political context. To know is to call out, to let appear, or to make apparent, evident. Whereas language itself is already expository, ex-pressing things or calling them out by name, it is also at the same time concealing, since it relies on a set of connections, syntactic and semantic rules, that overdetermines the field of appearance and understanding, no matter how expansive. "*The limits of my language*," said Wittgenstein, "mean the limits of my world" (Wittgenstein 2001, 68). Simone Weil went even further, comparing language to imprisonment:

> At the very best, a mind enclosed in language is in prison. It is limited to the number of relations which words can make simultaneously present to it; and remains in ignorance of thoughts which involve the combination of a greater number. These thoughts are outside language, they are unformulable . . . although every one of the relations they involve is capable of precise expression in words. So the mind moves in a closed space of partial truth, which may be larger or smaller, without ever being able so much as to glance at what is outside. (Weil 2000, 88–89)

Critique calls out, into *its* language, connections, presuppositions, and structures that are pre- or metadiscursive, behind or beneath what is said,

hidden by what is said. This operation assumes a behind or beneath, an assumption that shows itself in a variety of philosophical guises: the conditioned and the conditioning, the founded and the founding, the order of effects and the order of causes, the subconscious and the conscious, and, of course, the superstructure and the base structure. As Marx put it: "The sum total of [the] relations of production constitute the economic structure of society, *the real foundation*, on which rises illegal and political superstructure into which corresponds definite forms of social consciousness," and "with the change of the economic foundation the entire immense superstructure is more or less rapidly transformed" (*CCPE* 4–5). It matters less, for our purposes, how a particular philosophy conceives of the "foundation": if it is indefinite (Anaximander), if it consists of pure forms (Plato), of the transcendental structures and strictures of rationality (Kant), of economic conditions (Marx), of structures of the psyche (Freud), of existential-ontological structures (Heidegger). All these cases exhibit the same topological arrangement: we have what *appears* on the surface and that which does not *itself* directly appear. The surface appearance is then seen as "symptomatic" or revelatory, for the critic, of what does not appear. And if something does not appear, it is either because it is categorically invisible or because it is repressed or forgotten, hidden or censured.

Not surprisingly, scopophilia—the desire and the drive to reveal, expose, unveil, unearth—permeates and excites the epistemology of critique and its desire. No more surprising is it that the excitement of scopophilia is counterbalanced by paranoia, or at least suspicion—"scopophobia," as I referred to it in chapter 1. In *Freud and Philosophy* Paul Ricoeur coined the term *school of suspicion* (Ricoeur 1977, 32), which has since become a focal point for the characterization of critique's interpretative attitude. "For Marx, Nietzsche, and Freud," whom Ricoeur considered the three masters of the school of suspicion, "the fundamental category of consciousness is the relation hidden-shown, or, if you prefer, simulated-manifested" (Ricoeur, 33–34). And with this "category of consciousness," Ricoeur tells us, we get the hermeneutical imperative to read "between the lines," "behind" or "beneath" the text in search of hidden or unconscious meanings or ideological contents. The spirit of the adventurer and the discoverer is thus also the spirit of the detective. The "dark" and the unknown are lands of promise as they are of terror, of the awesome and the awful, of wonder and horror, and there is libidinal investment in both. In either case, in the figure of the

foundation, and what it rests on or conceals, the topological vocabulary and imagery of critique is unmistakable and can be spotted from afar—as in Singer's account of Marx's *Capital*: "The aim of *Capital* . . . is *to rip aside [the] mystical veil* over the life-processes of modern society, *revealing* these processes as the domination of human beings by their own social relations" (Singer 2018, 69, italics added); or in Adorno and Horkheimer's preface to *Dialectic of Enlightenment*: the "factory and everything pertaining to it [are] an ideological *curtain*, within the social whole, *behind which real doom is gathering*. . . . That is the premise of our [book]" (*DE* xviii, italics added); or in these wonderful (and somewhat less gloomy) words from Hebrew poet Shimon Adaf:

> World under world
> bellows of new lungs
> breathing underground in a kind of darkness
> light under light
> leaf under leaf strikes the fences
>
> That which I thought shadow is the real body.
> (Chalfi, Bernstein, and Adaf 2014, 132)

LIMIT AND TURN

Traditionally attributed to Rembrandt and known as *Philosopher in Meditation* (though the name of the painting is subject to debate, as are the identities of the figures in it), this painting richly captures the topography of critique: the different layers of interiority and depth (those visible and those only suggested), the play on light and darkness, and the generally oppositional (dualistic) logic of the composition and the symbolism (fig. 1). A Marxist and a feminist might also point out that if the painting is in fact of a philosopher in meditation, then the darkened figure of a woman (who is not, one assumes, the titular philosopher) working, tending to the fire makes present the material conditions and class antagonism or oppressive gender roles that necessarily undergird this allegedly "pure" activity of thought. In Descartes's meditation, no such woman appears, though he certainly had a butler. This observation aside, what I find most suggestive about the painting is the axial/spiral rotation of the stairs at the center of

this space. Together with the darkness, and thus invisibility, that the painting so wonderfully makes visible, almost as if it was a commentary on the very act of painting and on the nature of vision and visibility, the spiral staircase lends the two-dimensional artwork depth, as if prompting it to spin around its own axis, its right turning into its left, its up into its down, its inside into its outside, its front into its back, or as if the painting itself could turn around and look at whatever lies behind it. I would sooner take this axis to be the subject of the painting than the physical presence of the philosopher in it. This is a painting of a topology of thought.

"Where are we when we think?" Arendt once asked (*LMT* 195). This question is just as difficult to answer as is the question "Where is the spectator?" Neither the thinker nor the spectator are anywhere to be seen. "The subject," as Wittgenstein put it, "does not belong to the world: rather, it is

FIGURE 1 Rembrandt, *The Philosopher in Meditation*, 1632.

the limit of the world" (Wittgenstein 2001, 69). As we have seen, the concept of limit is crucial for this orientation and its environment. Without limit, no inclusion or exclusion, no ground or underground, no opposition. Whether literally or symbolically, physically or metaphysically, the spectatorial subject looks *on* and can only look in one direction at a time. She is therefore always cutting space in half—the half toward which she looks and the one she has her back to. Her body is that limit, shared among the world behind her, which she has her back to, and the world before her, which she sees. And she cannot see herself or the seeing—the limit itself—since, as dictated by the structure of seeing, looking looks *out* and looks *on*, consciousness is *intentional*. In this way, the subject, which sets up the conditions for the possibility of the visible or theoretical world, is always at the threshold of this world, at the limit of visibility, language, and thought. This subject is therefore also the condition for the possibility (and necessity) of invisibility, ineffability, the unconscious. The subject is at the crossroad between reason and madness. The subject is the in between. Whenever the subject is made explicit, explicated, pronounced, cast wholly to one side, it is no longer the (true) subject but an object for some subject's scrutiny. Subjectivity is therefore doomed, like Rembrandt's staircase, to turn and turn about itself, like a cat in pursuit of its tail.

This liminal positionality is the axis around which one "turns," and just as the limit or ground is constitutively metaphysical, the turn is metastrophic. A metastrophic turn is never a turn from one place to another, say, from inside to outside or from below to above. Empirical turns of this sort do not disrupt space; they occur within it, they presuppose it, they leave it at peace. Metastrophic turns, by contrast, are *converting* or *revolutionary*, flipping the entire order and set of coordinates. What I previously thought was outside ("exterior reality") is, in fact, inside; what I thought was the cause is, in fact, the effect; what I thought was the disease is, in fact, a symptom; what I thought was active is, in fact, passive; what I thought was mere representation is the thing in itself (and vice versa). We could depict the horizontal axis of inside/outside and the vertical axis of over/under in the shape of the infinity sign, with the subject, or critic, as the center point at which the line intersects with itself. In the liminal positionality of the critic is inscribed the perennial possibility of, and propensity for, metastrophical turns. Hence the critic's penchant for revolution. Here also is inscribed the meaning of *reflection*: turning upon oneself, redoubling oneself with each

turn. Writing of the figure of the "eye in a philosophy of reflection," Foucault made this point:

> Lying behind each eye that sees, there exists a more tenuous one, an eye so discreet and so agile that its all-powerful glance can be said to eat away at the flesh of its white globe; behind this particular eye, there exists another and, then, still others, each progressively more subtle until we arrive at an eye whose entire substance is nothing but the pure transparency of vision. This inner movement is finally resolved in a nonmaterial center where the intangible forms of truth are created and combined, in this heart of things which is the sovereign subject. (Foucault 2003, 452)

A sovereign subject, a judgment day, a classless society, a ground to stand on . . . To be sure, no such ending or grounding is ever *in sight* because the topology of critique is *infinite*. This, I think, is the meaning of the term *utopia*, which habitually connotes a perfect world but is, in fact, a *non*space. Ironically, this space that defies spatiality itself, exceeding perhaps the conditions for the possibility of experience, is the emblematic figure of critique's topology. Space in its entirety might well be allegorical, a mere metaphor for utopia—the site of nonpresence, the no-longer, and the not-yet. What makes Plato's allegory of the cave the topological model for all critique is not Plato's specific philosophical commitments. Quite the opposite. Each time Platonism is *reversed* (and who has not reversed it?), each time the exclusionary prejudices of the inherited order or tradition (pagan, dogmatic, modern, metaphysical, ontotheological, patriarchal, heteronormative, colonial) are exposed, we are in fact *re*turning to the cave, reenacting its topology, seeking to awaken its sleepy inhabitants and turn their souls around.

Chronologies of Critique

It is a commonplace that birth, flowering and decline constitute the iron circle in which everything human is enclosed, through which it must pass.

—KARL MARX, *DOCTORAL DISSERTATION*

That we are in possession of . . . limiting boundary concepts enclosing our thought within unsurmountable walls—and the notion of an absolute beginning or an absolute end is among them—does not tell us more than that *we* are indeed finite beings. To assume that these limitations could serve to map out a place where the thinking ego could be localized would be just another [metaphysical fantasy]. Man's finitude, irrevocably given by virtue of his own short time span [on Earth] constitutes the infrastructure, as it were, of all mental activities.

—HANNAH ARENDT, *THE LIFE OF THE MIND*

The ontology of presence—the constitution of being as the present—implies a particular chronology, meaning, schematization of time. Augustine gave a rudimentary account of the present-prioritizing chronology when, after noting that the past is what is no longer and the future what is not yet, he concluded that, "neither future nor past actually exists. Nor is it right to say

there are three times, past, present, and future. Perhaps it would be more correct to say: there are three times, a present of things past, a present of things present, a present of things future." On Augustine's view, since there is only one time and reality, the present, the three tenses do not refer to different times but to different cognitive acts, all of which take place in the present: "the presence of things past is memory, the present of things present is sight, the present of things future is expectation" (C 246).

The more common view, which is no less lodged in the ontology of presence, is that the past and the future do refer to different realities: the past is all that *has been* present, and the future is all that *will be* and *will have been* present. This view implies a homogeneity of being in and through time. It is as if being traveled through time (in a "forward" direction), passing different stations along the way—years, decades, centuries, epochs. We are all situated within a metaphorical train, at the present moment, with our backs to the past, receding behind us, and our faces to the future, to which we continuously draw near, and which continuously slips back the moment we reach it. With these figures of speech (forward, back, facing), we can literally see an *orientation*, not only our orientation within time but an orientation *of* time itself: moving "forward," with its own face—like the front window of the train—looking ahead. In this chapter I will focus on different aspects and implications of this orientation, and schematization, of time.

OLD VERSUS NEW

The chronology suggested by these descriptions not only construes time as forward-moving but as homogeneous, unified, like space; there is only one *time*. Unlike time itself, which always moves forward, *we* can turn around, if only in thought, as when we "look back" to the past in nostalgia or study—the one we call "history"—but this still requires turning *around* from the default orientation of our movement, and even when we are thus turning our back to the future, we are inevitably still "moving forward" on the train of time. The looking forward and back happen "inside" of us, so to speak, in the imagination, colored as it is by dread or regret, illuminated by anticipation or dimmed by forgetfulness. Meanwhile, the present is reflected outside, through the windows of our train; here, unlike in the caverns of our thoughts, the view is the same to all: it is just out there, with

each passing scene falling behind. John Dewey described our fraught relationship to the past, and time in general, in melancholic terms:

> Most mortals are conscious that a split often occurs between their present living and their past and future. Then the past hangs upon them as a burden; it invades the present with a sense of regret, of opportunities not used, and of consequences we wish undone. It rests upon the present as an oppression. . . . All too often we exist in apprehensions of what the future may bring and are divided within ourselves. Even when not overanxious, we do not enjoy the present because we subordinate it to that which is absent. Because of the frequency of this abandonment of the present to the past and future, the happy periods of an experience . . . come to constitute an aesthetic ideal. (Dewey 2005, 18)

On a much grander scale, but no less melancholic, Walter Benjamin gave an account of historical progress, reflecting on a painting he owned by Paul Klee named *Angelus Novus* (*New Angel*): "This is how one pictures the angel of history. His face is turned toward the past. . . . But a storm is blowing from Paradise"—that is, from the beginning of time. It is a curious storm, which blows in one direction—forward—as if stemming from a huge air-blower. This storm blows in the angel's "wings with such violence that the angel can no longer close them. This storm irresistibly propels him into the future to which his back is turned." This storm, Benjamin explains, "is what we call progress" (Benjamin 2019, 201). It is a telling view of progress—one that moves away from the past rather than toward the future. What Benjamin's "angel of history" perceives in his backward stare ("His eyes are staring, his mouth is open") is "one single catastrophe which keeps piling wreckage upon wreckage and hurls it in front of his feet" (201). In this way, the storm has two effects: pushing (the angel of) history forward and ravishing everything on its way. This depiction of the past as catastrophic, as a process of decay and death, is, I think, the implication of an orientation and, indeed, provides an angle on an oft-forgotten implication of progress: the old is crushed under the surge of the new, killed by the new, replaced by the new, critiqued by the new.

The *old* and the *new*—these are relative terms, like the *before* and the *after*, the *below* and the *above*. We tend to overstate certain events or dates as marking our "modernity." The truth is that different historical disciplines

have different ways of mapping out time and dating modernity—philosophy usually marking the sixteenth century and "the scientific revolution" (the acceptance of the heliocentric system in astronomy), whereas art history tends to mark rather the late nineteenth and early twentieth century, and in popular discourse, "modern" is usually dated according to technological and cultural developments, especially those that happened in the last couple of years or decades at the most. Beyond that, however, it can be argued that the dawn of history—that is, the dawn of the kind of civilization that keeps record of its history, through myths, and traditions, in song, in painting, and eventually in writing—is already the dawn of modernity. History, if not civilization itself, *is* a modernization, as it casts its present as the future of, and often a break from, a past, a break that is sometimes regarded with sadness, as the mark of decadence or loss, sometimes with pride, as a mark of progress and achievement, and sometimes with a mixture of the two. And history is something of a literary genre; its course follows the timeline of a tragedy (or a Hollywood film): with a beginning, a middle, and an end. These epochs are often separated by crises, revolutions, restarts. Then the landscape changes (or so we imagine it), and the climate and the light. This is what time *looks* like to the journeying spectator: farthest back is pre-history, followed by ancient history, followed by the (suggestively named) "middle-ages," followed by modernity. Each of these chapters can be, and is, further subdivided according to the same core designations—"the ancient" has its own ancient, middle, and late phases ("archaic," "classical," and so on), and so do "the middle" and "the modern." Individual life is equally divided up into periods: infancy, childhood, youth, adolescence, "middle age" . . .

Where are we now? And what is the journey itself like? One evaluates, periodically, taking stock of one's life or history. What is our judgment on the course of history so far? Has it been a *good* development (a *literal* "progress")? Are we at the cutting edge of progress—the most "advanced" state? Or has it rather been a process of decadence and decline? Are we perhaps at the zenith of depravity—nihilism, consumerism, (late stage) capitalism? Have we finally hit bottom? Much appears to depend on how energetic we are or feel. If we pull our weight forward, picking up speed, huffing up the storm, then we are progressive. But if we pull our weight backward, pulling on the breaks, wary of progress and its rapidity, we are conservative. But how much influence do we actually have over the course and speed of time?

These questions have about as many answers as there are critics, but the very *questioning* of whether history is "headed" in the right or in the wrong direction, if modernity is a good or bad development (to be critiqued or heralded), along with the adjacent passions of optimism and pessimism, is a signpost of critique. If there is any other environment but that of critique, another fundamental orientation of self and time, one thing is certain: this train will never get there. This is neither a pessimistic nor an optimistic observation. The time train is part and parcel of its environment. There is no time "after" critique and there was no time "before" it, certainly nowhere to be seen or theorized. But as to whether it is possible to *get off* the train somehow, and if so, *when* and *where* to do so (the future, the past, the present?)—these are entirely different questions, and they exceed the purview of critique and its history.

FROM BEGINNING TO END

Back to our train: where are we now? Are we still journeying through modernity? Or have we left modernity behind? It is debatable. Our train advances continuously into the future, but the future is in turn pushed "back," away from us *into* the future as we advance. We never get to *meet* the future as such; we only look forward to it, just as we never get to return to the past; we can only look back on it.

Just as critique's topology poses and is fascinated by the figure of a limit, and with it the other side (the "beneath," the "outside," the "above"), so critique's chronology poses and is indeed obsessed with the limits of time: the "beginning" (*archē*) and the "end" (*telos*), natality and mortality. Here too, the problematic of the "beyond" inevitably asserts itself. Nietzsche found it especially bothersome: "Among all the questions dealing with motion, none is more annoying than the one which asks for its starting point. For though one may imagine all the other movements as causes and effects, the one original primal motion has still to be explained. For mechanical movements, in any event, the first link of the chain cannot be sought . . . since this would mean falling back on the contradictory concept of a *causa sui*" (Nietzsche 1996b, 100).

Causa sui is Latin for "self-causing," that which needs no other thing to instigate movement or action. The "annoying" problem to which Nietzsche alludes—the seeming inability to explain motion and change by means of

anything that does not itself require explanation—is also the oldest problem in the history of philosophy and science. Ironically or not, ancient philosophy in Greece began with the problem of beginning. From this early stage in philosophy's career, there appear to be two options: either change always existed and reality is in flux, a position often associated with the pre-Socratic Heraclitus; or change is illusory, and everything is in fact permanent, a position that is most evident in the pre-Socratic Parmenides and the Eleatic school that follows his teaching. Note that both positions, antithetical though they are, boil down to the idea that there is no beginning—either everything is eternally in flux, or everything is eternally unchanging. Although this rejection of beginning in favor of eternity is necessary for philosophical thought—at least the kind of thought that asserts first or universal principles—it is very difficult for most of us, as mortals, to accept it. The belief in a monotheistic creator certainly helps in this regard. "In the beginning, God created . . ." When was the beginning? When God decided to begin.

For a scrupulous theologian like Augustine, simply making such a statement was not enough. Augustine saw that, at face value, the opening statement of the scriptures makes little sense; he toiled over this problem, showing more integrity in the process than many later scientists would. "Grant me to hear and understand what is meant by *In the beginning You made heaven and earth*," he pleaded with his own soul (*C* 236). For like any thinking person he knew that if "the beginning" is absolute—if it is a *true* beginning—there can be nothing before it. It must therefore be the beginning of time itself, and this is a contradiction in terms. A beginning of time would have to be at once *in* time and *not* in time. For instance, if that beginning happened six thousand years ago (or 13.8 billion years ago, for that matter), it has a date, and if it has a date, it is in time. The question then immediately impels itself: Why didn't God do it 6,001 years ago? Why didn't time begin 13.9 billion years ago? And the response, "there was no time then," is ruled out by the question itself; of course there was time then: it was 6,001 or 13.9 billion years ago. Either the enumeration of "years," or whatever unit of measure, is merely conventional, in which case we are essentially dealing with eternity, or it is an actual quantity of time, in which case the question must be answered: why *then* and not before?

Augustine knew that what is truly at stake in this question is anxiety— the existential need for solid ground to stand on, to support oneself: "Who shall lay hold upon their mind and hold it still, that it may stand a little

while, and a little while glimpse the splendor of eternity which stands for ever: and compare it *[to a] time whose moments never stand*?" (*C* 240, italics added). Such is the irony built into the "most annoying problem": we search for a beginning of time because we *are* in time, and we literally cannot stand it. How can a being whose existence is inherently temporal, a latecomer to the world, know or experience a true beginning? And without a beginning, how can this latecomer truly *know* anything at all, given that to know a thing is to know its cause—to know why it happened or why it exists?

Why? is the question of reason. Identifying a beginning or a *first* cause is only one way to answer this question. Another kind of answer, another kind of *reason*, is the *final* cause, the purpose, or *telos* in Greek. We may take the "final cause" to mark the *end* of a movement (as when we ask, "to what end?"), but insofar as it is the *reason* for the movement or change, it is equally its beginning. Take for instance this hypothetical exchange with a college student: Why are you taking this course? Answer: Because I need the credit. Follow-up question: Why do you need the credit? Answer: I need it to earn my college degree. And why do you need a college degree? So I can go to law school and become a lawyer. And why (on earth) do you want to be a lawyer? Because it's a classy profession, and I will earn well. Why is that important to you? Because if I earn well, I can buy a big house and support myself and my family. Why do you want all that? This imaginary exchange would ultimately lead to the problem of the "meaning," or purpose, of life. In the end, as Spinoza argued, "Nobody can desire to be happy, to do well and to live well without at the same time desiring to be, to do, and to live; that is, actually to exist" (Spinoza 1992, 166). Aristotle considered that the desire to be happy is the most satisfactory answer to the question of the final cause, precisely because it is the only one that *answers it*: the idea is that happiness is something inherently desirable and needs nothing beside itself to make it so. It is also true, however, that *happiness* is a word and, not unlike the word *God* is for some, it can appear to be as empty as any tautology. What is the ultimate purpose? The "good." And what is the good? Well, it's the ultimate purpose, I just told you.

It remains true that life, and all actions and movements within it, is meaningless without some final cause that could end the chain of *whys*. There must be something that can be designated as a good in and of itself, without reference to something else that can be achieved through its means. In a similar way, explaining a phenomenon by pointing to its cause is un-

helpful if the cause itself remains unexplained. The problem, as annoying as anyone could fathom, is that for latecomers such as we are, there is no other finality but death, and even *this* finality has always been debated. The hope of eternal life is probably the best proof we have that life is not eternal. Like all oppositional duos, hope and dread are codependent, and in this forward-moving time there is *always* a before and an after, just as in this container-like space there is *always* an inside and an outside, an underground and an aboveground. The lack of absolute beginning and absolute ground to support existence, meaning, and knowledge is the very essence of time, and if space keeps turning, it happens in time. It is just this restlessness—time itself—that sends us searching for a beginning, turning and returning to the "beginnings," each time revising or reaching further back, just as our telescopes and spaceships each time reach further out (and in the grand scheme of things, have not yet reached very far). Time at once beckons and frustrates our aspirations as critics to know, to understand, to see the whole, the universal, to assert or conceive anything with true conviction and sense of right. Although *Why?* is the question of reason, it is also the one for which there is no rationally satisfactory answer. "Human reason," wrote Kant, "has this peculiar fate that . . . it is burdened by questions which, as prescribed by the very nature of reason itself, it is not able to ignore, but which, as transcending all its powers, it is also not able to answer" (*CPR* 7).

For the sociopolitical critic, a beginning of time may not appear to be the most pressing problem. The more potent one is how can we begin anew? How can we begin things *now*? As Jonathan Crary writes:

> Now there is actually only one dream, superseding all others: it is of a shared world whose fate is not terminal, a world without billionaires, which has a future other than barbarism or the post-human, and in which history can take on other forms than reified nightmares of catastrophe. It is possible that—in many different places, in many different states, including reverie or daydream—the imaginings of a future without capitalism begin as dreams of sleep. These would be intimations of sleep as a radical interruption, as a refusal of the unsparing weight of our global present, of sleep which, at the most mundane level of everyday experience, can always rehearse the outlines of what more consequential renewals and beginnings might be. (Crary 2014, 128)

Crary muses about more consequential renewals or beginnings, the likes of which we might still dream up, if only this late-stage capitalism allowed us a moment of respite in which to dream. But what might these consequential beginnings *be*? The critic often grows numb when it comes to this question, just as Socrates grows numb and evasive when he is prodded into discussing the meaning of the good. As critics, the one thing we can ever promise is this: the willed-for, postrevolutionary future will *not* be the same as it has been hitherto. It will be a world *without* billionaires, a world *without* evil, a world *without* class, a world *without* inequality. But with the "not," and the "without," the new draws its meaning from its opposite, the old. All we can say of the new beginning is that it will be other than the old. If it is to be a *beginning*, it must put an *end* to the old. The need to end (the creed of the critic) thus gives meaning to the need to begin, while the desire to begin (the urge of the revolutionary) prompts the imperative to end. But can a beginning that draws its meaning from the end ever reach that end?

Italian philosopher Giorgio Agamben is among the staunchest critics of modernity. In the Nazi concentration camp, Agamben sees not a mere "historical fact and an anomaly" (Agamben 1998, 166) but "the hidden paradigm of the political space of modernity" (123). He sees the concentration camp, moreover, as the very *telos* of Western history: "the destiny of the West." No verdict can be worse than that, but Agamben does not see in it a cause for despair, precisely because, if Auschwitz is the telos, the end, of this history, then with its advent, this history has indeed come to its end. So Auschwitz is on one side the destiny of the West, but on the other side, it is a *terra ethica* (ethical ground): the ground for a radically new beginning, which would "clear the way for a long overdue renewal of categories," "a completely new politics" (Agamben, 188, 134, 11). The prospect of such new politics, however, seems only to recede further and further as time goes by. In a more recent response to the global reaction to the COVID-19 pandemic and the tightening rein of mechanisms of surveillance and control, Agamben still finds himself in something of a camp:

> We live in houses, in cities, that are burning from bottom to top, as if they were still standing; people pretend to live there and go out into the street, masked among the ruins, as if they were still the familiar neighborhoods of the past. . . .

> Man disappears today, like a face in the sand erased on the shore. But what takes its place no longer has a world, only a naked life, silent and without history, at the mercy of the calculations of power and science. (Agamben 2020a)

"What is happening today on a planetary scale," Agamben writes in another article, "is surely the end of a world." But then his optimistic side reasserts itself against the pessimistic, just as the day comes in to chase away the night: perhaps, he wonders, "it is only starting from this destruction that something else may one day slowly or suddenly appear—not a god, of course, but not even another man—a new animal, perhaps, an otherwise living soul" (Agamben 2020b). The bipolarism of end versus beginning, in which we recognize the oppositional logic of critique, gives way to the bipolarism of dystopia versus utopia. I am not sure if it was Slavoj Žižek or Fredric Jameson who said that it is easier to imagine the end of the world than it is to imagine the end of capitalism. I would say it is simply difficult for us to imagine an end, period, just as it is difficult, and sometimes annoying, to imagine a beginning.

FROM END TO BEGINNING

In the early nineteenth century, Hegel infamously proclaimed the present to be the end of history. He certainly did not mean that in the sense of stoppage and certainly not in any negative sense. He meant, rather, that the present is the *telos* (the goal) of history. This claim, as it pertains to our purpose, has two faces—one structural and one political/ethical. The structural claim is that the present just *is* the end of history, which is, as we saw, a truism under the auspices of the orientation of critique. History by definition is *our* past, and we always stand at the end of this past, in many ways, the products or outcomes of this past. And history means literally a *story*, one that, like a confession, can only be told from the vantage point of the end: "This is how things have come to pass; this is how we arrived at where we are." In Arendt's words: "The meaning of what actually happens and appears while it is happening is revealed when it has disappeared; remembrance, by which you make present to your mind what actually is absent and past reveals the meaning [of it] in the form of a story" (*LMT* 133). Insofar as history is a story, the "end of history" is in fact its beginning:

the beginning of the story, which occurs after the events narrated in it have transpired. Hegel's word for the kind of retrospective/reconstructive outlook that begins its narration from the end, starting from the beginning and arriving at where we—the narrators—are, was "speculative" reasoning, which also means "theoretical."

But on a political/ethical level, the claim that the present is the end of history makes more specific reference to *Hegel's* present, which for a Hegelian remains our present as well—namely, late modernity, post-Enlightenment. Here, "end" is not simply the structural truism that every present is the end of a process but the very end of history as such. In this respect, the "end" really means the *purpose* and *aim* of historical development. Retrospectively, we see that the entire course of history has been semiconsciously geared, like a traveler searching through the gradually illuminating dark, toward the political, ethical, and juridical conditions that exist in the modern state. These conditions are the optimal ones for the possibility of self-determination, both on the collective level and on the individual. Hegel's history is thus not just a random sequence of events but a developing *plot*. Few would concede today that what Hegel saw as the optimal model for the modern state (the British constitutional monarchy) is indeed the optimal model. The young Marx already pointed out that the modern state must be democratic (later adjusting it to communist). But these adjustments were the products of immanent critiques rather than repudiation of the essential thesis that history is teleological, and that the modern state, be it democratic or communist, is the telos that implicitly guides it all along, becoming clearer and better defined as it nears.

To say that history is teleological and goal-oriented toward the optimal state of self-determination is not to deny contingencies. If all could be known or worked out in advance, no history would be needed. The process necessarily includes trials and errors, relative advances and relative failures. In fact, it is often a bloody affair, replete with wars and subjugations that reveal themselves in hindsight to be unjust and thus ensure, in part by the force of the traumas they leave in their wake, that they will not be repeated. More than a simple advancement, history on this view appears as a spiral movement: at once cyclical and progressive. It is not a straight-moving line but a series of restarts. Each new epoch reinterprets the beginning and the whole with the advantage of having knowledge of previous interpretations and the problems they incur, revising its self-understanding by revising

its history. The larger history is thus punctured by ideological and political revolutions in which this history is being corrected. But a restart is not the same as a completely *new* beginning. It is, instead, a matter of making gradually more explicit what has hitherto been only implicit and, moreover, only partially exercised and understood.

Hegel's metaphorical expression that the owl of Minerva (a symbol of wisdom and philosophy) "flies at dusk" means that wisdom belongs essentially to hindsight. But the reverse is no less true: our *foresight* far exceeds our present vision and capacities. Greek democracy, to give but one example, already postulated the ideal of equality, though it was unable to live up to this ideal in practice. The same, of course, holds to the founding of the United States, carried out by slave owners who solemnly preached the equality of all "men" before God. It is a teleological rule that we somehow intuit the right long before we can act accordingly. We have more or less confused beliefs long before we come to knowledge. But knowledge neither comes to replace or falsify these beliefs as much as it clarifies them and brings the ideas implicit in them into proper intellectual and emotional grasp. Thus, ideals are posited by cultures that are unable to fully comprehend them, yet they nonetheless act as *teloi* for future cultures. With advancement in knowledge (that is to say, with enlightenment—which is not a one-time event but a recurring one), future epochs exercise immanent ideology-critiques of previous ones, modifying in the process the practices and political organizations in which we seek to actualize those ideals. Marx changed the Hegelian understanding of how revolutions and progress work, arguing that philosophical or theoretical developments are entirely contingent on material transformations, both in the technologies and means of production and in the economical organization of society. "No social order," he said, "ever perishes before all the productive forces for which there is room in it have developed; and new, higher relations of production never appear before the material conditions of their existence have matured in the womb of the old society itself" (*CCPE* 5). This is by no means to deny that higher relations of production do appear.

This, then, is how teleology works: the end of history is necessarily inscribed in its beginning, even if it only becomes explicit at the very end; the end is nothing but the full grasp of the beginning, and of the whole. When Hegel argued that the present is the end of history, what he meant was that we finally understand—in theory as well as in practice—the ideals

that were vaguely present from the dawn of recorded history and certainly from the dawn of philosophy and science in Greece, the ideals in whose image our lives and institutions are shaped. What Hegel did not mean, however, was that time was thereby *over* and we can now retire or drop dead. This would make a mockery of the notion of "ideal." If anything, at the "end of history" we are finally ready to *begin* the endless—and in that sense posthistorical—process of living for the sake of the present, for the sake of living, rather than for the future: conscious self-determination and self-correction in light of adequately grasped and articulated values, if not so adequately practiced. The "end of history" means that the project of self-understanding can now be *forward* looking and projective rather than past looking. No more need for the wisdom of the Owl. *Revolutions*, too, on this view, are a relic of the past. The decisive revolutions have already occurred. No new scientific revolution is needed, no political revolutions, no artistic revolutions, and no new religions—only science, politics, art, and religion. It was to this, of course, that Marx objected above all. The end of history, as he saw it, was by no means at hand, and by arguing otherwise Hegel and his disciples were counterrevolutionary, providing reactionary justifications for the status quo.

Per the narrative of the present book, however, this Marxist development is further expressive of, and occurs on the ground of, the chronology of critique rather than revolutionizing this chronology itself. And in light of this, there is some room to doubt whether the communist revolution *could* achieve what Kant's and Hegel's Enlightenment couldn't. The "beginning" and the "end" are ideal signposts. Hegel understood this better than most other philosophers; this is why his spiral conception of history is so sophisticated: holding together the permanence of the structural coordinates and the instability of their concrete determinations. But understanding structural premises and sophisticatedly elaborating on them does not undo the premises, let alone put them to question or consider alternatives. With all the efforts to dialectically reconcile the end and the beginning, "the end" is *necessarily* futural. The fact that soon after Hegel's death Hegelianism split itself up into Right and Left Hegelianisms is a reminder of how oppositional logic works, be it dialectical or simply dualistic. That after the end of revolutions was pronounced a Marx *had* to be born to promote a radical new revolution is something that, retrospectively, seems predictable (though Hegel could hardly have foreseen it). The more interesting ques-

tion, perhaps, is whether a contemporary Marxist can foresee what Marx could not have: that no revolution will be the last, and no historical event that can actually *happen* can put "an end" to anything at all. The end is as elusive as the beginning.

Hegel was critical of Kant for endorsing a bad-infinite type of approach to historical progress. This complaint pertains to the categorical separation between the real and the ideal of which I have spoken in chapter 5. Per Kant, the regulative ideals that guide us are *in principle* transcendental; they are ever objects of thought, never of experience. Hegel saw that what this meant was that we shall never catch up with our ideals but are doomed to infinite striving and perpetual disappointment—a perennially "unhappy consciousness," life as tragedy. Hegel saw that, on this view of things, it is hard not to admit defeat in advance. This critique of Kant, however, can miss the point he was making. Kant did not expect us to admit defeat any more than he took the limitation of knowledge to be a shortcoming. He was making a *positive moral* claim. Kant asked: should any society "be entitled . . . to perpetuate an endless guardianship over each of its members and through them over the people?" (Kant 1994, 138); and he answered, as many of us would: No, no society may enforce any doctrine or way of life that denies future generations the capacity and the right to progress further or to radically change course. He generalized this into a principle:

> [Any] contract, which would be concluded in order to keep humanity forever from all further enlightenment is absolutely impossible, even should it be confirmed by the highest authority through parliaments and the most solemn peace treaties. An age cannot conclude a pact and take an oath upon it to commit the succeeding age to a situation in which it would be impossible for the latter to enlarge even its most important knowledge, to eliminate error and altogether to progress in enlightenment. Such a thing would be a crime against human nature, the original destiny of which consists in such progress. Succeeding generations are entirely justified in discarding such decisions as unauthorized and criminal. (Kant 1994, 138–39)

This lesson would have been well learned, for instance, by the founders of the Kibbutzim in Israel. The Kibbutz was a wonderful communist idyll: a society in which all private ownership—including family ties ("my" daughter, "my" son)—is banned, and all possession is communal; a society in which each is paid by the community according to their *needs*, not ac-

cording their status or their aspirations; a society in which all housing and education is free and all houses are the same shape and size, surrounded by common areas and common walking-paths; a society without fences. This idyll, to the chagrin of many, is now mostly a relic of the past. Why? Not only because idylls, when put to practice, often reveal less wholesome consequences but, more fundamentally, because those who conjure them up have *children*, and these children have children of their own. Show me one child who is happy to replicate their parents' and grandparents' values, and I will show you three that are not. Is it the result of capitalism or consumerism? Perhaps, though I wouldn't swear on it. I wouldn't know what ground to stand on or what book to hold when swearing to something like that. This is less a comment about the nature of values than it is about the nature of generations. Although I am not a prophet, I do assume, as Kant did, that the nature of generations will not change with future generations. Hemingway began *The Sun Also Rises* with a remark that Gertrude Stein had made to him: "You are a lost generation." In response, he quoted from Ecclesiastes: "One generation passeth away, and another generation cometh; but the earth abideth forever. . . . The sun also ariseth, and the sun goeth down, and hasteth to the place where he arose. . . . The wind goeth toward the south, and turneth about unto the north; it whirleth about continually, and the wind returneth again according to its circuits. . . . All the rivers run into the sea; yet the sea is not full; unto the place from whence the rivers come thither they return again" (1:4–7). Essentially, what Hemingway was telling Stein is that *every* generation is lost, and every generation is found.

If this is the case, then no vision of justice can be expected to be conclusive or intrinsically right, except (as is Kant's point in the cited passage) the one that posits itself as tentative and replaceable. In the nineteenth century, John Stuart Mill wrote that justice systems of past ages often come to "appear so tyrannical, that people are apt to wonder how they ever could have been tolerated," adding that the same people who so wonder can be "forgetful that they themselves perhaps tolerate other [injustices] under an equally mistaken notion of expediency. The entire history of social improvement," he said, "has been a series of transitions, by which one custom or institution after another, from being a supposed primary necessity of social existence, has passed into the rank of an universally stigmatized injustice and tyranny" (Mill 2003, 234). We have certainly witnessed revolutions that began with righteous conviction only to give way to tyrannies,

sometimes even crueler and more despotic than those that preceded them. The revolutions are new, but the lessons seem old. In the words of James Baldwin, "Time and time and time again, the people discover that they have merely betrayed themselves into the hands of yet another Pharaoh, who . . . will not let them go" (Baldwin 1963, 98).

Not only a society of pastors, but also a society of scientists, should acknowledge this fact. If we can expect there to be PhD programs and PhD students in future societies, we can also expect our present knowledge to become obsolete. New theories, and sooner or later dramatic and unforeseen paradigm shifts, would come to topple assumptions that are now considered beyond dispute. And if this is the case, then there can be no such a thing as "true knowledge" of nature or of the past, except as they pertain to circumscribed regions. More: it is precisely in the *name* of truth and knowledge that current claims will be refuted, since mere relativism lacks the force of conviction to topple or refute anything. Human nature is not fundamentally different from nature at large as we experience it. Just as the sun rises and sets, so, too, every enlightenment is followed by darkness. Such is the intricate bond between critique and knowledge: critique is at once wedded to a robust ideal of knowledge *and* to the business of shattering ideals.

As I recall my father teaching me how to swim, I remember that he would stand before me inside the swimming pool and open his arms wide, calling me to jump in from my place on the edge of the pool, ensuring me of the safety of his embrace once I landed in the water. But when I finally mustered the courage to jump in, he began to walk back slowly in the pool. He was tall, in my eyes at least, and the pool was shallow, so he could stand firm and simply walk back. His arms still open, like some angel of history, chased away by the ruckus I was making about me in the water, like a maniac, flapping every limb I had at my disposal. This, I reckon, is what the end is really like for us critics: with every inch we make toward it, it retreats a few inches back. And some of us learn how to swim.

REVOLUTION AS REBELLION AGAINST TIME

Beginning and *end*, as Arendt said, are limit-concepts. As limit concepts, they are never locatable within time; they serve to structure time as a whole. In the previous chapter, in discussing the topologies of critique, we've seen

the way a limit operates in space; it splits up space into two oppositional dimensions: an inside and an outside, an underground and an overground. The transition from one to the other is not continuous, as if they were two separate and adjacent spaces, but occurs via a metastrophic turnaround of space itself around its invisible axis. The beginning and the end operate in time in a similar way. In what we call "revolution" or "conversion," time is split up into a before and an after. Here, too, the transition from one side to the other is not a mere flow of time but a dramatic shift in history, in the manner in which time is narrated. In foresight, the revolution stands as an invisible portal to a radically different, unforeseeable future. This is why the missionaries, like Paul and Augustine, or the philosophers who have exited the cave and now return to liberate others, cannot adequately say what is "on the other side." Their promises are vague; they speak only in negations and refutations. You must *undergo* the turn in order to know, in retrospect, what it means and why it is better.

As seen in the aporetic chapters of part 1 of this book, many of critique's core notions, such as that of enlightenment (out of the heart of darkness) and of autonomous agency (wrested from within passivity) require tolerating paradox—inexplicable reversals. The necessity of these reversals to support the conceptual and ideological edifice of critique accounts for the disposition to which I have often alluded under such phrases as "revolutionary temperament" and "penchant for revolution." Any philosophical text that contains a conversional moment, wherein what comes later turns out to have been the hitherto-invisible *ground* of what has come before, exhibits this orientation: Platonic dialectic, the Catholic conversion, social contract theories, the Kantian critical turn, Hegel's *oeuvre*, of course, and the original Marxist theories. We also see the advent of a revolution, or *Kehre*, in Heidegger's work, for example.

Since it structurally promises more than it *can* promise, the revolutionary temperament appears to parade the *intrinsic* value of change—the more radical it is, the better: change as life, change as betterment, change as knowledge, change as growth, change as meaning, change as purpose. Of course, hypothetically speaking, the critic might argue that what confers value on change or revolution is not change itself but *betterment* (happiness, for instance, or justice). This may be so, but the problem is that betterment is not, strictly speaking, permissible under the auspices of this chronology or schematization of time, especially given that history as a whole can be an

object of thought and, as such, can be deemed unjust, which means, non-progressive. This possibility, and the capacity to actualize it with empirical evidence, is structural. The ontology of presence, along with the categorical opposition between what is and what ought to be, dictate the following premises:

(a) Reality is what is present.

(b) The present is not as it ought to be.

(c) The good—what ought to be, what is desirable—is not present.

(d) The good, therefore (if there is or can be such a thing), must either be a regulative ideal or in the future, provided that the future is somehow categorically different from the present.

(e) Hence, the good is the product of, or is necessarily bound up with, change.

This schema is perhaps responsible for what Lee Edelman diagnosed as the "structural optimism of politics" (Edelman 2004, 5) and "the unquestioned value of futurism," specifically of *reproductive* futurism with its "pervasive invocation of the Child" as the locus and sanctity of all meaning and value. Our actions are sanctified by the promise of a better future for our children. The constant deferral inscribed in this logic caused Edelman to call out "the Ponzi scheme of reproductive futurism" (3–4). The suspicion of a Ponzi scheme is aggravated in view of the fact that the figure of the child appears to double as both the end and the means, as suggested by the immortal question to which the children of this future-oriented society are subjected ad nauseam: "What do you want to be when you grow up?" (I wish that, as a child, I would have been wise enough to respond: "I want to grow up to be the kind of person that doesn't ask this question . . ."). We live for our children, who in turn live in preparation for adulthood, whose value will be rooted in *their* children. Edelman loves to cite "Tomorrow," a song from the musical *Annie*, which he hates: "Tomorrow, Tomorrow, I love you, Tomorrow. You're always a day away." If the child is there to sanctify adults' loss of innocence and shrinking future, the world-changing adult is there to sanctify childhood's apparent uselessness and naivety. Adults today appear to grow older more slowly, just as the youth appear to grow older much faster. And the moral roles appear to be flipped: the youth admonish the old for not being sufficiently responsible for their own (the youth's) future. The

temporal logic of futurism survives such changes and turnabouts intact.

The claim that the value of change is intrinsic on this schema is not to deny that reality is dissatisfying, let alone the specific determinants of this dissatisfaction. The dissatisfaction is an entailment of the capacity to step back and behold something like "history" or the "world" as a whole. It is true that one can also be *satisfied* with what they see, just as a critique or a judgment can be "positive." But negativity remains a perennial possibility insofar as the critic is structurally alienated, removed, from the object of critique. A "positive critique" or a "satisfied critic" are therefore hardly the paradigmatic cases, and it is hard not to accuse someone who says the present state is good and only getting better of being somewhat uncritical, if not downright reactionary. What chiefly concerns us here, however, is not whether the world or history is a sordid affair but whether it can be *otherwise*, that is, not whether change in general is possible but whether *this* basic ontological fact about the world—that it appears sordid to the critic—can change. It is perhaps not by chance that the same term, *revolution*, has two oppositional meanings. On the one hand, revolution means *real* change— that *singular event* that breaks with the past and constitutes progress rather than mere continuation or repetition of the same. On the other hand, revolution refers to the *cyclical movement* of the stars around their orbits— regular, predictable, harmonious, the eternal recurrence of the same. So which is it, eternal repetition or radical, irreversible break? Is revolution a cycle or a progress?

A famous poem by Hannah Szenes, a Jewish poet who died during World War II while serving as a special operations fighter, suggests a possible commonality between the cyclical and the progressive. The poem, "Eli, Eli" (My God, my God), is written in the form of a prayer:

> Eli, Eli,
> let it never end,
> the sea and the sand,
> the rustling of the water,
> the shining of the sky,
> the praying of man.

If the "praying of man" implies *hope*, and hope implies the longing for change—as constitutive of human nature as shining is constitutive of the starry skies—then, indeed, let that desire for change never end. Let there

be a permanent revolution as asked for by Trotsky. But if *the prayer*, as suggested by Szenes, is itself the thing hoped and prayed for—and not a means to some other end that can be attained—then we should not be surprised to find a Catholic seeking confession in heaven or a Marxist plotting revolutions against the communist state. It can only be disappointing *not* to find such people.

Revolution is, to use Nietzsche's terms, the will's rebellion *against time*—the time that never stops and never stands still. And this rebellion is, literally, as old as time. Per Greek mythology (some versions of it, at least) the very first revolution was indeed aimed against the reign of Time, for it was the overthrow of the Titans by the Olympian gods, led by Zeus against his father, Cronus—a name that most likely connotes Time. In truth, this revolution is not even the first, for according to myth, Cronus himself already carried out a revolution, castrating his own father, Uranus (Sky), and in a fatal act of misjudgment throwing his father's (still fertile) testicles into the sea. These myths seem to tell us that, inasmuch as revolution is always a revolution *against* time, it is also the revolution *of* time itself, an affirmation of its eternal March forward. It's not only a human phenomenon; all things youthful rebel against all things that grow old. Such is the cyclical nature of Time and of the seasons.

Little wonder it is that the revolutionary stance itself, for all its lust for novelty, can easily get old. The epithet "revolutionary," especially in post-revolutionary or otherwise avowed leftist societies, can become a cliché if not a contradiction (as what happens, for example, when secret service agents for an oppressive state call themselves "Revolutionary Guard"). The novelist Milan Kundera, who survived the atrocities of Soviet rule in his native Czechoslovakia, quipped about the irony of the leftist revolutionary idyll of "a Grand March" in his novel *The Unbearable Lightness of Being*:

> Yes . . . the Grand March goes on, the world's indifference notwithstanding, but it is growing nervous and hectic: yesterday against the American occupation of Vietnam, today against the Vietnamese occupation of Cambodia; yesterday for Israel, today for the Palestinians; yesterday for Cuba, tomorrow against Cuba—and always against America; at times against massacres and at times in support of other massacres; Europe marches on, and to keep up with events, to leave none of them out, its pace grows faster and faster, until finally the Grand March is a procession of rushing, galloping people

and the platform is shrinking and shrinking until one day it will be reduced to a mere dimensionless dot. (Kundera 1984, 266–67)

There is also an intellectual variant to this nervous March: the history of ideas is itself paved with revolutions. Descartes turned Plato on his head. Kant turned Descartes on his head. Hegel turned Kant on his head. Marx and Engels did the same to Hegel. Nietzsche did the same to Marx. And in recent decades, things have only gotten more hectic. We turn and turn about: a linguistic turn is followed by an affective turn, which is followed by an anarchist turn, each turn coronating a new regime and system: a new objectivism, a new materialism. Each new philosophy performs a ritual shoving of its intellectual predecessors into a collective hole in the ground. Our intellectual landscape is thus always post-this or post-that: postmodernist, poststructuralist, post-Zionist, and so on. A particularly telling development is the notion of "postcritique" (for example, Hoy 2004; Anker and Felski 2017; Sutter 2019). As I stated at the outset of this book, I think that a genuine attempt to offer a critique of critique should come to terms with the internal limitations and pitfalls of this endeavor itself. Nothing can come *after* critique because the "after" bespeaks the chronological schema of critique itself. Critique can never "end" because the desire to end it belongs to its very nature: its death drive is its libido, and vice versa.

The dream of revolution is expressive of critique's ambivalence toward time—its *own* time. It is expressive of the frustration at being constitutively latecomers into, and early departed from, this world and history—a world and a history that form the condition for the possibility of critique itself. Critique is therefore always, as Nietzsche called it, "untimely," at odds with the conditions for its own possibility, and this being at odds fuels its revolutionary craving. If it is possible to think *outside* of critique, or challenge its reign over our thought, our intellectual heritage, and the prevalent discourse, a few things must be acknowledged: (1) just as there is no event that is not historical, so there is no history that is not constituted and schematized by a certain *temporalization*; (2) temporalization, which is a function of what I am calling here orientation, is structurally *meta*historical (it is not itself "an event" in history or time); (3) an alternative temporalization, which would inevitably accompany reorientation, is not the same as changing or revolutionizing "the world." The idea and value of revolutionizing the world is a product of orientation (critique) and is the first thing to dissipate

with reorientation.

The titular "new-," "post-," "turn" still convey critique's own tempo-rality. In contrast, an alternative temporalization or historicization would likely obviate the metanarrative of progress *and* decadence, the fixation with "modernity" (pro *or* con) and with the end/beginning of history or the world, along with the presupposition of the unity, and linear direction-ality (however spiral or dialectical) of history. Alternative temporalizations would also entail alternative ontologies, epistemologies, and ethics if they are to be consistent. María Lugones, for example, appealed to alternative "knowledges, relations, and values . . . [that] are logically . . . at odds with a dichotomous, hierarchical, 'categorial' logic" (Lugones 2010, 742–43). Such knowledges, she emphasized, are neither premodern nor postmodern but *non*modern: subject to different chronologies. One of the implications of this claim, I take it, is that thinking outside of modernity is not the same thing as *critiquing* modernity or "moving past" it. It is, rather, thinking in a chronological register in which *modernity* and *modernization* are not operative terms. In the same way, thinking outside of critique is not the same thing as critiquing it or moving past it. In the end, critique and mo-dernity (as well as "postmodernity" and "premodernity") belong together, not because critique is a modern phenomenon but because the designation *modern* is the product of the spectatorial orientation.

CONCLUSION

Critique and Its Betrayals

There is a joke about a police captain looking to promote an officer to the rank of detective. Each candidate for the promotion is shown a mugshot of a criminal in profile and asked to deduce some information about the criminal from it. The first candidate fails after proposing that the criminal in question has only one ear. "The criminal most likely has two ears," the captain responds, "but since the mugshot was taken in profile, only one of them is visible." The second candidate reaches a similar conclusion: "Due to some misfortune, this criminal lost one of his ears. . . ." But the third candidate shows more promise: "This criminal is wearing contact lenses," she concludes. Impressed by this candidate's capacity to peer into the invisible, the captain inquires about her deduction process. "It's elementary," she says; "you can't wear glasses if you only have one ear. . . ."

I no longer remember where I first heard this joke, but I always found it illustrative of the hazards of automatic critique: of *attributing the limitation of our own perspective to the object*. As a teacher, I use this joke to explain to my students why I think it's wiser when commenting on a new text to say, "*I* am confused" instead of "this text is confusing," or "*I* don't see the argument clearly" as opposed to "there is no clear argument here." They

usually get the point, and this adjustment is relatively easy to make. But there is a deeper truth at play that pertains even to the most sophisticated, knowledgeable, and attentive critiques. For example, if I critique "history" as exhibiting a decadent course of progress—no matter how much empirical evidence I draw on—I am at least in part critiquing the infrastructure of my own orientation. It does not occur to me in such a case to question, for instance, the conditions for the possibility of history appearing as a unified whole or the extent to which I am implicated in its constitution as such.

Roland Barthes, defending his work against the accusation of formalism (or "structuralism" as it is usually known), wrote that, if it were less "terrorized by the specter of 'formalism,' historical criticism might have been less sterile; it would have understood that the specific study of forms does not in any way contradict the necessary [principle of] . . . History. On the contrary, the more a system is specifically defined in its forms, the more amenable it is to historical criticism. To parody a well-known saying, I shall say that a little formalism turns one away from History, but that a lot brings one back to it" (Barthes 2013, 220). My position is a bit different than Barthes's, because I do not think orientations are amenable to "historical criticism" (orientations are not historical phenomena, and assuming that they must be is more likely to make one's thinking dogmatic, or oblivious to its own mode of historicizing, than to make it critical). But like Barthes, I consider that formalism, as the one practiced in this book, should bring one back to history rather than remove one from it. This is because the formal analysis of orientational structures shows that the orientation does considerable work in structuring reality and our analysis of it. The more we recognize the structures, the more we can begin to discern reality. That is not to reify a form-content, subjective-objective opposition. I do not think, as Kant did, that we are trapped in a bubble of our intelligence, a bubble that bars us unmediated access to "things themselves." I see no reason to assume that an orientation is anything but the way in which things *are* and show themselves. The idea of orientation does not imply that we lack direct access to the world, only that there can be *more than one* access—that the "same" reality can be oriented in more than one way.

There is something artificial about, first, distilling the formal aspects of an orientation from the specific contents through which they reveal themselves and, second, isolating one orientation from others. My aim in this artifice is not to undermine the importance of contents, or of "History"

as Barthes terms it, but, on the contrary, to increase our awareness of the way we think and our attention to what we think about, and to cultivate the kind of thinking we can call "multistable" ("multistable perception" is the sort incurred by ambiguous images like a duck-rabbit). Can I orient differently? Can the world, or whatever it is I am studying, be differently oriented? How?

But reality is not the only thing that matters in articulating the formal structures of critique. *Thinking* matters just as much, as do the values, the commitments, the assumptions inscribed in it—its own forms. An orientation not only has value; it *is* value, the source of valuation. A critique of critique furnishes us with immanent standards for judging concrete manifestations of critique. In the following pages, I want to look at some of the intrinsic pitfalls of critique, characteristic ways by which it goes sour. Every orientation of critical thinking is liable to get "jammed," in which case it takes its categories for granted to the point of forgetting about them altogether. I will call this phenomenon betrayal, because when it happens, one of the primary manifestations is turning against, betraying, the core commitments that are distinctive of critique. In betrayal, critique becomes its own enemy. The word *betrayal* has two connotations, both equally relevant here: on the one hand, to betray something is to turn against it or disappoint it; on the other hand, to betray means to "give away" something, in the sense of unintentionally revealing it, as in the statement, "his behavior betrayed his true intentions." When an orientation is "betrayed," its structures are at once concealed and revealed. The concept of *parékbasis* (παρέκβασις) in Aristotle's political theory can serve as a good illustration of betrayal in this double sense.

THE LOGIC OF BETRAYAL, OR THE DEVIATION FORM

Parékbasis means digression or deviation from a path. In its use in Aristotle's ethics and political theory, it is usually translated as a *deviation form*. After identifying three kinds of political constitution—monarchy, aristocracy, and timocracy—Aristotle warned that there is an "equal number of deviation forms—perversions [of them], as it were" (*NE* 1069): the deviation form of monarchy is tyranny, of aristocracy it is oligarchy, and of timocracy it is democracy. If we adjust Aristotle's terminology to better suit the political phenomena familiar to us, his insight about deviation forms remains as

astute as ever: Stalinism, we could say, is a deviation form of communism; fascism (or populism, if you prefer) is one of democracy. How so? Arguably, what Stalinism, with its practices of state surveillance, interrogation, and internment, did was turn each "comrade" into a potential informer against all others: if you don't hurry up and give away your neighbor, there is a good chance your neighbor will beat you to it and give you away instead. Such a turning of all-against-all betrays the very essence of camaraderie and community. This means that there can be nothing *further* from the spirit of communism than Stalinism, yet owing to its classless, one party organization and highly bureaucratized governmentality, communism itself makes this betrayal possible. Stalinism therefore betrays communism in both senses of the term: it discloses its essence by perverting it. Above all, what it betrays (in the positive sense of the word) is a danger intrinsic to the communist form. In Aristotelean terms, it is a deviation form *of* communism.

Like Aristotle's political constitutions, each orientation of critical thought has its own deviation forms. And just as the deviation forms of political constitutions are all antipolitical—if by *political* we understand an actual concern for the well-being of the polis—so, too, the deviation forms of orientations of critical thought are all *uncritical*. A critique of critique, as I see it, is not a matter of debunking critique, which would be futile, but of protecting or reviving it. This is achievable, first, by elaborating on its commitments—which get lost as soon as words that originally designate ideas, sensations, and sensibilities deteriorate into clichés—and, second, by making more patent the dangers intrinsic to critique and its possible betrayals.

This concluding chapter presents the ways in which I think critique betrays itself and how each of its betrayals highlights an essential feature of critique, precisely by turning against it. Both aspects—the negative and the positive—belong to a critique of critique. I discuss three kinds of betrayal: (a) "Total Critique": a complete denunciation of the present world without any visible alternative; (b) "The Critique of All-against-All": a proliferation of infighting and manifest lack of solidarity among critics; and (c) "The Activist Mystique": the tendency to exalt practice and action and denigrate theory, to the point of succumbing to an anti-intellectual posture. In the first betrayal, the oppositional standpoint gives way to defeatism; in the second, the unifying ethos creates discord; in the third, the revolutionary creed joins hands with reactionary forces. In all three, critique stands to become *uncritical*, dogmatic—an anticritique. Unlike the aporias that are

irreducible facets of critique, these betrayals are perennial dangers that can be averted.

FIRST BETRAYAL: TOTAL CRITIQUE

By "total critique" I understand the betrayal wherein all the virtues of critique—its rational sophistication, its erudition, its moral fervor—are called on to expose the magnitude, pervasiveness, and totalizing nature of systemic injustice, which nothing can escape. In this totalizing form, critique is just as compelling as it is depressive. "The Culture Industry: Enlightenment as Mass Deception" (*DE* 94–136)—a masterpiece of neo-Marxist literature and critical theory—exemplifies total critique. What we take from this text and how it affects us may vary. For many, reading it has marked a true turning point—an enlightenment. In this section, I deliberately highlight the problematic of totality, the role played by the critic in describing totality, and the potential dangers it involves.

Adorno and Horkheimer write about the totalizing and homogenizing nature of the capitalist consumerist culture: "Culture today is infecting everything with sameness. Film, radio, and magazines form a system. Each branch of culture is unanimous within itself and all are unanimous together. Even the aesthetic manifestations of political opposites proclaim the same inflexible rhythm" (*DE* 94). The authors prove the point by showing how a plethora of rapidly evolving technologies join arms with each other to produce a tightening grip on consumers' consciousness: "Television aims at a synthesis of radio and film [which] promises to intensify the impoverishment of the aesthetic material so radically that the identity of all industrial cultural products . . . still scantily disguised today, will triumph openly tomorrow" (97). If the technology had its way, they tell us, "the film would already be delivered to the apartment on the model of the radio" (130). Of such observations one says they are "prophetic." Since the inventions of the World Wide Web and of digital media, this prediction has become reality—the film has been delivered to the apartment and even to trips on public transportation. But the fact that something is prophetic does not yet endow it with critical merit. Is there something that can be, or needs to be, *done* about this downward spiral toward a technohomogenizing culture?

It is not only the case that culture is gradually becoming a unified and oppressive mechanism, but also that *everyone* appears to be in on it: "Al-

though the operations of the mechanism appear to be planned by . . . the culture industry, the planning is in fact imposed on the industry by the inertia of a society irrational despite all its rationalization." A mass society is constructed in and through the mass art and entertainment industry that it consumes. This society forms a peculiar transcendental subject: a monolithic, impersonal, godlike consciousness of no one in particular. Irrational—lacking judgment, self-consciousness, or conscience—this mass society nonetheless fulfills all the functions of a transcendental consciousness: classification and organization of all that appears according to "the schematism of production" (*DE* 99).

In this reality, the whole swallows up the parts, to the point that they are impossible to distinguish: "The whole confronts the details in implacable detachment, somewhat like the career of a successful man, in which everything serves to illustrate and demonstrate a success which, in fact, is no more than the sum of those idiotic events." The "whole," having become a totality, is no more than a "filing compartment which creates order [but no] connections." But, like every whole, it includes everything and excludes nothing: "The whole world is passed through the filter of the culture industry," which is evidenced by the "familiar experience of the moviegoer, who perceives the street outside as a continuation of the film he has just left" (*DE* 99). The modern film "trains those exposed to it to identify film directly with reality." Specifically, it trains the moviegoer not to think; for, with the density and splendor of its special effects, the film "denies its audience any dimension in which they might roam freely in imagination" (*DE* 100). In the cinema, as later, out in the world, they must stay intently focused lest they lose the thread of "the action."

The telos of this totalizing culture is control—totalization itself. Its true enemy is therefore the "wayward detail," which cannot be assimilated, and especially "the thinking subject," who, if given free rein to imagine, would threaten the totalizing schema. So "individuals are tolerated only as far as their wholehearted identity with the universal is beyond question" (*DE* 124). Here, too, the industry works in cunning ways: it does not repudiate individuality or individualism as a politically totalitarian regime might, with its police forces, intelligence agencies, and concentration camps. On the contrary, the culture industry coerces through *seduction* and *co-optation*. Rather than demonizing individualism and eccentricity, it glorifies them, but at the same time it turns them into yet another commodity for homog-

enization and sale. In commodified form, all shows of originality or rebelliousness, from "the standardized improvisation in jazz to the original film personality who must have a lock of hair straying over her eyes so that she can be recognized as such" (*DE* 124–25), are rendered completely harmless.

Again prophetic, the essay anticipates contemporary discussions about the behavior modification technics of advertising on social media: "Advertising and the culture industry are merging technically no less than economically. In both . . . the mechanical repetition of the same culture product is already that of the same propaganda slogan. In both, under the dictate of effectiveness, technique is becoming psychotechnique, a procedure for manipulating human beings" (*DE* 133). The ultimate product of the culture industry is human-robots after its own image—sophisticated, highly individualized, but completely exchangeable. "Industry is interested in human beings only as its customers and employees and has in fact reduced humanity as a whole, like each of its elements, to this exhaustive formula. As customers they are regaled, whether on the screen or in the press, with human interest stories demonstrating freedom of choice and the charm of not belonging to the system. In both cases they remain objects" (*DE* 118). As a totality, this mechanism is also *inescapable*:

> The power of industrial society is imprinted on people once and for all. The products of the culture industry are such that they can be alertly consumed even in a state of distraction. But each of them is a model of the gigantic economic machinery, which, from the first, keeps everyone on their toes, both at work and in the leisure time which resembles it. . . . Each single manifestation of the culture industry *inescapably* reproduces human beings as what the whole has made them. And all its agents, from the producer to the women's organizations, are on the alert to ensure that the simple reproduction of mind does not lead on to the expansion of mind. (*DE* 100, italics added)

If escaping this gigantic economic machinery is impossible, what can one say about resistance or opposition to it? Here, too, the same strategy is in effect: the culture industry defeats opposition by co-opting and commodifying it: "Anyone who resists can survive only by being incorporated. Once *registered* as diverging from the culture industry, they *belong* to it as the land-reformer does to capitalism" (*DE* 104, italics added). The culture industry has no need to oppress because it allows no resistance. If the thinking subject is its enemy, it is "an enemy who has already been defeated"

(*DE* 120). Absorbing rather than fighting against the ideals of autonomy and resistance, the entertainment industry renders them docile. Those who quixotically refuse incorporation are ridiculed: "Anyone who continues to doubt in face of the power of monotony is a fool. The culture industry sweeps aside objections to itself along with those to the world that it neutrally duplicates. One has only the choice of conforming or being consigned to the backwoods" (*DE* 118–19). Genuine objectors are thus "condemned to an economic impotence which is prolonged in the intellectual powerlessness of the eccentric loner. Disconnected from the mainstream [they are] easily convicted of inadequacy" (*DE* 106). In these bitter lines we finally lock eyes with *the critic* and his apparent self-perception: an eccentric loner, economically impotent and culturally marginalized, if not completely irrelevant. In the face of the "same babies grin[ning] endlessly from magazines" and to the tune of the "endlessly" monotonous pounding of "the jazz machine" (*DE* 119), what is left to us critics but the apparently futile endeavor of protocoling the totalizing effects of consumer society and the demise of individuality and thought? What is left to us but to chronicle the death and futility of critique itself?

How do we explain this paradox? Adorno and Horkheimer's "The Culture Industry" is a tour de force, sliding with little friction through a dazzling maze of cultural reference and detail. At every turn, with every connection drawn, the essay exhibits the associative, imaginative, and ironical brilliance of prescient, free-thinking intellects, armed with a vast arsenal of knowledge and insight. You can hardly blame the reader who experiences a dissonance between the content and the form, between the depressive assertion of impotence in face of total decadence, and the flamboyant manifestation of theoretical puissance and analytic joy (in destruction). In the end, who are you really, Mr. Critic? Are you an eccentric loner rejected by a system to which you are unequal, or are you some Olympian god looking down at the self-ruination of entertainment-drunk masses? And what is it that you want? Hegel once wrote that, in the night, all cows are black, which means that, when our perspective totalizes, everything that falls within it appears totalized; when our perspective endarkens, everything appears dark. Works of total critique ironically *mirror* the world they abhor almost to the point of relishing its manifest interconnectivity and irrational rationalism. This does not necessarily render the theory fallacious, gratuitous, or even exaggerated, but it does render it responsible.

Although an archetype, Adorno and Horkheimer's "The Culture In-
dustry" is not the only or last to exhibit a "total critique." Other potential
exemplars include Marcuse's *One-Dimensional Man: Studies in the Ideolo-
gies of Advanced Industrial Society* (1964), Debord's *Society of the Spectacle*
(1967), Foucault's *Discipline and Punish* (1975), Žižek's *Violence* (2010), and
Crary's *24/7: Late Capitalism and the Ends of Sleep* (2013). An endorsement
by McKenzie Wark on the back cover of Crary's *24/7* underscores the lin-
eage: "Crary updates Marcuse's *One Dimensional Man* with a vigilant cri-
tique of the totality of the seemingly eternal present of this pseudo-world."
The notion of *updating* is key: total critique must keep up with the contin-
uous advancement of the means of production. There is the danger that the
work of previous critics, in light of technological and economical "prog-
ress" (or deepening decadence), should become obsolete: "As late as the
1960's," Crary states in his book, "numerous critiques of consumer culture
[still] outlined the dissonance between [the oppressive] environment . . .
and individuals who . . . grasped even dimly its essential discrepancy with
their hopes and life needs." But the 1960s are long past. Today, Crary ob-
serves, the very "idea of divergence between a human world and the opera-
tion of global systems . . . seems dated and inapt. Now there are numerous
pressures for individuals to reimagine and refigure themselves as being of
the same consistency and values as the dematerialized commodities and
social connections in which they are immersed so extensively" (Crary 2013,
99). If this is what happens today, it is scary to imagine what will happen
tomorrow.

Sometimes total critique alludes to a different, utopian future, as in this
chronologically complex double negation by Crary, who gestures to the
possibility of a world in which "history can take on other forms than reified
nightmares of catastrophe" (128). But such utopian gestures are dwarfed by
the depressive message. Perhaps these critiques themselves are meant to
exhibit resistance; perhaps they *are* the escape from what they deem "ines-
capable." But if that is the case, they achieve little more than inspiring their
readers to continue their own legacy—that is, keeping total critique up to
date with the exacerbating symptoms of a terminal illness. The Frankfurt
School itself has been cognizant of the problem of total critique, especially
in its subsequent "generations," and has increasingly gravitated toward a
more pragmatic, constructive, and—as some call it—"normative" path.
Jürgen Habermas resuscitated the faith in human rationality and moder-

nity, while offering a more complex view of what rationality and modernity entail. But it may seem that we are throwing away the baby—the revolutionary spirit—with the bathwater of total critique. I think that if there is a problem with the "bath" of total critique, it is not that the water needs replacing but that the baby is missing. As harsh as the Marxist critique of capitalism and the bourgeoisie has been, it nonetheless recognized them as necessary conditions for revolution: "the productive forces developing in the womb of bourgeois society create the material conditions for the solution of [the] antagonism" (*CCPE* 5). The total deprivation and near-dehumanization of the proletariat is also what elevated them to the status of a universal class and infused them with the necessary revolutionary impetus. The very point of exposing the systematic nature of injustice in Marxist theory was disclosing in it the conditions for its own upheaval.

That said, progressive and utopian though it has been, original Marxism also started the trend of idealism-bashing, an early manifestation of the betrayal. In the spirit of the industrial revolution, all sanctity was given to the material, the technological, and the economical, whereas all forms of idealism—Platonic ideality, Christian spirituality, Kantian transcendentality, Hegelian systematicity, and so forth—were regarded as so many vessels for ideological conformity with the ruling classes. Any theory is deemed "bourgeois" if it fails to prioritize the one thing that matters: political economy, the means and the relations of production.

If this account of Marxism appears reductive, like accounts of other traditions offered in this book, the reduction is performed by their own effective history—their popular reception and legacy—and even if it necessarily eliminates nuance and dialectical tensions, this legacy nonetheless exposes decisive tendencies in the original. History is no less a judge of a work's essential contribution than the subtlest of critics and close readers who claim knowledge of what that contribution *truly* is or ought to be. As I see it, at least part of the Marxist legacy is the idea that realism or materialism *replaces* idealism, and here lie the seeds of betrayal. There is no point in judging reality, no point of view from which to judge it, except on idealistic grounds. Schelling said it best: "Idealism is the soul of philosophy; realism is its body; only the two together constitute a living whole. Realism can never furnish the first principles but it must be the basis and the instrument by which idealism realizes itself and takes on flesh and blood" (Schelling 2003, 30).

The *turn* from idealism to materialism is not itself a betrayal; like the intellectual revolutions that preceded it, it expresses critique's orientation, since spectatorial agency always entails a critical turn. On a structural level, the turn itself manifests the opposition between realism and idealism—that is, between the way things *are* (in this case, the idealism of the philosophical tradition) and the way they *ought to be* (philosophical materialism). Historically, however, the content of this turn came to conceal its form; what was the product of a turn became a reified premise, concealing the revolutionary spirit underlying it. The increasing suppression of idealism, including the fundamental love of and trust in humanity, history, and world, makes reality and its science appear sad and dry, indeed, oppressive. If the oppositional analysis of material conditions is an end in itself rather than a means to the end of idealism's realization, then the reality analyzed appears total and lacking inner opposition or any basis for a turn.

SECOND BETRAYAL: CRITIQUE OF ALL-AGAINST-ALL

The revolutionary spirit requires not only idealism, and faith in freedom, justice, equality, universality, but also solidarity. Unity is both a necessary condition for, and a desired goal of, revolution. This leads us to a second betrayal, which happens when the same spirit yields sectarianism instead. In *The Life of Brian*, Monty Python's parody of the life and times of Jesus, Brian approaches a group of Jewish revolutionaries in the hope of joining their ranks in the fight against the Roman occupiers. "Are you . . . ," he whispers, "the Judean People's Front?" "Judean People's Front?!" they respond in outrage. "We're the *People's Front of Judea*. Fucking Judean People's Front! Huh! Wankers. The People's Front of Judea gets things *done*. We're not a load of . . . *splitters*." Brian doesn't fully get the distinction: "But I hate the Romans as much as anybody," he protests. "Listen," they say, "the only people we hate *more* than the Romans are the fucking Judean People's Front" (Monty Python 1979, 17–18). This sketch could well be a parody of the sectarianism and infighting among critical thinkers today, as liberals clash heads with socialists, Marxists with adherents of identity politics, Black feminists with white feminists, Afropessimists with all of the above. We can parody this situation, but the stakes in these battles are high and getting higher. The fear of saying the wrong thing can border on paranoia, which is justified by the retaliation meted out against those who are perceived as

crossing a line. And this infighting diverts the fire away from *our* Romans. Instead of being the primary objects of critique, leaders and intellectuals on the right appropriate the tropes of critique ("fake news," "deep state," "privileged elites") and turn them against the critics themselves, capitalizing on their already heightened sense of guilt about their privilege and their anxiety about being "cancelled."

Attacked both from within and without, both by their supposed allies and by their natural foes, many thinkers who would otherwise be prone to theoretical and practical-organizational critique feel burnt-out or despondent, preferring to retreat into silence. Others adjust uncritically to the situation, drawing new lines of fire or entrenching themselves in the existing camps. Jake Hale, a philosopher who played an active role in the development of trans philosophy and in trans communities in and outside of academia, said in a recent interview:

> I [have] lost the passion for the community-based work. Over the years, it seems to me there has developed a great deal more horizontal hostility. There's very little hostility directed toward the forces that are really oppressing us, compared to what we direct toward ourselves. And the degree to which folks are getting just torn apart is disheartening to me. I don't know what to do about it other than just go live my life doing other things. (Zurn and Pitts 2020, 5)

More than a decade ago, Bruno Latour expressed a comparable exasperation:

> Wars. So many wars. Wars outside and wars inside. Cultural wars, science wars, and wars against terrorism. . . . Wars against ignorance and wars out of ignorance. My question is simple: Should we be at war, too, we, the scholars, the intellectuals? Is it really our duty to add fresh ruins to fields of ruins? Is it really the task of the humanities to add deconstruction to destruction? More iconoclasm to iconoclasm? What has become of the critical spirit? Has it run out of steam? (Latour 2004, 225)

The term I propose for this warring atmosphere, which Hale calls "horizontal hostility," is the critique of all-against-all. It is yet another betrayal that expresses something essential about critique through contradiction; what is contradicted is the imperative to *unite* the workers (or the thinkers) of the world.

Not all hostility among critics is horizontal, however. Genuine griev-

ances and significant disparities among critical thinkers do exist, and I hope that with the ability to recognize *orientations* of critical thinking we can better distinguish clashes that express *intra*orientational opposition from those that express *inter*orientational disparities. The latter would involve different ontological, epistemological, and ethical commitments, different topologies and chronologies that do not intersect. Such interorientational disparities, however, can only become muffled in the cacophony of the critique of all-against-all, which discourages attentiveness to other positions and an honest examination of one's own. And if disparities between orientations are concealed by the critique of all-against-all, how much more are the essential commonalities between those who adhere to the same orientation. If there is a disagreement between a *critical* feminist theorist, a *critical* queer theorist, a *critical* trans theorist, a *critical* race theorist, and a *critical* Marxist about what constitutes the oppressed class, this is only because they all share the logic and ontology of classification and an oppressive-antagonistic conception of power. More important, they share, or at least claim to share, the goal of changing the world and making it inclusive of differences—a goal whose true antithesis is expressly exclusionary, xenophobic politics. It is telling that vocal proponents of the latter do not acknowledge any substantive difference between the combating camps, referring to all of them *en masse* under such umbrella terms as liberals, socialists, or critical race theorists. These right-wing pundits may misname or misrepresent their opposition, but they at least *have* a truly oppositional figure against which they unite their ranks.

The infighting among critics discloses essential features of the orientation itself, above all its drive to unity, and with it, antagonism toward multiplicity (Monty Python's "splitters"). The combatants are thus ideological enemies precisely because they are, on a deeper level, ideological partners in the cause of unification. Their polemics revolve around the question of what is the *right form* of critique, or what is the true Left, and if one group of critics is, in the eyes of the other, "even worse than the Romans," it is because they threaten the *us-them* dichotomy and thus cross a symbolic picket line and create discord among the ranks. Under the oppositional logic of critique, since they are not *us*, they must be *them*, but as such, they are the *worst* kind—namely, infiltrators, informants, traitors. In recent years, one of the growing trends among critics is to identify their rival critics as secret assets of the CIA—some of whom are so secretive they are not even

aware of having been recruited. Traitors they are, indeed, who methodically undermine critique's capacity to unite and turn it into its very opposite: a horizontal battlefield, a critique of all-against-all. There seems to be no need for the CIA to achieve such sectarianism and discord, we critics can take care of it ourselves.

This spirit is not unique to our times. Indeed, one of the many ways we tend to overstate the oppositions among us as critics is by lamenting "the times." The tendency for a critique of all-against-all already ran rampant in ancient Athens as soon as philosophical schools began forming in the example of Plato's Academia. These schools were nurtured by inner rivalries among students who ended up, literally, splitting (the most famous of these is Aristotle, who, prior to splitting out to establish his own school in the Lyceum, was a longtime prominent member of Plato's Academy). In Christianity, similar hostilities and oppositional splits grew in proportion as the movement transformed from critical fringe to centralized imperial power. Protestantism and the Reformation were inevitable, for before the institution of Catholic orthodoxy, Christianity was itself a protest movement, an *antidoxa*. And it should go without saying that Protestantism did not remain a unified front for very long. Soon, the infighting among proliferating Christian factions in Europe became one of the bloodiest spectacles the world has ever known.

Communism was birthed in similar struggles, which never stopped tearing and splitting it apart from within. Peter Singer tells us of how, while exiled in London, Marx "spent his time reading omnivorously and engaging in doctrinal squabbles with other left-wing German refugees" (Singer 2018, 8). Marx's writing and thinking exhibited a penchant for bickering from the start. *The Holy Family*, better known as *The German Ideology*, is almost entirely a takedown of rival socialists and Left Hegelians on whom Marx never tired of lavishing his scorn. The same is true of much of *The Manifesto of the Communist Party*, which did as much to trash rival communists as to unite the workers. Nor is Marx himself the sole or last culprit in this trend. The Communist Party in twentieth-century France split itself up into acronymic factions with the predictability of biological mitosis. You must know the joke: How many communists does it take to change the world? Not nearly as many as it takes to change a lightbulb. Without unity, the notion of a "Front" (the Judean People's Front, the People's Front of Judea) gives way to vertigo, as it becomes unclear and ever shifting where

the front is and where the back, who the enemy is and who the friend, and each one pirouettes in a paranoid dance that nonetheless seems oddly choreographed and coordinated.

Sectarianism and "the spirit of contention" (Weil 2000, 83) is perhaps only symptomatic of a deeper tendency in critique—its authoritarian, domineering disposition, as inscribed in its sovereign conception of power and monocular epistemology. "Though theoretically opposed to what he called 'a superstitious attitude to authority,'" Singer writes, "Marx was so convinced of the importance of his own ideas that he had little tolerance for opinions different from his own. This led to frequent rows in the Communist Correspondence Committee and in the Communist League that followed it" (Singer 2018, 7). More than a century later, the authoritarian streak in communism could be seen in the critical reception to Jacques Rancière's *Proletarian Nights: The Workers' Dream in Nineteenth Century France*, which presented an archival study of correspondences and diaries by proletariat workers in nineteenth-century France. In their writing, these workers discuss their dreams and thoughts, their aesthetic, as well as their political ambitions. In an introduction to a second edition of the book, Rancière described the rancor with which its original publication was greeted: "The social sciences declared [my] accounts of workers' excursions lacking in historical importance, since they were far from *the solid realities* of the factory and organized struggle. By this token, they confirmed the social order that has always been constructed on the simple idea that the vocation of workers is to work—good progressive souls add: and to struggle—and that they have no time to waste playing at flâneurs, writers, or thinkers" (Rancière 2014, viii, italics added).

In other words, the critics saw Rancière's focus on the proletarians' dreams as falling short of what really *matters* about them and their condition—the *concrete* fact of their oppression and whatever they do or do not do to change it. Rancière's response to the criticism turns it on its head. What is oppressive, on his account, is not only the actions of capitalists but the "constructed social order" reified by these critics, who not only determine what reality is and is not *for* the workers but also consolidate their historical status as voiceless, mindless, menial laborers who cease to be historically relevant as soon as they cease to be exploited. This view of history is, Rancière insisted, "beneath its apparent objectivity, a manner of putting things and beings in a hierarchical order." Doing this, he claimed,

is ultimately the critics' way of asserting *their own* value and reign over the field of discourse: "Belief in historical evolution, said Walter Benjamin, is the legitimization of the victors. For me it is the legitimization *of the knowledge* that dictates what is or is not important, what makes history or does not" (viii, italics added).

The intellectual's portrayal of the "oppressed" as entirely un-intellectual, María Lugones argued, is an "arrogant perception":

> Through travelling to other people's "worlds" we discover that there are "worlds" in which those who are the victims of arrogant perception are really subjects, lively beings, resistors, constructors of visions even though in the mainstream construction they are animated only by the arrogant perceiver and are pliable, foldable, file-awayable, classifiable. I always imagine the Aristotelian slave as pliable and foldable at night or after he or she cannot work anymore. . . . Aristotle tells us nothing about the slave apart from the master. We know the slave only through the master. . . . After working hours, he or she is folded and placed in a drawer till the next morning. (Lugones 1987, 18)

Critique, which is essentially oppositional to the orthodoxy, tends to devolve into an orthodoxy itself, delegitimizing all dissension or deviation from the prescribed Cause. A particularly sharp takedown of this conversion from critique to orthodoxy is given in the title and content of a recent book by Palestinian activist and scholar Sa'ed Atshan, *Queer Palestine and the Empire of Critique*. Atshan writes of the difficulties experienced by the "Queer Palestine" movement in which he is active. Not unlike Rancière's study of workers, this queer liberation movement, which began in Palestine and expanded internationally, encountered some of its fiercest opposition among Western academics. The latter critiqued the movement for contributing to Israel's "pink-washing"—that is, diverting attention from the *real* struggle against the Israeli imperialist occupation. The problems of queers in Palestine, and their solidarity with queers in other parts of the world, Israel included, not only divides the Palestinian people (*splitters!*) but also supports the Israeli propaganda that paints the Palestinian culture, and Arab culture more generally, as religiously backward and oppressive. To this complaint was added a critique of the liberal rhetoric of the movement, which is, so the accusation goes, rooted in Western imperialism and colonialism and is therefore similarly collaborationist.

Responding to these critiques, Atshan argues "that some influential Western academic paradigms, in their efforts to oppose imperialism, have inadvertently contributed *to the empire of critique*, adding yet another layer of surveillance and critical scrutiny to the struggles of queer Palestinian solidarity activists" (Atshan 2020, 184–85, italics added). As an Israeli, my point here is not to deny Israel's pink-washing or to critique its critics, but to underscore Atshan's suggestive formulation of the much broader phenomenon at stake in this dispute, namely, the way in which a critique of empire can metamorphose into an *empire of critique*, which polices and surveils its own citizens, the critics. To be sure, true activism often requires a unity of rank and focus of energies. Debates about the articulation of the cause and the right mode of approach, however fierce, are as important as they are inevitable. But when the demand for unity of purpose sanctions the silencing of the very people whose liberation is at stake, critique betrays them and betrays itself.

THIRD BETRAYAL: THE ACTIVIST MYSTIQUE

In its progressive guises, as we have seen in previous chapters, critique tends to view history as a dark tunnel with a light at its end. The future corrects and even vindicates history's faults. In turn, being active on this view means causing change. These notions spell out the premise that past and present existence is quite literally a means to an end; everything has value only insofar as it causes something else but not insofar as it is what it is. We see this logic at play in all expressions of critique. Even Plato's forms are never encountered directly, only via something else, something whose value and meaning are bestowed on it by what it, itself, is not. Interestingly, these features of critique bring it danegorusly close to the instrumental reasoning of the culture industry, under whose auspices, Adorno and Horkheimer argued, everything "is perceived only from the point of view that it can serve as something else, however vaguely that other thing might be envisaged. Everything has value only insofar as it can be exchanged, not in so far as it is something in itself" (*DE* 128).

In the materialist guise of modern critique, this instrumentalizing tendency is articulated in terms of a theory-practice opposition. Theory is tacitly taken to have value only in relation to what it is not, namely, practice—particularly the kind of revolutionary practice that aims to rad-

ically change the state theorized. Thus, we read in Marx's *Theses on Feuer-bach* that "man must prove the truth, the actuality and power . . . of his thinking in practice" (*TF2* 144), and the conclusion to the *Theses* is now legendary: "The philosophers have only interpreted the world, in various ways; the point is to change it" (*TF11* 145). It is clear that Marx himself is not guilty of the suggestion that theory and practice are mutually exclusive or that theory is inessential; nevertheless, a hierarchical opposition between theory and practice is certainly pronounced here, and in a manner that less dialectically minded readers and activists can easily misconstrue, and have repeatedly misconstrued, to be a denigration of theory. In the student up-heaval of 1968 in France, this assumption found a variety of expressions. In its wake, Adorno wrote that,

> Today once again the antithesis between theory and praxis is being misused to denounce theory. When a student's room was smashed because he pre-ferred to work rather than join in actions, on the wall was scrawled: "Who-ever occupies himself with theory, without acting practically, is a traitor to socialism." It is not only against him that praxis serves as an ideological pretext for exercising moral constraint. The thinking denigrated by action-ists apparently demands of them too much undue effort: it requires too much work. (Adorno 2005, 263)

The conceptual opposition of theory and practice is not reducible to this or that slogan; it belongs to the essential conflict within the spectatorial orientation between the intellect and the will, between the intellect and power, and between seeing and doing. Marx's frustration at the failure of his fellow Hegelians and of Hegel himself to perceive the import of revo-lutionary practice does not refer to chance deficiency on the part of intel-lectuals. The deficiency, if there is one, ensues from the fact that critique is essentially a *theoretical* standpoint, and that the theoretical standpoint itself is defined in part through its transcendentalism and its withdrawal from the "work-world"—the world in which we move and act. Who else but a theorist, responding to a theoretical heritage and milieu, would need to *emphasize* the import of practice, to *salvage* practice, in the way Marx does in his *Theses*? In addition, only to a theorist or a spectator would the notion of "practice" be so intrinsically linked to the notion of revolution, some dramatic change that must happen in one's life and in the world. It is therefore *the thinker* that Marx wishes to cast into the world; he wants

us to see that a philosopher need not be *merely* a spectator or interpreter but can *also*, and at the same time, be a political agent. In the longer run, this effort to sublate the theory-practice opposition, reminding theory of its practical import, resulted not only in radicalizing the opposition itself but in demoting theory to a mere means to the end of revolutionary practice and practical change—as if the latter *did* have intrinsic value.

Even the fight of Frankfurt School critical theorists against "instrumental reasoning" and their furious defense of the intrinsic value of theory is steeped in structural ambivalence. If critical theory is such that opposes the present state of the world, and if the only impetus for it is the need to practically change the world, then, unless critical theory *is* the desired change, it has no intrinsic value. This reverses Aristotle's conception of *theoria* as the *only* activity that has intrinsic value, the only activity that could, in the broader scheme of things, justify the existence of the *polis* and its political animals. For Aristotle, as for Socrates before him, the only reason that could necessitate changing the political state is to better facilitate an environment that nurtures philosophical activity—a multibranched science for Aristotle, a self-examined life for Socrates. This activity, in turn, is regarded as the very substance of the good life. Theory *is* the good life, and the theory-loving polity is the best kind.

By contrast, we can infer from the statement by Horkheimer with which this book began that if the state of the world were not sordid, there would be no critical impulse, no desire to change the world, and therefore no theory. Or, recalling Schopenhauer: "If the world were not something that, *practically* expressed, ought not to be, it would also not be theoretically a problem" (Schopenhauer 1966, 579). On this (theoretical) ground, we are led to assume that an ideal or just world would obviate, if not the need for theory in general, then certainly the need for *critical* theory or critique. But how can a world without critical theory be just or ideal for someone whose vocation in this world is to be a critical theorist?

If I am right in saying that critique and the spectatorial orientation to which it belongs are essential possibilities of being and of thinking, then we can rest assured that theory and critical theory are here to stay. Future generations would not suddenly be *content* with their inheritance or the spectacle of their world. Saying this does not change the fact that critique is capable of, and perhaps even inclined to, *misconstruing* itself as something that is reactive rather than generative. When this is the case, it behaves like

one of those recordings in *Mission: Impossible* that are set to self-destruct. When everything critique touches, including itself, becomes a means to an end, and the end—as in Hegel's "Bad Infinite"—is categorically out of reach, critique makes itself redundant.

The instrumentalization and debasement of theory is in my view the most calamitous of critique's self-betrayals. It is the oppositional logic turned against itself, and a reactionary attitude to boot. For nothing characterizes the reactionary forces driving the free-market economy more than its contempt for all things theoretical and "abstract." Nothing turns it on as much as a young entrepreneur or corporate leader announcing the product that would "change the world." *Why? What for?* Anti-intellectual sentiments are in the air we breathe, the news we consume, the rhetoric of politicians and advertisers, and these very same sentiments are endorsed by academics as well. Thus, for example, the "philosophy job-market" (an actual term) appears to value nothing more today than what is "applicable" or "applied." "Courses on Critical Thinking" (critique, that is) are highlighted in philosophy department web pages as providing future students with the "necessary skill sets" for the pursuit of other professions. Many institutions refer to their philosophy departments as "service departments" because, while supplying the alleged necessities of the core curriculum (including courses on critical thinking), they are not seen as having any purpose of their own. As critics, we can easily come to internalize this culture—this Aristophanic mocking gaze—mistaking it for our own. When this happens, we get bogged down by feelings of inadequacy. The world is in shambles, and what do we do about it? *Nothing*, or nothing that *matters*. We talk and ruminate in air-conditioned offices and maybe even write, while looking up admiringly to those *real* activists (who in turn look down at us)—those nonacademic Che Guevaras of the world who, having just ended world poverty and oppression, ride their motorcycles into the sunset. We wonder whether "in times like this" it is not indecent for us to be reading old books in our "armchairs," in our "clouds," in our "ivory towers"—those heterotopias to which the practical folk mockingly consign us. It may do us good to remind ourselves that the structural commitment to radical change and progress and the blind admiration of go-getters and world-changers is something we have in common with the capitalist culture we oppose. We may also recall the words of Socrates, who, under the threat of death, retorted that the unexamined life—a life without theory—is

not worth living for a human being. Or as Arendt wrote: "thinking may set tasks for itself; it may deal with 'problems'; it naturally, indeed always, has something specific with which it is particularly occupied or, more precisely, by which it is specifically aroused; but one cannot say that it has a goal. It is unceasingly active, and even the laying down of paths itself is conducive to opening up a new dimension of thought, rather than to reaching a goal sighted beforehand and guided thereto" (Arendt 1978, 296). Pace Marx, I do not see how "the point" can be changing the world. What *can* be the point is something that calls for thinking. And if it is true that critique's vocation is restricted to the exposition of, and fight against, injustice, then critique, however necessary, cannot be the be-all and end-all of critical thought.

ALTERNATIVE ORIENTATIONS:
CRITIQUE, EMANCIPATION, REVOLT

The purpose of critiquing an orientation, recognizing and articulating its formal aspects, is not only pointing out its limitations but also underscoring its unique contributions and potencies. An orientation is not defined by its betrayals; on the contrary, these betrayals contradict its values. The phenomenon of "total critique," to reiterate, contradicts the idealism inherent to critique and its revolutionary drive. The "critique-of-all-against-all" contradicts critique's aspiration to universality and equality. The "activist mystique" contradicts critique's theoretical force, which makes it possible to think outside the demands of the "work-world." I have argued that these commitments and values—opposing the ideal to the real and theory to practice, aspiring to universality and equality, believing in rationality and objectivity—are *unique* to the spectatorial orientation and its conceptscape: its ethos, logos, and pathos.

In the introduction to this book I drew an analogy to Kant's *Critique of Pure Reason*, specifically to his statement that he "found it necessary to [limit] knowledge in order to make room for faith" (*CPR* 29). In the context of his critical project, Kant meant something like this: I found it necessary to limit theoretical reasoning to make room for a fundamentally different kind of reasoning, one he called "practical." Similar to Kant's project, the critique of critique has two main goals. The first is to offer a comprehensive account of the parameters of critique and the spectatorial orientation in which it is rooted, to show the conditions that make it possible and beyond

which it cannot venture without losing its integrity or betraying itself. The second goal is to make room for other orientations of critical thought, or—since other orientations exist whether we make room for them or not—to prepare the ground for the *recognition* and *articulation* of other orientations. An alternative orientation of thought—to be on a par with, yet different from, critique and the spectatorial orientation presented here—would entail a different configuration of the world and the self; a different logos, ethos, and pathos; and a different experience and conception of being, time, and space.

I recognize at least two such orientations, which I name *emancipatory thinking* and *thinking in revolt*. If critique is rooted in a spectatorial orientation, emancipatory thinking is rooted in an agentive-practical orientation and thinking in revolt in an affective orientation. If the mode of being that is distinctive to critique is consciousness, that of emancipatory thinking is desire and drive, and that of thinking in revolt is suffering. If critique is *anti*doxic, emancipatory thinking is *hetero*doxic, and revolt is *para*doxical. Proximally, and for the most part, a human being is spectator, agent, *and* sufferer all at once. Yet we are, all of us, in a state of conflict or tension between these orientations. If we look at the duck-rabbit image, for example, we see that it presents us with two alternative images at once: it is the image of a duck *and* the image of a rabbit, but we cannot see or concentrate on both at once; rather, we need to "switch" from one to the other. Such a switch can sometimes happen spontaneously, sometimes deliberately, sometimes imposed. It is along these lines, I suggest, that we "switch" orientations.

Critique belongs to a spectatorial orientation but is not synonymous with it, for it connotes a particularly proactive spectatorship, one that *upholds* itself in opposition rather than getting immersed or lost in the spectacle. Similarly, emancipatory thinking belongs to an agentive-practical orientation but is not synonymous with it; what renders it a *critical* modality of thinking and being—and therefore an alternative to critique—is the heightened attunement to oneself and one's environment, clear conceptions of the true and the good, a strong set of commitments and values. Just as the critic is not only a conscious but a self-conscious being, the emancipatory thinker is not just a drive but is self-driven. Gilles Deleuze expressed this thought when, for example, he described Spinoza and Nietzsche as "philosophers whose critical and destructive powers are without equal, but this power always springs from affirmation, from joy . . . from the exigency of

life against those who would mutilate and mortify it" (Deleuze 2004, 144). He was thus presenting Spinoza and Nietzsche (and himself) as what I call emancipatory thinkers—thinkers who are critical but are not critics; thinkers who affirm realities that are worth affirming rather than setting themselves in opposition to reality *tout court.*

The third orientation, thinking in revolt, is rooted in an affective orientation but is not synonymous with it. It is a critical manner of *upholding* victimhood or suffering. While it is certainly not self-victimization, it is also not the same as simply being victimized. Instead, it mobilizes experiences of exclusion, oppression, or humiliation in revolt against the powers that oppress. Queer theorist Lee Edelman exemplified revolt when he wrote that "queers must respond to the violent force of [the] constant provocations [against them] by saying explicitly what [the provocateurs] hear anyway in each and every expression . . . of queer sexuality: Fuck the social order. . . . Fuck the whole network of Symbolic relations and the future that serves as its prop" (Edelman 2004, 29). The logic of revolt, as expressed in Edelman's brand of queer theory, is not oppositional but contrarian, disruptive, disquieting. It is a matter of personifying society's phobias, thus making them present for what they are, rather than trying to quell or overcome them.

These statements by Deleuze and Edelman have little in common with critique's characteristic indictment of the present and its imperative to change the world and advance a better future. Deleuze affirms the present rather than opposes it, and Edelman disavows the future and the imperatives ushered in its name no less than he opposes the present. These are not incidental statements or sentiments, nor are they unique to these authors; like critique, they express orientations in the world and of the world, in history and of history. Each of them represents an *essential* orientation: spectator, agent, sufferer. None is better or truer than the others, and critical thinking does not need to make a final choice among them. They coexist as thinking's essential possibilities—its vitality and its capacity to turn, to overturn, to return. These orientations meet, to use Eliot's words again, "at the still point of the turning world," where thinking happens, where the dance is.

References

Adorno, Theodor. 1985. *Minima Moralia*. London: Verso.

———. 2005. *Critical Models: Interventions and Catchwords*. New York: Columbia University Press.

Adorno, Theodor, and Max Horkheimer. 2002. *Dialectic of Enlightenment*. Stanford: Stanford University Press.

Agamben, Giorgio. 1998. *Homo Sacer*. Stanford: Stanford University Press.

———. 2020a. "When the House Burns." Oct. 15. https://architectsforsocialhousing. co.uk/2020/10/15/when-the-house-burns-giorgio-agamben-on-the-coronavirus -crisis.

———. 2020b. "Regarding the Coming Time." Nov. 23. https://autonomies.org/2020 /11/giorgio-agamben-regarding-the-coming-time.

Anker, Elizabeth S., and Rita Felski. 2017. *Critique and Postcritique*. Durham, NC: Duke University Press.

Arendt, Hannah. 1978. "Martin Heidegger at 80." In *Heidegger and Modern Philosophy*, edited by Andrew Murray, 293–303. New Haven, CT: Yale University Press.

———. 1981. *The Life of the Mind*. 2 vols. San Diego: Mariner.

———. 2005. *Essays in Understanding, 1930–1954*. Edited by Jerome Kohn. New York: Schocken.

———. 2008. *The Jewish Writings*. Edited by Jerome Kohn and Ron H. Feldman. New York: Schocken.

Aristophanes. 2005. *The Complete Plays*. Translated by Paul Roche. New York: New American Library.

Aristotle. 2001. *The Basic Works of Aristotle*. Edited by Richard McKeon. New York: Modern Library.

Atshan, Sa'ed. 2020. *Queer Palestine and the Empire of Critique*. Stanford: Stanford University Press.

Augustine. 2006. *Confessions*. Indianapolis, IN: Hackett.

———. 2010. *On the Free Choice of the Will*. In *On the Free Choice of the Will, On*

Grace and Free Choice, and Other Writings. Edited by Peter King, 3–126. New York: Cambridge University Press.

———. 2014. *The City of God.* Peabody, MA: Hendrickson

Bacon, Francis. 1999. "The Great Instauration." In *Francis Bacon: Selected Philosophical Works,* edited by Rose-Mary Sargent, 66–85. Indianapolis, IN: Hackett.

———. 2000. *The New Organon.* Cambridge: Cambridge University Press.

Baldwin, James. 1963. *The Fire Next Time.* London: Michael Joseph.

Barthes, Roland. 2013. *Mythologies.* New York: Hill and Wang.

Baudry, Jean-Louis. 1974. "Ideological Effects of the Cinematic Apparatus." *Film Quarterly* 28, no. 2 (Winter): 39–47.

Beauvoir, Simone de. 2011. *The Second Sex.* New York: Vintage.

———. 2018. *The Ethics of Ambiguity.* New York: Open Road Media.

Benjamin, Walter. 2019. *Illuminations.* Edited by Hannah Arendt. Boston: Mariner.

Bergson, Henri. 1998. *Creative Evolution.* Mineola, NY: Dover.

Blumenberg, Hans. 1996. *Shipwreck with Spectator.* London: MIT Press.

Butler, Judith. 1988. "Performative Acts and Gender Constitution." *Theatre Journal* 40, no. 4 (Dec.): 519–31.

Chalfi, Raquel, Ory Bernstein, and Shimon Adaf. 2014. *Kaleidoscope.* Ontario: Mosaic.

Crary, Jonathan. 2014. *24/7: Late Capitalism and the Ends of Sleep.* London: Verso.

Curd, Patricia, ed. 2011. *A Presocratics Reader.* Indianapolis, IN: Hackett.

Debord, Guy. 1995. *Society of the Spectacle.* New York: Zone.

Deleuze, Gilles. 2004. *Desert Islands and Other Texts, 1953–1974.* Edited by David Lapoujade and Michael Taormina. New York: Semiotext(e).

Descartes, René. 2005a. *The Philosophical Writings of Descartes.* Vol. 1. Translated by John Cottingham, Robert Stoothoff, and Dugald Murdoch. Cambridge: Cambridge University Press.

———. 2005b. *The Philosophical Writings of Descartes.* Vol. 2. Translated by John Cottingham, Robert Stoothoff, and Dugald Murdoch. New York: Cambridge University Press.

Dewey, John. 2005. *Art as Experience.* New York: Tarcher Perigee.

Edelman, Lee. 2004. *No Future.* Durham, NC: Duke University Press.

Eliot, T. S. 1971. *Four Quartets.* Boston: Mariner.

Fellini, Federico, dir. 1963. *8½.*

Felski, Rita. 2015. *The Limits of Critique.* Chicago: University of Chicago Press.

Foucault, Michel. 1984. *The Foucault Reader.* Edited by Paul Rabinow. New York: Pantheon.

———. 1995. *Discipline and Punish.* New York: Vintage.

———. 2003. *The Essential Foucault.* Edited by Paul Rabinow and Nikolas Rose. New York: The New Press.

Fraser, Pamela, and Roger Rothman, eds. 2018. *Beyond Critique: Contemporary Art in Theory, Practice, and Instruction.* New York: Bloomsbury.

Gadamer, Hans-Georg. 2016. *The Beginning of Philosophy.* London: Bloomsbury Academic.

Gauguin, Paul. 2002. "Letter to Fontainas." In *Art in Theory, 1900–2000*. Edited by Charles Harrison and Paul J. Wood, 18–20. Malden, MA: Blackwell.

Harcourt, Bernard E. 2018. "Virtual Transparency." In *Transparency, Society and Subjectivity*, edited by Emmanuel Alloa and Dieter Thomä, 369–91. New York: Springer International.

Hegel, G. W. F. 1975. *Philosophy of Right*. Oxford: Oxford University Press.

——. 1977. *Phenomenology of Spirit*. Oxford: Oxford University Press.

——. 1995. *Lectures on the History of Philosophy*. Vol. 1. Lincoln: University of Nebraska Press.

Heidegger, Martin. 1962. *Kant and the Problem of Metaphysics*. Bloomington: Indiana University Press.

——. 1985. *Early Greek Thinking*. San Francisco: Harper.

——. 1998. *Parmenides*. Bloomington: Indiana University Press.

——. 2008a. *Being and Time*. New York: Harper Perennial.

——. 2008b. *Ontology—The Hermeneutics of Facticity*. Bloomington: Indiana University Press.

——. 2009. *History of the Concept of Time*. Bloomington: Indiana University Press.

——. 2013. *The Question Concerning Technology*. New York: Harper Perennial.

Hemingway, Ernest. 2016. *The Sun Also Rises*. New York: Scribner.

Hesiod. 1993. *Works and Days and Theogony*. Indianapolis, IN: Hackett.

Horkheimer, Max. 1975. "The Latest Attack on Metaphysics." In *Critical Theory: Selected Essays*, 132–87. New York: Continuum.

Hoy, David Couzens. 2004. *Critical Resistance: From Poststructuralism to Post-Critique*. Cambridge, MA: Bradford.

Kant, Immanuel. 1993. *Grounding for the Metaphysics of Morals*. Indianapolis, IN: Hackett.

——. 1994. *Basic Writings*. Edited by Allen W. Wood. New York: Modern Library.

——. 2003. *Critique of Pure Reason*. Basingstoke: Palgrave Macmillan.

King, Martin Luther, Jr. 2003. *A Testament of Hope: The Essential Writings and Speeches*. Edited by James M. Washington. San Francisco: HarperOne.

Klein, Jacob. 1992. *Greek Mathematical Thought and the Origin of Algebra*. New York: Dover.

Kuhn, Thomas S. 2012. *The Structure of Scientific Revolutions*. Chicago: University of Chicago Press.

Kundera, Milan. 1984. *The Unbearable Lightness of Being*. New York: Harper Perennial.

Lacan, Jacques. 2007. *Écrits*. Translated by Bruce Fink. New York: Norton.

Latour, Bruno. 2004. "Why Has Critique Run out of Steam?" *Critical Inquiry* 30, no. 2 (Winter): 225–48.

Lugones, María. 1987. "Playfulness, 'World'-Travelling, and Loving Perception." *Hypatia* 2, no. 2 (Summer): 3–19.

——. 2010. "Toward a Decolonial Feminism." *Hypatia* 25, no. 4 (Fall): 742–59.

Marcuse, Herbert. 1991. *One-Dimensional Man*. Boston: Beacon.

Marx, Karl. 1975. *Doctoral Dissertation*. In *Collected Works of Marx and Engels*. Vol. 1, 25–108. New York: International Publishers.

Marx, Karl, and Friedrich Engels. 1978. *The Marx-Engels Reader*. Edited by Robert C. Tucker. New York: Norton.

Mill, John Stuart. 2003. *"Utilitarianism" and "On Liberty."* Malden: Wiley-Blackwell.

Montaigne, Michel de. 2012. *Selected Essays*. Edited by James B. Atkinson and David Sices. Indianapolis, IN: Hackett.

Monty Python. 1979. *The Life of Brian (of Nazareth): A Script*. London: Banbury.

Mulvey, Laura. 2009. *Visual and Other Pleasures*. New York: Palgrave Macmillan.

Nietzsche, Friedrich. 1967. *"The Birth of Tragedy" and "The Case of Wagner."* New York: Vintage.

———. 1980. *On the Advantage and Disadvantage of History for Life*. Indianapolis, IN: Hackett.

———. 1989. *"On the Genealogy of Morals" and "Ecce Homo."* New York: Vintage.

———. 1996a. *Human, All Too Human*. New York: Cambridge University Press.

———. 1996b. *Philosophy in the Tragic Age of the Greeks*. Washington: Gateway.

———. 2006. *Thus Spoke Zarathustra*. New York: Cambridge University Press.

———. 2016. *We Philologists*. CreateSpace.

Plato. 1997. *Complete Works*. Edited by John M. Cooper. Indianapolis, IN: Hackett.

Rancière, Jacques. 2014. *Proletarian Nights*. New York: Verso.

Ricoeur, Paul. 1977. *Freud and Philosophy*. New Haven, CT: Yale University Press.

Rilke, Rainer Maria. 1981. *Duino Elegies*. Falls Church, VA: Azul.

Rousseau, Jean-Jacques. 1964. *The First and Second Discourses*. Translated by Roger D. and Judith R. Masters. New York: Bedford/St. Martin's.

Sartre, Jean-Paul. 1969. *The Wall and Other Stories*. Translated by Lloyd Alexander. New York: New Directions.

———. 1970. "Intentionality." *Journal of the British Society of Phenomenology* 1, no. 2: 4–5.

———. 1993. *Being and Nothingness*. New York: Washington Square Press.

Schelling, F. W. J. 2003. *Philosophical Inquiries into the Nature of Human Freedom*. LaSalle, IL: Open Court.

Schmitt, Carl. 2006. *Political Theology*. Chicago: University of Chicago Press.

Schopenhauer, Arthur. 1966. *The World as Will and Representation*. Vol. 2. New York: Dover.

Sedgwick, Eve Kosofsky. 2003. "Paranoid Reading and Reparative Reading." In *Touching Feeling*, 123–152. Durham, NC: Duke University Press.

Shapin, Steven, and Simon Schaffer. 2017. *Leviathan and the Air-Pump*. Princeton, NJ: Princeton University Press.

Shakespeare, William. 2014a. *As You Like It*. In *The Complete Works of Shakespeare*. San Diego: Canterbury Classics.

———. 2014b. *Hamlet*. In *The Complete Works of Shakespeare*. San Diego: Canterbury Classics.

Singer, Peter. 2018. *Marx*. New York: Oxford University Press.

Sloterdijk, Peter. 2009. "Rules for the Human Zoo." *Environment and Planning D: Society and Place* 27, no. 1: 12–28.

Spinoza, Baruch. 1992. *Ethics.* Indianapolis, IN: Hackett.

Sutter, Laurent de. 2019. *Postcritique.* Paris: PUF.

Swift, Jonathan. 1996. *Gulliver's Travels.* Mineola, NY: Dover.

Thibon, Gustave. 1997. Introduction to *Gravity and Grace*, by Simone Weil. Lincoln, NE: Bison.

Wachowski Lana, and Lilly Wachowski, dirs. 1999. *The Matrix.*

Weil, Simone. 2000. *Simone Weil: An Anthology.* Edited by Siân Miles. New York: Grove.

Wilderson, Frank B., III. 2020. *Afropessimism.* New York: Liveright.

Wittgenstein, Ludwig. 1965. "A Lecture on Ethics." *Philosophical Review* 74, no. 1 (Jan.): 3–12.

———. 2001. *Tractatus Logico-Philosophicus.* Translated by D. F. Pears and B. F. Mc-Guinness. London: Routledge.

———. 2009. *Philosophical Investigations.* Chichester: Wiley-Blackwell.

Wittig, Monique. 1992. *The Straight Mind and Other Essays.* Boston: Beacon.

Yancy, George. 2016. *Black Bodies, White Gazes.* Lanham, MD: Rowman & Littlefield.

Žižek, Slavoj. 2008. *Violence.* New York: Picador.

Zurn, Perry, and Andrea Pitts. 2020. "Trans Philosophy: The Early Years. An Interview with Talia Mae Bettcher, Loren Cannon, Miqqi Alicia Gilbert, and C. Jacob Hale." *APA Newsletter on LGBTQ Issues in Philosophy* 20, no. 1 (Fall): 1–10.

Index

critical distance, xiv, 28–29, 57–58, 119, 153. *See also* evaluation; transcendental (spectator)

critical theory, 16, 30–33, 48–54, 64–71, 111–12, 123–35, 203–4, 207–8. *See also* Adorno, Theodor; Frankfurt School; Horkheimer, Max; theory

critical turn, 46–48, 52–53, 77, 90, 94, 103, 169, 193, 209. *See also* conversion; metastrophic turn; revolution; turning

critique: activism and, 121–29; alienation and, 38, 55–65, 73, 76, 90, 94, 155, 194–95; as background norm, 1–2, 12–13, 52–54; being as presence and, 38–42, 109–10, 112–21, 145–55, 179–82, 193–98; betrayals of, 19, 201–19; chronology and, 179–81, 185–92, 197–98; common sense and, 26–27, 31–32, 44; confession and, 73–80; culture of, xii, 1–3, 6, 8, 13, 52–54, 135–37, 145–46, 157; definitions of, xiii–xiv, 3–4; dogmatism and, 20, 34, 102–3, 112, 176, 200–19; education and, 98–106; enlightenment tropes and, 15–16, 38–46, 193; historicity and, 12, 68, 179–81; judgment and, xiii–xiv, 9–10, 23, 46–48, 117–18, 120–21, 138–40; Kant's version of, xi, 3–4, 12–13; oppositionality and, xiii–xiv, 9–10, 18–19, 22–25, 33–34, 65–71, 89–90, 185–86, 199–200; of orientations, 219–21; revolutionaries and, 209–15; sociohistorical grounding of, 155–61; spectacularity and, 37–38, 52–56, 217–21; total, 203–9. *See also* evaluation; judgment; oppositionality; spectacle and spectacularity

Critique of Pure Reason (Kant), 3, 11, 219

culture industry, 203–9

Dasein, 149, 152, 157

death, 152–53

death drive, 29, 197–98

debate, 135–37

Debord, Guy, 37–38, 41, 207

deconstruction, 12

deduction, 138–40

defamiliarization, 5–6, 17, 20

Deleuze, Gilles, 220–21. *See also* emancipatory thinking (orientation)

Descartes, René, 32, 58–59, 90–98, 110, 113–14, 127–28, 133, 148–49, 155–57, 165

desire: alienation and, 56; to change the world, 3, 28–30, 33–34, 129–35, 185, 195–96, 217–19; classification and, 141–44; education and, 98–104; emancipatory thinking and, 12, 220–21; to expose, 172; for self-substantiation, 150–51, 209; for the end of critique, 18–19, 197; perception and, 33–34; perversions of, 96–98; will and, 62–63. *See also* pleasure principle

deviation forms, 201–2

Dewey, John, 179

Dialectic of Enlightenment (Adorno and Horkheimer), 33, 173

dialectics: critic-establishment dynamic in, 64–71; disputation and, 135–37; education and, 101–2; Hegelian, 30, 73, 82–83, 101–2, 136–37, 186–87; Kantian, 64–65; Marxian, 84–86; Platonic, 45–46; rationality and, 30–33. *See also* oppositionality; spectacle and spectacularity; unification

Discipline and Punish (Foucault), 207

diseases, 130–32

disputation, 135–37

dogmatism, 20, 34, 102–3, 112, 176, 200–19

doubt, 90–94, 99, 103, 110, 134, 149–50. *See also* Descartes, René; skepticism

dreaming, 58–59, 134, 149

CPSIA information can be obtained
at www.ICGtesting.com
Printed in the USA
JSHW030010211222
35255JS00003B/3

9 781503 633827